THE CALL OF THE HOMELAND

Peripheral Vision

A WORLD ART BOOK BY **CHARLES GREEN**

CRAFTSMAN
HOUSE

CONTEMPORARY AUSTRALIAN ART 1970–1994

For Lyndell Brown

"Mr. Milestone observed that there were great
capabilities in the scenery, but it wanted shaving
and polishing. If he could have it under his care
for a single twelvemonth, he assured them no
one would be able to know it again.
Mr. Jenkinson thought the scenery was just
what it ought to be, and required no alteration.
Mr Foster thought that it could be improved, but
doubted if that effect would be produced by the
system of Mr. Milestone."

Thomas Love Peacock
Headlong Hall and Nightmare Abbey

Distributed in Australia by Craftsman House,
20 Barcoo Street, Roseville East, NSW 2069
in association with G+B Arts International: Australia,
Austria, Belgium, China, France, Germany, Hong Kong,
India, Japan, Malaysia, Netherlands, Russia, Singapore,
Switzerland, United Kingdom, United States of America

ISBN 976 6410 26 7

THE IAN POTTER FOUNDATION

Design: Terence Hogan
Printer: Toppan, Singapore

Frontispiece: Narelle Jubelin, *Dead Slow* (detail), 1991-2, mixed
media and *petit point* installation, Glasgow. Courtesy Mori Gallery,
Sydney. Photograph: Heidi Rosaniuk

Contents

Acknowledgements

In early 1990, passing through New York, I met Paul Taylor, the founder of *Art & Text*, for the first time. By the end of the evening I had been convinced that the project I outlined to Paul – this book – could be realised, and I am indebted to him for his example of a generous participant in the world of contemporary art. From 1990 onwards, all my art criticism was written with the intention of completing a book on recent Australian art. Then, in 1992, the Visual Art/Crafts Board of the Australia Council awarded me a one-year Fellowship to write *Peripheral Vision: Contemporary Australian Art 1970-1994*. I am deeply grateful for the interest that the Australia Council demonstrated in my work. The Council has been a powerful and unstinting patron of Australian art and art criticism. In addition, the Department of Fine Arts at the University of Melbourne provided me with a base and, from 1994, with timely support. The Ian Potter Foundation generously awarded me a grant to assist with the considerable costs of obtaining illustrations.

Various parts of this book were originally published as catalogue essays or in art magazines; although extensively rewritten for this book, I am grateful for these opportunities to develop the following passages in print. Chapter 1 draws on material first published in *Off the Wall/In the Air: A Seventies Selection*, Monash University Gallery and Australian Centre for Contemporary Art, 1991; *Aleks Danko: Zen Made in Australia*, University of Melbourne Gallery, May 1994; "Mike Parr", *Artforum*, February 1990; "Lost and Found: The Empire of Death", *Binocular: Focusing/Time/Lapses*, 2, October 1992; "Lyndal Jones", *Artforum*, January 1993. Sections of Chapter 2 originally appeared in "Rewriting the Seventies", *Art Monthly*, July 1989; "How painting recaptured Melbourne", *Art Monthly*, December 1989; "Davida Allen", *Artforum*, April 1990; "Janenne Eaton", *Artforum*, February 1991; "Debra Dawes", *Artforum*, October 1991; "Abstract?" (with Stephen Wickham), *West*, Summer 1991; "Robert Rooney", *Art & Text*, January 1994. Chapter 4 draws on "Peter Tyndall", *Artforum*, April 1991. Chapter 5 contains material originally published as "The Dark Wood: Domenico de Clario", *World Art*, November 1993; "Working on Water: Jennifer Turpin", *World Art*, March 1994. Chapter 6 draws on "Western Desert Paintings and Contemporary Culture", catalogue essay, *Aboriginal Paintings from the Desert*, Moscow Union of Artists, Moscow, 1991; "Pansy Napangati", *Artforum*, October 1989; "Juan Davila", *Artforum*, May 1990; "Unofficial World", *Art & Text*, September 1992; "Sydney Biennale", *Artforum*, April 1993; "Tim Johnson", *Art & Text*, September 1993. Chapter 7 is based on "Fiction and Treachery: Contemporary Australian Art", *Australian Perspecta*, Art Gallery of New South Wales, October 1993.

The complicated task of assembling the illustrations for this book was made almost bearable by the great generosity and common sense, with a few surprising and deeply frustrating exceptions, of many artists. For the most part, I have credited photographers but where there are omissions in credits and permissions I unreservedly apologise. Every attempt has been made to obtain agreements to reproduce images. John Simkin worked on the index.

I am also grateful to *World Art*'s Melbourne office, and especially Terence Hogan, the book's designer, and my editor, Stephanie Holt, for her detailed and perceptive work on the manuscript. Douglas and Helen Green also offered careful advice and editing. Allusions to theories of the copy recur through the book; here, I borrowed extensively from Lyndell Brown's review of these theories in her unpublished 1992 Master of Arts (Visual Art) thesis for the Victorian College of the Arts, "Falsifying History". Most of all, I wish to clearly acknowledge her continual, untiring editing, revisions and suggestions through all the versions of this book.

Prologue

1 Melbourne-based art critic Chris McAuliffe developed this insight in an unpublished paper on Brett Whiteley's orientalism.

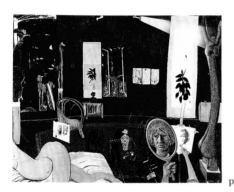

p:1

2 Henri Matisse, "Notes of a Painter" [1908], reprinted in Herschel Chipp (ed.), *Theories of Modern Art*, University of California Press, Berkeley, 1968, p. 135.

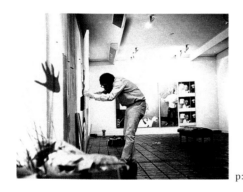

p:2

p:1 Brett Whiteley, *Self Portrait in the Studio*, 1976, oil, collage, hair on canvas, 200.5 x 259 cm. Courtesy Art Gallery of New South Wales.

p:2 "I want to leave a nice well-done child here: 20 Australian artists" (installation view), curated by Harald Szeemann as John Kaldor's "Art Project 2", Bonython Galleries, Sydney, April 1971. Photograph courtesy John Kaldor.
The photograph shows Harald Szeemann installing the exhibition in Sydney with the unusual collaborative painting by Brett Whiteley, Tony Woods and William Pidgeon, *Linked Portrait*, 1971, mixed media on wood, 373 x 462 cm, shown in the background. The exhibition travelled to the National Gallery of Victoria, Melbourne, in June 1971.

A gulf separates the world of Brett Whiteley's *Self Portrait in the Studio*, 1976, from contemporary Australian art. Though Whiteley painted until his early and lonely death in a motel room on the coast south of Sydney in 1992, few would regard him as a contemporary artist, nor would they regard the experience offered by the picture as contemporary despite Whiteley's prescient and redeeming awareness, in his vast polyptych, *Alchemy*, 1972-73, of Australia's location in Asia.[1] Whiteley presents a vision of plenitude awash in a pathos that has not recognised itself. His delectable blue studio swims in a space in which all objects are positioned on the same visual register: a million-dollar view of Sydney Harbour from the North Shore is neither further nor closer than the equally sinuous body of a nude woman. His self-consciously democratic equivalence of sensation is a pretext for the instant availability of each object; by conflating body with harbour, Whiteley hoped desperately to achieve an already anachronistic identification with two traditional subjects of conservative art – "woman" and "landscape" – in a rush of psychedelic symbiosis. The objects are available, because they are presented only as objects – not self-sufficient subjects with individual personalities. Such an abstract relationship to his models is fitting, because his painting, for all its defects, aptly describes both a lifestyle (based on sensation and dependent on availability) and a vision. The vision is essentially the same as that of Henri Matisse's famous *Red Studio*, 1911, a work to which many of Whiteley's paintings are heavily indebted. Matisse's famous painting is a view onto an art of mental and formal balance.[2] If the French artist's interior is a vision of plenitude and equivalences deriving from a rigorous examination of *politesse*, pleasure and the weight of colour, then Whiteley's plenitude is always excessive and demanding of a conspicuous consumption (of excessive visual, erotic and extra-pictorial stimulus) in order for belief to be maintained in spite of the strains that threaten to appear. Whiteley's equivalences are hyped up, strident and aggressive. Although his formal decisions, such as the Modigliani-like distortions of drawing or the ubiquitous, saturated Yves Klein blue which serves everywhere as both figure and ground, originate in a principle of equivalences, they are really an extreme, mannered resuscitation of a modernist corpse by all the exaggerated means necessary to hide its fallacies. Matisse would probably have abhorred the lack of measure in an art out of balance.

The viewer implied by Whiteley's *Self Portrait in the Studio* remains determinedly heterosexual, white and male. This, of course, reflects Western art's traditional mode of address, as opposed to its traditional audience which has often been female. These desires have been coded into pictures like Whiteley's for so long that they seem natural: the tabloid, bohemian ambience of Whiteley's carefully decorated pad – its hint of free sex, drugs, the psychedelic distortions of perspective, and bird's-eye viewpoints – appeals to prurient curiosity. While the picture is cleverly knowing – the reference to Matisse is overt, images of art are scattered all through the painting, a sculpture is positioned like a rocket ready for take-off – it is also reverent. This reverence has none of the irony or parody of classic modernism; Whiteley's picture will not bite its owner's hand, since the history of art is taken for granted as a source of validation rather than contestation or disgust. Thus, at the epicentre of all lines of sight is the heroic, tortured face of the artist. Reflected in a small mirror, the painter is the centre of the picture's spatial vortex, and the space of the painting is already disappearing down this vortex, collapsing into a dependent series of already exhausted self-validations (the artist as hero, the artist as romantic seer, the artist as existential outsider) like water down a plughole.

Introduction

1 As this is necessarily a selective account, I would encourage readers to explore other sources. There are relatively few books on Australian contemporary art. These include monographs on individual artists and a few anthologies of essays by different art critics. Some of the best, and most up-to-date, published sources on contemporary Australian art are not books. The exhibition catalogues of state galleries, contemporary art spaces and, often, commercial galleries, have long essays analysing the art on display and are usually well-illustrated, with detailed bibliographies and resumés on the artists. There are several art magazines, including *World Art, Art & Text, Agenda, Eyeline* and *Art and Australia* that sympathetically cover contemporary art. Magazines and catalogues are held in large academic libraries. For thoughtful, revisionist discussions of important general themes in recent Australian art, see Ian Burn, *Dialogue*, Allen & Unwin, Sydney, 1991. The essential history of Australian art (significantly, ignoring everything except painting) is Bernard Smith and Terry Smith, *Australian Painting 1788-1990*, Oxford University Press, Melbourne, 1991. The main dictionary of Australian art is Alan McCulloch and Susan McCulloch, *Encyclopaedia of Australian Art*, revised edition, Allen & Unwin, Melbourne, 1993. For the art of the 1970s, see Paul Taylor (ed.), *Anything Goes: Art in Australia 1970-1980*, Art & Text, South Yarra, 1984, and Anne Marsh, *Body and Self: Performance Art in Australia 1969-92*, Oxford University Press, Melbourne, 1993. For excellent texts and illustrations on Aboriginal art, see Peter Sutton (ed.), *Dreamings: The Art of Aboriginal Australia*, Viking, London, 1989.

2 See Geoffrey Dutton, *The Innovators: The Sydney Alternatives in the Rise of Modern Art, Literature and Ideas*, Macmillan, Melbourne, 1986.

3 From the decades after World War II until the 1970s, contemporary art in Australia was decisively shaped by international modernism. Employing the idioms of modernist (usually cubist- or expressionist-derived) abstraction, local artists during the 1940s and 1950s placed themselves in opposition to groups for whom more traditional forms – such as landscape painting – represented a desirable, conservative synthesis of old and new, provincial and international. During the 1970s, differences between the avant-garde – the cutting edge of contemporary art – and an increasingly large institutional network of state galleries, contemporary art spaces and art magazines began to diminish.

Peripheral Vision: Contemporary Australian Art 1970-1994 is a critical survey of Australian art during the last two decades, commencing with the moment of modernism's obvious obsolescence. The book is an introduction to its subject, surveying contemporary art through the work of a limited number of artists and charting a narrative introduction to many – but by no means all – of the ideas current in art from the 1970s onwards. The criteria for inclusion were that the art discussed should reflect, even if to reject, the great contemporary artistic narratives of postmodernism and postcolonialism; these complex, multi-faceted narratives were also seen in popular culture and even in political life in Australia's movement towards a republic. A few artists are profiled in depth, but many well-known names are completely omitted because the book offers a series of close discussions rather than academic disquisitions or a lengthy catalogue of artists. For the same reason, *Peripheral Vision* is largely a tale of two cities – Sydney and Melbourne – although much important art was produced outside these large centres. A definitive, balanced account of the themes covered in this book is not yet possible.[1]

It is the particular achievement of late modernism in Australia, of which Whiteley was one of the last representative figures, to have modernism and, later, postmodernism, adopted as the paradigmatic versions of contemporary art even though other visions of contemporary art, such as traditional landscape painting and tonal realism, are still practised by a considerable number of artists.[2] From this point of view, Brett Whiteley is already a distant, but historically necessary, Old Master; artists such as Albert Tucker or Arthur Boyd, members of the "Angry Penguins" generation who came to prominence in the 1940s, are ancient dinosaurs. There are, then, many different art worlds. The milieu of postmodern, late modern and postcolonial art described in this book and seen in state public galleries during survey exhibitions such as Perspecta, held every two years at the Art Gallery of New South Wales, is only one of these art worlds. A work such as Debra Phillips' 1993 Perspecta installation, *Sillage #1*, 1993, can be accommodated only with considerable difficulty by traditional definitions of art, but finds a place immediately inside the wide boundaries traced here. Modernist art survives beside postmodern art, defensively aware of its own conservatism and stuffy appeals to notions of quality. The art made by conservative landscapists is another example of a different art world, ignored by art critics and fashionable magazines, with its own networks of galleries, clubs and magazines. Each art world understands the words *contemporary art* differently.

The world of Australian art changed radically over the last two decades: prosperous galleries closed because of insolvency; major reputations were questioned; new names and interest groups moved to centre stage. Although the social and economic situation of art remained, in broad terms, the same – a luxury commodity consumed by very few in a fragile, economically dependent, late-capitalist culture – contemporary art achieved a fashionability in the 1980s that was as remarkable as it was short-lived.

The apparent calm and glacial certainty with which critics passed judgement on art several generations ago can be seen today as a remarkable and carefully contrived achievement. Although critics often refer to widely held and ostensibly stable historical judgements, the 1990s are marked by widely divergent opinions – not only about the merits of different artists but, more fundamentally, about the aims of evaluation, criticism and culture itself. An identifiable art world clearly separate from that of mass culture no longer exists. Acceptance of the apparently universal basis of modern art (the fundamental, "pure" qualities of visual order: colour, line, form and so on) has crumbled.[3]

The art of the 1970s, examined in the first chapter of this book, is an essential backdrop to more recent work. For the first time since then, installation, performance and conceptual art have become crucial to the definition of contemporary culture. Emerging and mid-career artists alike employ these forms to make work regarded as significant and reflective of our time. Feminist analysis, brought to art in the 1970s by the Women's Art Movement, continues to be one of the most important influences on contemporary art, with most artists affected to different degrees by the analysis of identity as a gendered construction. A desire to privilege the marginal and perverse is also absolutely central to both the 1970s and the 1990s.

The middle chapters of this book describe the impact of postmodernism, suggesting that even

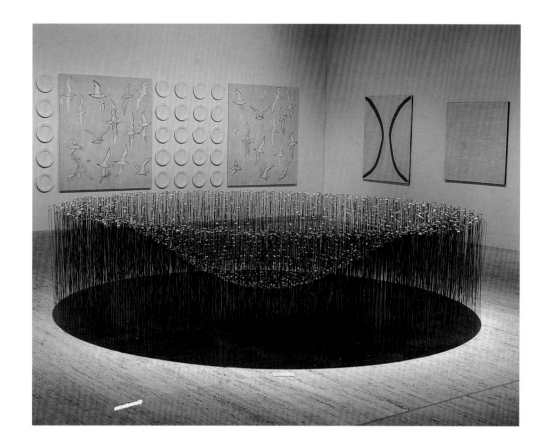

Right: Australian Perspecta 1994 (installation view), Art Gallery of New South Wales, Sydney, October 1993. The photograph features Debra Phillips, *Sillage #1,* 1993, installation, bronze and steel. Collection: News Ltd.

though our period is postmodern, there is no coherent postmodern style or school of artists, for the impact of postmodern ideas has been highly variable. Even older artists have been profoundly affected by the force of postmodernism – by its recontextualisation of modern history and art. So what do postmodern artists share? They refuse the categorical imperatives of much modernism, which were the mythologies of originality and uniqueness of vision. Postmodernism defined itself as a rupture – against a modernism conceived falsely as monolithic in the superficial rhetoric of throwaway art magazines and art-school tutorials. In the early paintings of artists such as Nolan, Tucker and Whiteley, modernist art had also seen itself as a disruptive fracture in the cultural landscape. Perhaps most importantly, postmodern culture is aware that every painting, every statement and every judgement has the traces of other paintings, statements and judgements. As a perspective that sees art as always embedded in discourse, this is definitely not end-of-the-line cynicism.

Another viewpoint shapes the latter half of the book – that of postcolonialism. The cosmopolitan hyperreal of postmodern theory, with its exclusively televisual world of glancing images and media haze, did not exactly apply to the experience of Australian artists in the 1980s and 1990s. Australian culture, to say the least, was an extreme, atypical case of postmodern experience. Thus it was argued that the concepts of Western postmodern culture did not represent a universal experience, and that it was necessary to question the metropolitan perspective on regional culture because, to a considerable degree, postmodern assumptions reinscribed the conceptual boundaries of centres like New York. Art history continues to reproduce these discourses of the centre because the glamour and attraction of world centres like Paris and New York are so commanding from a provincial distance and because history incorporates revisions only slowly.

Cultural domination is still at play in contemporary Australian art, and is located in the long and majestic history of Western art from Renaissance Italy to the impeccably elegant, postmodern art magazines of Europe and America. It is just as important, then, to examine how and where differences have been produced. Australia's isolated position conditions the production of the metropolis's pale shadow but perversion of the master's language slyly deflects its domination. This ambiguity is the underlying subject of this book.

Next page: Stelarc, *Event for Penetration/ Exploration,* 1976, performance, Museo Universitario, Mexico City. Photograph: Xicohtencatl Pavia Castro. © Stelarc.

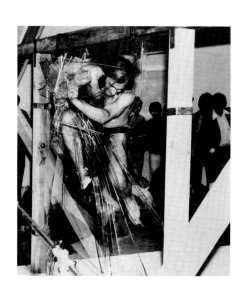

Off the Wall and In the Air: The 1970s

OFF THE WALL: THE ARTISTIC RELEVANCE OF 1970s ART

For the first time since the 1970s, we are able to see the endurance – even resurgence – of forms and ideas that were prevalent during that decade. Installation, performance and conceptual art – deliberately ephemeral, prototypal 1970s forms that left little trace – were rapidly eclipsed or sidelined with the rediscovery of painting during the 1980s but became crucial to a definition of the 1990s.

We need to know the 1970s: they are the background against which recent art should be read. The decade saw the emergence of many artists who continue to make significant contemporary art today. One important feature of contemporary art is its conflation of 1970s idealism with more recent, postmodern theories of the body as a social text and of representation as an irrevocably mediated activity. Then, there was considerable emphasis on the intentions of the artist. There is a vast gulf between that determination by artists to shape discourse and a postmodern acceptance, now, of the death of the author as the sole arbiter of meaning. The ubiquitous stress on the artist's intentions is at odds with postmodern notions of intertextuality, quotation and the intricate tracery of other authors hidden in every work.[1] However, in the effort to define the shape of the present, the differences that separate contemporary audiences from the 1970s are often elided.

The rationale for many works in the 1970s is in fact antipathetic to redefinition within the context of the hyperreal, postmodern present. Therefore, it is important to emphasise that the 1970s are far from voiceless. Artists such as Mike Parr and Robert Hunter, who are central to any discussion of the 1970s, have also produced recent work of international significance. With exemplary care and clarity, writers such as Donald Brook and Anne Marsh continue to write about and critique into the 1990s the praxis we take to be paradigmatically that of the 1970s. For that reason many of the artists discussed in this chapter, including Mike Parr, Domenico de Clario and Aleks Danko, also appear later in the book.

Our surprising ignorance of the 1970s is the result of its proximity – who was willing to admit to wearing corduroy flares until the start of the 1990s, when the "grunge" look began to be fashionable? Its art was more or less obliterated by institutions during the following decade. In the teleological progression favoured by historians and curators, art demonstrating aesthetic advances was favoured over work that was indifferent to artistic judgement. After all, the very innovations that facilitated a redefinition of art, beyond the belief in art as a timeless enterprise, were ironically the means by which the 1970s were turned into art history and grainy photographs of ephemeral performances in low-rent galleries were curated and commodified.

The new art of the 1970s – Performance Art, Earth Art, Process Art, Conceptual Art, Pattern Painting, Community Art, Women's Art – was a development from the innovations in practice and theory of the previous decade. Many commentators noted that modernism had finally ground to a halt in the late 1960s. After years of market hegemony during the 1960s, the formalist Establishment was on the defensive. When English sculptor Anthony Caro, a protegé of American critic and guru Clement Greenberg, spoke to students at the National Gallery Art School in Melbourne during a visit to Australia in 1971, he bemoaned his St. Martin's College students' refusal to make "serious" sculptures, accusing them all of wishing to call themselves "living sculptures" or go for long walks in the countryside. The respective targets of his indignation were English artists such as

1 For a concise explanation of these concepts, including "the death of the author", see Roland Barthes, "From Work to Text", in his *Image–Music–Text*, Hill & Wang, New York, 1977, pp.155-164, and reprinted in Brian Wallis' excellent anthology, *Art After Modernism: Rethinking Representation*, New Museum, New York, 1984, pp.169-174.

Previous page: detail of **1:16**.

Gilbert & George, Hamish Fulton and Richard Long, all of whom visited Australia to make important works during the period we discuss.[2]

By the mid-1980s a process of obliteration was well advanced: critics asserted that art had been caged in by repressive 1970s puritanism; museums moved to marginalise their representation of alternative forms – off to the basement with the sticks and twigs. Diversionary mutations, such as the post-feminism of the late 1980s, at first sight trivialised the key achievements of the 1970s. Painting returned to the centre of cultural life. Now, however, we have come to value at least three of that decade's central concerns: the profound conceit (incorrect, as it turned out) of the death of art; the explosion of every possible idea about art (to the point of almost ineffectual pluralism) together with the expansion of possible identities for artists; and, finally, the attempt to recreate art institutions. They form the three themes of this chapter.

ART IS DEAD: ARTISTIC CRISIS AND RADICAL DISSENT

Radical Art and Artistic Disappearance

The moves that artists made into new forms – and especially those towards the dematerialisation of the art object – were linked in their minds to various forms of radical politics rather than to a purely aesthetic dialogue. Donald Brook, an extremely influential advocate for post-object and experimental art forms in Sydney as critic for the *Sydney Morning Herald* and later in Adelaide at Flinders University, recalled in 1988 that:

> the post-object art of the 1970s to which I believed I was contributing was not one movement but at least a dozen, travelling in almost as many directions. But the central idea was of a dissent which has been consistently misdiagnosed.[3]

Much 1970s art, as Brook implies, was distinguished by its transformational or self-transformational intention, the concern to work outside established systems, and a sympathy with radicalism. These feral intentions were often more naive and unfocused than effective.

Running through the discourse of the 1970s was a linkage of artists' intentions to Left-wing radicalism, and an awareness of the cultural trauma associated, after 1968, with the idea of the death of art. Artists wished to move outside the boundaries of previous work, to make anti-art (or even stop making art) and either to deal directly with nature or with a politicised cultural discourse.[4] Marginal and underprivileged cultural groups were consistently regarded as important examples. Activity modelled on the perverse, the deprived and the criminal – like that of Melbourne artist Ivan Durrant – attracted considerable attention. Durrant's actions, from the exhibition of a severed hand (allegedly purchased from a needy student) to his slaughter of a cow at the entrance of the National Gallery of Victoria, achieved massive notoriety and the attention of the police. Mitch Johnson experimented with incendiary devices in public places, blowing up lamp-posts; Paula Dawson (who later became well-known for her pioneering work with holograms) shattered sheets of corrugated iron with explosives. Stelarc launched himself at a wall of plate glass in 1976, smashing through the glass with considerable force and cutting himself seriously in the process.[5]

Although Australian artists were distant from late-1960s American and European turmoil, they were far from unaffected by the sense of utopian possibility current in popu-

2 All were influential role models for younger artists during the 1970s. Gilbert & George were sponsored by Sydney patron John Kaldor as one of his important Art Projects.

3 Donald Brook, "From the margin", in *The present and recent past of Australian art and criticism*, special supplement, *Agenda* n.2, August 1988, p.9.

4 Many observers claim to remember one "exhibition" where Sydney artist Neil Evans swallowed tape-worms which then lived inside his stomach for the duration of the "show". Evans later gave up art – a radical artistic act in itself. Neil Evans described another piece, *The Organic Account of Neil Evans, April 1970*, 1970, thus: "*The Organic Account* lists everything I ate and drank, everything I crapped or pissed or eliminated bodily in any other way. The time of each ingestion and rejection was recorded." Neil Evans, quoted in interview with Terry Smith, in Tony McGillick and Terry Smith (curators), *The Situation Now*, Contemporary Art Society, Sydney, July 16-August 6, 1971, p.37.

5 Stelarc, who lived outside Australia for long periods, principally in Japan, was, and remains, one of very few Australian artists to achieve a considerable international reputation. He was best known for his "suspensions" – performances where the artist hung in mid-air, his body attached to cables by hooks inserted into his skin – and attempts to create a new body using complex prosthetic limbs. Stelarc's 1972 performance at Pinacotheca in Melbourne was seen by many artists: in this early work, he was suspended in a harness; his gaze was amplified by laser eyes.

lar culture and the fine arts. The anti-Vietnam movement was only one aspect of an often inconsistent mood of social change in Australia. Young Australians were profoundly affected, not just by events in Paris during 1968 but by the alternative youth culture of the American West Coast and by self-consciously artistic rock & roll bands such as Iron Butterfly and The Grateful Dead. Local bands and venues – Spectrum and the T. F. Much Ballroom, for example – reflected these influences.

Italian critic Germano Celant, a crucial figure in European art of the 1970s, looked back in 1985 and noted that:

> The creative events of 1967-68 thus marked a historical watershed: the dogma of neutrality was rooted out, since there is no way of separating the object from the creative act, from the awareness of and participation in its reasons and technical input. Art is no longer a virginal nature.[6]

Celant also observed that the 1968 exasperation about unrealisable utopias, after the failure of student riots, made the 1970s schizophrenic. Artists with radical sympathies – many marched against the Vietnam War during Moratorium demonstrations in Australia's capital cities – naturally if uncritically identified the practice of art with an often inconsistent alternative culture. This perception was based on a shared sense of being "outside" the system. Many artists, confronted by the choice between a conception of the artist as a suited professional with a one-way flight to New York or an image of the artist as a social critic and committed conscience, felt a profound if confused desire to move outside conventional domains of art to a different relationship with their audience. The few, however, who were prepared to move outside "the system" into the counter-culture disappeared into the alternative milieus of inner-city community activism and rural hippy-commune politics, leaving little trace of their existence. The schizophrenia noted by Celant ensured that cultural criticism would be imaged as crisis or that it would simply disappear.

Domenico de Clario: Lost and Found in Richmond

In the late 1960s, the disappearance of art into life seemed both imminent and urgent. In Domenico de Clario's *Untitled*, 1973, this disappearance was almost attained. Based in measured systems, it drew on the artist's architectural studies and his desire to re-establish relationships with the real world and its objects.

For three weeks de Clario gradually moved a quantity of everyday items from the small gallery at Pinacotheca, in Melbourne, into the gallery's cavernous main space. This was done according to a random process. The main gallery's floor was divided into 120 separate squares. De Clario moved ten objects at a time from the first room to the second; their destination was decided by the throw of a set of dice. At the start of the exhibition the small gallery was full: a motorcycle, books, clothes, loaves of bread, toys, a child's rocking horse, a vacuum cleaner. Much of this had been gleaned from friends' car boots. Lost to everyday life, these items were found for a while in the gallery before they resumed an existence in cars, cupboards and on book-shelves. For the show's duration, the artist's motorcycle sat in the gallery, a fact noted by the *Age*'s reviewer, Patrick McCaughey, who sympathised with the artist's reliance on public transport.

Looking back, one observes that, like *Untitled*, many works from the period play a game of lost and found with their viewers, as if their attention span was eternal and time

6 Germano Celant, "The European Concert and the Festival of the Arts", in Germano Celant (curator), *The European Iceberg: Creativity in Germany and Italy Today*, Art Gallery of Ontario, Toronto, 1985, p.19.

1:1 Domenico de Clario, *Untitled*, 1973, installation, Pinacotheca, Melbourne.

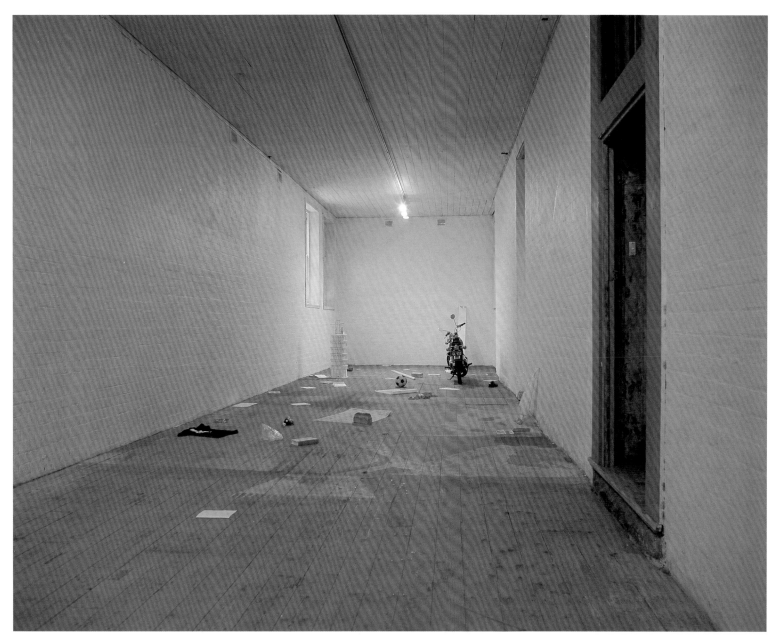

was suspended within a gallery's white walls. In fact, much Process Art, like Earth Art, demanded from its audience stamina that was very rarely granted, still less rewarded by subsequent institutional immortality.[7] De Clario's installation remains in a few grainy photographs. At this critical moment, art tended to disappear into life.

A desire to deal with the particular disorientation caused by the experience of art as a form of cultural capital – fluid, abstract and invisible – resulted in incessant documentation and game-playing. Objects from everyday life were employed not as aesthetic forms but because of their existing meanings, which they did not lose. The double coding afforded by real objects suggested their original functions whilst allowing them to embody the figures of new representational systems. De Clario was intensely aware of this intangibility; he asserted that *Untitled* was an investigation of the auras left by his real objects, their absences and the extent to which they projected into space.

Untitled was de Clario's nervous attempt to fix perception before sensation slipped away into the stream of time. It was marked by anxiety. Documentation of the present was based on an awareness of the failure of previous artists to adequately deal with an ontology of minute experience. This anxiety and pathos was shared by other Pinacotheca artists like Dale Hickey, Robert Rooney and Simon Klose, who worked together to enumerate every possible, quasi-conceptual attribute of a cup, in a large joint exhibition of paintings in 1973. De Clario's inclination was more theosophic, recognising time's subjective ability to move at shifting velocities. Installations like his insisted on their status as interruptions: they remained largely lost to the museums that they covertly and poignantly addressed. Reception was brief and often hostile. De Clario's *Elemental Landscapes*, 1975, installed at the National Gallery of Victoria, was dismantled by order of the then Director Gordon Thomson, prompting an angry sit-in by artists and students. Publicity for their cause was a Pyrrhic victory, however, since the installation's energetic curator, Jennifer Phipps, was later removed from the gallery's staff.

If retrospectively we empathise with the freedom that the rejection of traditional forms was supposed to have created for us, we are more likely to see the pathos actually embodied in de Clario's installation shots or Robert Rooney's melancholic Instamatics of neatly folded underwear.

"No cultural rubbish": The Claims of New Art

During the later 1960s, claims were made that contemporary art would "alter" its audience. This centred around the perceptual changes induced by viewer participation in phenomenological inquiries, as they were incarnated in conceptual art works. Harald Szeemann's earlier exhibition "When Attitudes Become Form", at the Kunsthalle, Berne and Institute of Contemporary Art, London, in 1969, was a crucial example to many artists. English critic and member of the Art & Language group, Charles Harrison, republished his catalogue essay in *Studio International*. His rather breathless text was read by many Australian artists:

> Art changes human consciousness. The less an art work can be seen to be dependent, in its reference, on specific and identifiable facts and appearances in the world at one time, the more potent it becomes as a force for effecting such a change… By opening ourselves to such experience we render possible the realignment of our own consciousness in favour of the constant rather than the immediately insistent factors of human life.[8]

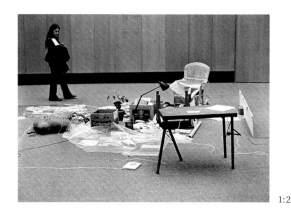

1:2

7 To grasp de Clario's work properly, one would have had to have visited the gallery each day. Almost certainly, the only person to do this was the Director, Bruce Pollard. Attendances at cutting-edge galleries were, and remain, woefully small. To visit Earth Art sites, such as American artist Robert Smithson's *Spiral Jetty*, 1970, in Utah, or Marr Grounds' complicated 1970s multi-sited Australian installations, required a massive commitment of time and energy.

8 Charles Harrison, "Against Precedents", *Studio International* v.178 n.914, September 1969, p.90.

1:2 Domenico de Clario, *Elemental Landscapes*, 1975, installation, National Gallery of Victoria, Melbourne. Photograph: Brecon Walsh.

1:3 Dale Hickey, *Cup*, 1972-73, oil on canvas, 32 x 32 cm. Courtesy Robert Lindsay Gallery, Melbourne.

Traditional painting and sculpture, including fashionable abstract painting, were incapable of such ties with alternative politics. This post-object critique of art devolved, however, into an administrative and bureaucratic activity, dependent for its purpose on the perpetuation of art – not the death of art. Critic and Art & Language member Terry Smith observed, with an unorthodox sense of chronology in an apocalyptic essay for the 1975 Mildura Sculpture Triennial, that:

> we find ourselves at the tail end of a decade quantitatively rich in the production of diverse and extreme art, yet paradoxically marked by a failure of sensibility such that the making of art has become an embattled, rootless and theoretically-fragile pursuit.[9]

Many artists chose to retreat from the brink of this quasi-nihilism and to start again. Dale Hickey moved from *90 White Walls*, 1970, a collection of photographs of ninety different white walls, presented like file cards in a handmade wooden box, to the apparently conventional cup paintings of 1972-73. His development was consistent with an underlying commitment to a linguistic inquiry influenced by Wittgenstein, but minimalist painting obsessed by the Zen "cupness" of a cup was only going to intersect with its iconoclastic, puritan American cousin for a brief historical moment. It would have little in common with other streams of advanced art that envisaged, as West German critic Bazon Brock remembers, "no cultural rubbish that had to be sent to museum dumping grounds. The museum itself was to become a department store, transit depot for groceries and articles of everyday use."[10]

This cultural moment was widely noted, by those for whom the times were changing, and by those for whom they most certainly were not. There was a gulf evident at the 1973 Mildura Sculpture Triennial between the older welded-steel sculptors and younger post-object artists like Ross Grounds. The incompatibility between works like Grounds' ecological bunker dug deep into the red Mildura earth, *Ecology Well*, 1973, and the heavy-metal offerings of older sculptors, led to the enclave of formalist works being labelled "Karo Korner".

THE EXPANSION OF ART: NEW FORMS AND NEW IDENTITIES

Kevin Mortensen, Peter Kennedy, Robert Hunter: Blurring the Division between Art and the Real World

If "anything goes", how do artists make decisions? The new art forms stressed their oppositional politics. They also, and this is not the same thing, blurred the division between galleries and the real world outside their doors. Of all the art that temporarily filled Australian galleries and museums over the last 30 years, there was no genre more elusive but crucial than performance – the form where this blurring was most obvious and where the link with a different vision of the artist was most completely realised.

Performance Art spanned an enormous range of activity, from the early happenings of the late 1960s (the late-modernist psychedelic *bricolage* of Stelarc's post-millennial reconstructions of the human body), to Lyndal Jones' sophisticated, complex *Prediction Pieces* of the 1980s and 1990s, which will be examined in a later chapter.

Many performances combined unintentionally hilarious clichés and excruciating boredom with sudden, electrifying glimpses of the dark edges of human activity; artists often rejected the most cherished ideas of modernity and societal normality. Perfor-

9 Terry Smith, "Art Criticism/Self Criticism", in Tom McCullough (curator), *6th Mildura Sculpture Exhibition*, Mildura Regional Art Gallery, Mildura, 1975, p.3.

10 Bazon Brock, "Cultural and artistic development in West Germany from the Sixties to the Eighties", in Germano Celant (curator), *The European Iceberg*, p. 248.

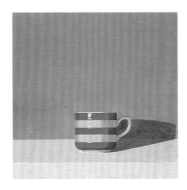

1:3

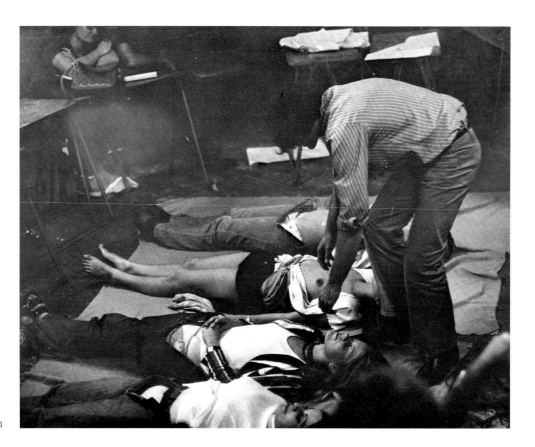

1:4

11 Anne Marsh, *Body and Self. Performance Art in Australia 1969-92*, OUP, Melbourne, 1993, p. 25. Marsh's book gives an exhaustive analysis of 1970s performance.

12 Peter Kennedy, quoted in Jennifer Phipps (curator), *Two Contemporary Artists: Peter Kennedy and John Nixon*, National Gallery of Victoria, Melbourne, 1976, unpaginated.

1:4 Tim Johnson, *Disclosures*, 1972, performance, Sydney University Fine Arts Workshop. Photograph courtesy Museum of Contemporary Art, Sydney, gift of Tim Johnson, 1991.

1:5 Kevin Mortensen, *The Seagull Salesman, his stock and visitors, or figures of identification*, 1971, installation/performance, Pinacotheca, Melbourne. Photograph: Ian Wallace. Courtesy Australian Galleries, Melbourne.

mance Art was always more than Body Art, in which the identification of the limits of psychic and physical endurance was explored. Stelarc's first, aptly titled performance, *Event from micro to macro and the between*, 1969, incorporated motifs that were to be repeated endlessly during the 1970s at performance festivals and conferences.[11] Three dancers performed in front of images projected onto screens while the audience experimented with the alternative states of perception offered by specially designed helmets. Interactivity (and deliberate exploitation of the audience) was incorporated in other types of performance, such as Tim Johnson's early *Disclosures*, 1972-73, which featured Johnson's removal of the audiences' clothing and a group experience of sexual arousal, or Kevin Mortensen's epic deception, *The Delicatessen*, 1975, in which Mortensen collaborated with Eddie Rosser, an actor who took the role of a veteran scarred by war atrocities. Mortensen rented a shop in Mildura, at 70 Langtree Avenue, months before the opening of the 1975 Mildura Sculpture Triennial, and Rosser gradually prepared the shop for business, measuring it up, sweeping the pavement and sleeping on a stretcher bed. The shop that I saw during the Triennial contained, of course, no merchandise, and nothing seemed to happen, but it was not until the Triennial opened that the local populace realised that Rosser and his delicatessen were a work of art.

The dispersal of art activities through the community, rather than their concentration in museums, was Peter Kennedy's aim. He "felt that Marxist art theoreticians had not come up with a solution for making art an integral part of community life".[12] His performance/actions involved the use of non-professional participants in real-life, real-time situations. Kennedy's *Introductions*, 1976, documented the artist's work with members of a Hot-Rod Club, an Embroidery Club, a Bushwalking Club, and a Marching Girls Club. He prepared videos and watercolour portraits of each group, by which he facilitated the

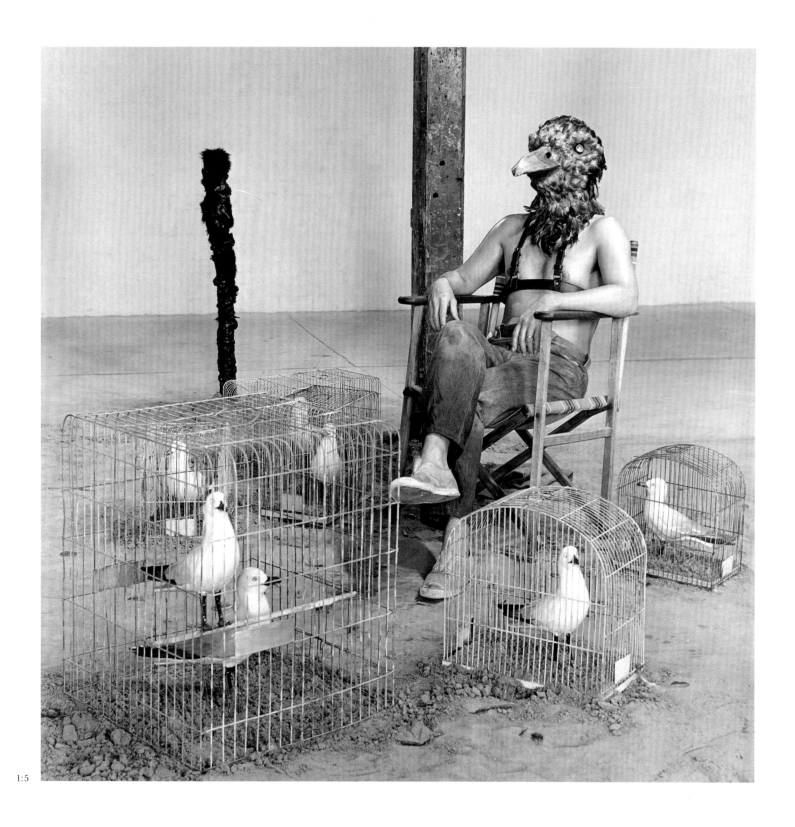

1:5

1:6

1:6 Inaugural exhibition, Pinacotheca, Richmond (installation view), 1970. The photograph shows, at left, Robert Hunter's *Untitled*, 1970, synthetic polymer paint on paper and masking tape, six units of 165.2 x 151.8 cm and, at right, Robert Rooney's *Superknit 1*, 1969, synthetic polymer paint on canvas, 134 x 235 cm. Both works were subsequently acquired by the National Gallery of Victoria.

1:7 Peter Kennedy, *Introductions*, 1976, installation. Courtesy Sutton Gallery, Melbourne.

1:8 Bonita Ely, *Mt Feathertop*, 1979-1981, installation, Art Projects, Melbourne. Courtesy Sutton Gallery, Melbourne and Annandale Galleries, Sydney.

1:7

13 John Nixon, "Blast: A General Note", in Jennifer Phipps (curator), *Two Contemporary Artists*, unpaginated.

14 Donald Brook presented the most articulate dissection of this paradox in numerous articles including his 1988 "From the margin" and the 1969 Power Lecture, "Flight from the Art Object", reprinted in Bernard Smith (ed.), *Concerning Contemporary Art*, Oxford University Press, Sydney, 1974, pp. 16-34.

15 Robert Hunter, quoted in Gary Catalano, "Robert Hunter", *Art and Australia* v.17 n.1, March 1979, p. 78.

16 Bonita Ely, artist's statement, *Murray River Punch* pamphlet, Melbourne, 1980, unpaginated.

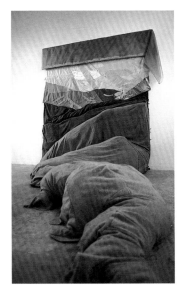

1:8

introduction of one club to another. Kennedy exhibited this project in 1976 at the National Gallery of Victoria. His coexhibitor was John Nixon, whose arrangement of text on cards, *Blast*, 1976, sought to critique the vocation of artist. Nixon wrote: "Finally it comes down to 'where do *you* stand!?' Now that's more than a simple question; after all, isn't it a question of *your* 'form of life'."[13] His polemic, pamphleteering style was all exclamation marks and underlining. Nixon's insistence on a second-person address, *from within* the institutions of art, was intended to defeat the normal social relations of viewing. Whether such an aim was not in itself an impossibility was an issue taken up by many critics, most articulately by Donald Brook.[14]

The same was true of a very different artist, Robert Hunter. For his 1970 installation at Pinacotheca, Hunter stencilled 11 grids onto the gallery's walls in grey paint; in the inaugural exhibition at the gallery he taped paper to the walls. He later said, "I want to make something alien – alien to myself" and described his desire to avoid creating "*objets d'art*".[15] Hunter's steadfastly consistent movement beyond formalist discourse meant that his inquiry into the particular elements constituted in the act of viewing – amongst which, from the late 1980s onwards, was the experience of flight, in more psychedelic and only superficially minimal paintings of white on white – soon parted company with the straightforward minimalism of his American friend Carl Andre.

Bonita Ely: The New Wave of Women's Art

Bonita Ely's work was also distinguished by these contradictions. Like Elizabeth Gower, Ely was one of the important artists who emerged from the milieu of the Women's Art Movement in the mid-1970s. She was involved in a variety of projects: the compilation of the Melbourne-based Women's Art Register (an exhaustive collection of slide documentation of Australian women artists); participation in the Women's Art Movement (given impetus by pioneering American, feminist art critic Lucy Lippard's 1975 visit to Australia); and completion of works such as the enormous *Mt Feathertop* project, shown at Art Projects in separate instalments during 1979 and 1981. An immensely ambitious and powerful work, this was a prototype for ecological art of the late 1980s. It comprised paintings, an out-sized *papier mâché* sculpture of the mountain itself, and Hans Haacke-like documentations of ecological pillage. Ely was also involved in performance, and there she escaped the complicity of the aesthetic and its aspirations to the museum wall. Impeccably dressed and coiffured, in suburban drop-dead glamour, she presented *Murray River Punch*, 1980, to an astonished student audience at Melbourne University in the Student Union foyer, indistinguishable from any number of minor-league celebrities giving away free samples and snacks in supermarkets. The recipe was as follows:

Using a blender or beater combine:
6 cups deoxygenated water
2 tbl. sp. fertiliser
1/4 cup of human urine
1/4 cup of human faeces
1 dst. sp. dried European carp
Place mixture on a gentle heat. Add:
2 cups salt
Stir constantly until the salt dissolves then bring to the boil.
Remove from heat. Stir in:
2 tbl. sp. superphosphate
2 tbl. sp. insecticide [16]
2 tbl. sp. chlorine. Serves 18 people.

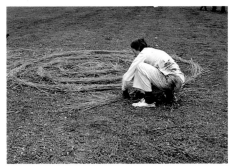

1:9

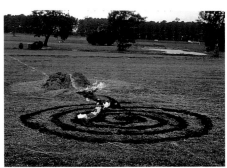

1:10

17 Anne Marsh, "Women Artists at the Triennial", *Art Network* 3&4, Winter/Spring 1981, p. 24.

18 Anne Marsh, "The interception of performance art and feminism in the 1970s", in *The present and recent past of Australian art and criticism*, special supplement, *Agenda* n. 2, August 1988, p.11.

1: 9-10 Bonita Ely, *Jabiluka UO2*, 1979, performance, Preston Institute of Technology Performance Festival, Melbourne. Courtesy Sutton Gallery, Melbourne and Annandale Galleries, Sydney.

1: 11 Bonita Ely, *The Murray River*, 1980, mixed media including Murray River sands, pigments and handmade paper, dimensions variable. Courtesy Sutton Gallery, Melbourne and Annandale Galleries, Sydney.

1: 12 Bonita Ely, *Histories*, 1992, mixed media, 55 x 215 cm. Courtesy Sutton Gallery, Melbourne and Annandale Galleries, Sydney.

1: 13
Title: *detail*
 A Person Looks At A Work Of Art/ someone looks at something …
 SHOOTING GALLERY/RITUAL SIGNIFICANCE
Medium: *A Person Looks At A Work Of Art/ someone looks at something …*
 CULTURAL CONSUMPTION PRODUCTION
Date: – 1978–
Artist: Peter Tyndall
Courtesy: Anna Schwartz Gallery

In contrast, Ely also produced a ritualistic anti-uranium piece, *Jabiluka UO2*. This was performed in Melbourne during 1979, and also at the halcyon 1980 performance festival, ACT 2, in Canberra. The author assisted in both performances. Ely, dressed in a white boiler-suit, erected an elaborate sand-castle from coloured earths and then arranged a spiral of flammable straw across the adjacent lawn. Her male assistant traced a rigidly straight path in white lime across the field towards her, eventually scattering the sand construction. Simultaneously, Ely set fire to the straw, etching a primal design onto the grass.

Ritual-based performance focused on the revelation of an identity so primal that it would be side-lined as both overtly Australian and covertly artificial in the next decade. Performances such as *Jabiluka* were to be criticised during the 1980s; Anne Marsh said, in a 1981 review of women artists at Melbourne's First Sculpture Triennial, at La Trobe University, that "ritual is a fairly safe bet if you're backing neutral politics".[17] Ely's feminism certainly wasn't that, but reinscriptions of woman-as-other playing nature to man's culture were seen as regressive by a newer generation of theorists during the 1980s. The shamanism and ritual of performances such as those by Bonita Ely and Jill Orr were far from the analytic postmodernism which examined "issues" and the politics of representation itself. Such art would replace performances like Ely's and Orr's in public and critical eyes during the 1980s.[18]

In the 1980s, Ely turned to printmaking from this background in performance art. Like Mike Parr she was interested in the limitations of the body as an object, but she was also intensely aware that the blankness of paper was political and, for her, specifically feminine. Like other feminist artists of her generation, she was determined to foreground this awareness and turn it into a positive quality. Ely completed *The Murray River* in 1980, using a combination of print-based technologies: handmade paper; staining by natural earths; and etching. She overtly "feminised" her sheets of paper, identifying their white empty spaces as both landscape and a woman's body. Her large, fragmented works on paper of the 1990s moved further into mixing and matching an encyclopedic range of

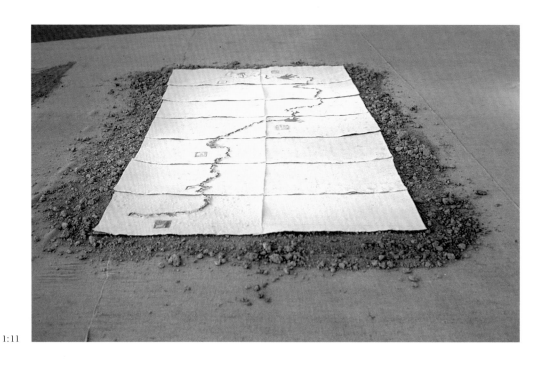

1:11

1:12

visual systems, information and words. Bonita Ely moved outside the comfortable conventions of modernism and its formalist view of media as a neutral resource awaiting the artist's intervention. Her performances also crossed the boundaries of Body Art into less narcissistic modes such as community participation. Representation, the artist has continued to assert, is both political and personal.

Peter Tyndall and Robert Rooney: Authorship as a Laughing Matter

What were the constructed worlds that 1970s artists saw as the Self? The indivisible authority of a well-known name was not easily discarded. Conceptual artist Mel Ramsden retrospectively observed, in 1990, the difference between the expanded view of authorship held by the Art & Language group, and "the conventional view of authorship held by one of the journal's most important founding editors, Joseph Kosuth. For him, his authorship was no laughing matter."[19] Many artists were aware of the relativity of essential identity described by contemporary thought. In 1981, Peter Tyndall obliquely described the subject in a manner that exactly fitted his own paintings and installations, including his shooting gallery at the 1978 Mildura Sculpture Triennial:

> A painting does not float, independent, half-way up a random wall. "It" is physically dependent on the strings which support it against the gravitational force which would bring "it" down … nor can "the (one's) perceiving" be considered outside the influence or colouring of either the physical light (physical lights) or the metaphoric lights (cultural knowledge …)[20]

Tyndall's gently didactic sideshow was both a shooting gallery without conventional prizes (but with lengthy semiotic discussions) and an examination of the social body. It was inevitable, in the wake of such a dispersed notion of the art object, that meaning would be seen to reside in the person of the artist. The search for "truth" would assume largely autobiographical forms.

Superficiality itself was a dominant mood and artistic method; this "Cool" quality was widely remarked upon in Melbourne art and was exemplified by painter and art critic Robert Rooney, an important figure in the experimental group of artists associated with Pinacotheca. In Rooney's works from the 1970s, like *Holden Park 1 & 2*, 1970, superficiality and Cool were necessary accomplices in his search for the Self. Unable to locate meaning and identity with the, in retrospect naive, assurance of most of his contemporaries, he suggested its testimony in the circulation of objects. In his own conceptual

1:13

19 Mel Ramsden, quoted in Michael Baldwin and Mel Ramsden, "Michael Baldwin and Mel Ramsden on Art & Language", *Art & Text* n.35, Summer 1990, p. 32.

20 Peter Tyndall, "Slave Guitars (*formerly Slave Guitars of the Art Cult*)", *Art & Text* n.4, Summer 1981, pp. 44-45.

21 Robert Pincus-Witten, "Anglo-American reference works: Acute conceptualism", *Artforum* v.10 n.2, October 1971, p.84.

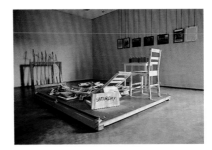

1:14

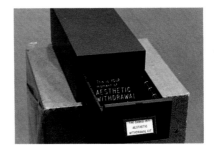

1:15

22 Aleks Danko, artist's statement, in Tony McGillick and Terry Smith (curators), *The Situation Now: Object or Post-Object Art?*, Contemporary Art Society Gallery, Sydney, 1971, p.25.

23 Aleks Danko, interview with the author, Melbourne, January 1994.

24 Mike Parr, "Parallel Fictions: The Third Biennale of Sydney, 1979", *Art and Australia* v.17 n.2, December 1979, p.183.

1:14 Aleks Danko, *Born April 7th 1950*, from *Fragments 1971*, installation, Watters Gallery, Sydney, 1975. Collection: Queen Victoria Museum & Art Gallery, Launceston. Photograph: John Delacour. Courtesy Sutton Gallery, Melbourne and Bellas Gallery, Brisbane.

1:15 Aleks Danko, *The Danko 1971 Aesthetic Withdrawal Kit*, 1971, steel 3" x 5" filing-card drawer. Photograph: Douglas Thomson. Courtesy Sutton Gallery, Melbourne and Bellas Gallery, Brisbane.

1:16 Robert Rooney, *Holden Park 1 & 2*, 1970, sheet of colour photographs, 76 x 102 cms. Collection: Monash University Gallery. Courtesy Pinacotheca, Melbourne.

photographs of the 1970s, Rooney could not retrieve subjectivity, and was too honest to pretend differently. American critic Robert Pincus-Witten's epigram, "I document, therefore I am", summarised many post-object artists' methods.[21]

Aleks Danko: The Conceptual Art of Administration

Aleks Danko gained notoriety during the 1970s as a kind of clown conceptualist. He definitely encouraged this: in contrast to the otherwise extremely ponderous essays for the catalogue of an important 1971 exhibition, "The Situation Now", Danko submitted the following description of his works: "I enjoy the fact that they are useless in their present function and possess a strange, pleasant unpleasantness. Moreover, I enjoy pulling faces."[22] The pseudo-clinical presentation of himself in the works for "The Situation Now", *Self Portraits I, II, and III*, 1970, was repeated (for example in *Born April 7th 1950*, 1975), confirming Danko's determined three-fold intentions: to vacate the self from the body; to present his corporeal form as an index, not an icon; and to question the status of art as a communicative act. Danko's pieces gained immediate attention because, like a ghoulish post-object conscience, they addressed the most pressing issues without apparent piety, but with humour and macabre, Gothic shock value. *Born April 7th 1950* completely avoided didacticism; the experience of dislocation of personality (into improbable, slightly repulsive signs of the body and its functions) undercut that of alienation. Danko was the Caravaggio of conceptualism.

Many of his conceptual sculptures featured this fetishisation of bureaucratic conceptualism through the elaborate craft of packaging; the packaging itself usually took the form of different kinds of boxes. He was aware of Marcel Duchamp's use of boxes and sexual motifs, and approved of his hyperalertness towards style and authorship.[23] His works, such as *The Danko 1971 Aesthetic Withdrawal Kit*, 1971, had the secretive portability valued by professional thieves or confidence tricksters. *The Danko 1971 Aesthetic Withdrawal Kit* should be counterpointed with the many boxes of filing cards through which artists, including Mike Parr and the American minimalist Robert Morris, indexed the 1970s. Danko's steel 3 x 5 inches filing-card drawer was labelled "The Danko 1971 Aesthetic Withdrawal Kit". The drawer was pulled open to an empty box, immediate disappointment and a card which read "This is your moment of aesthetic withdrawal". Like American Robert Morris's notorious *I-Box*, 1962, it was a sleight-of-hand and suggested several semiotic puns based on melancholy identifications of art, drugs and sex.

Mike Parr: The Safe House of Cathartic Experience

Mike Parr achieved a different notoriety in the early 1970s, as a performance artist whose works involved tests of endurance and self-mutilation. He shared with Danko a desire to work inside the space of the museum. However, Parr saw the museum as a place where "real life" would be suspended. In an article on performance in the 1979 Sydney Biennale, Parr powerfully articulated his belief that the museum offered artist and audience a kind of "safe house", where an enhanced relationship could be created out of cathartic experience.[24] Though the themes now seem familiar, the way that Parr explored his relationship with an audience – shocking or trapping them into an often brutal complicity – had considerable impact. In *Cathartic Action/Social Gestus No. 5*, 1977, the formation of identity and its attendant loss of innocence was equated with the artist's childhood loss of an arm. Representing the exorcism of that trauma, he hacked

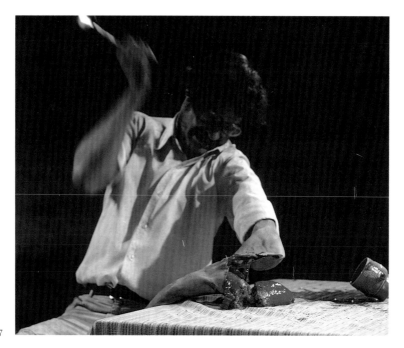

1:17

25 Mike Parr, "Parallel Fictions", *Art and Australia* v.17 n.2, p.183.

26 Mike Parr, artist's statement, in Robert Lindsay (curator), *Relics and Rituals: Survey 15*, National Gallery of Victoria, Melbourne, 1981, unpaginated.

27 Mike Parr, in Robert Lindsay (curator), *Relics and Rituals*. For an extensive description of Parr's art, see David Bromfield, *Identities: A Critical Study of the Work of Mike Parr 1970-1990*. University of Western Australia Press, Perth, 1991.

1:17 Mike Parr, *Cathartic Action/Social Gestus No. 5*, 1977, performance, The Sculpture Centre, Sydney, from *Rules & Displacement Activities Part 3*, 16mm film, b&w and colour, 90 minutes. Photograph: John Delacour. Courtesy Anna Schwartz Gallery, Melbourne and Sherman Galleries, Sydney.

1:18 Mike Parr, *Black Box: Theatre of Self Correction, Part 1, Performance No. 1*, 1979, performance, 3rd Biennale of Sydney, Art Gallery of New South Wales, Sydney. Photograph: John Delacour. Courtesy Anna Schwartz Gallery, Melbourne and Sherman Galleries, Sydney.

off an imitation limb before a horrified audience. A 1979 statement of Parr's about the performances of Marina Abramovic/Ulay now seems autobiographical:

> Performance art like this is cathartic both for the performers and the audience, emotions emerge afterwards in a rush as a consequence of being dammed up ... Everyone feels relieved: a rite has been survived, order and meaning have been re-established, but at a new order of clarity that incorporates part of the intensity felt.[25]

The artist was well aware of the psychoanalytic and therapeutic implications of his work, which continually made literal and metaphoric use of the idea of catharsis, observing in a statement for a 1981 exhibition at the National Gallery of Victoria that:

> My films build on the absence of the image (the sign of the wound in *Rules & Displacement Activities* is the montage itself). I am interested in the long space of the past (re-open wounds and the past returns with a rush) ... At the point of convergence, we share a language in common.[26]

Parr attempted to find the point at which normal bodily processes, such as aversion to pain or the desire to breathe, would collapse under the onslaught of his interventions. Clear affinities with the work of Austrian Body artist Hermann Nitsch, and the dramatisation of psychoanalytic theories such as mirror-phase reflexivity through instant replays on video monitors, emphasised Parr's desire to test the limits of the availability of the body as an object – even to the performer. He was also preoccupied with the reverse: the accessibility of the Self. The artist's "I" was described by Parr in 1981 in existential terms:

> For a long while for me, the framed record seemed to deny the existentialism of the event; the fact that each performance is a form of survival and that the performance is experienced by the performer at the edge of the present tense.[27]

An endless journey towards the self was imaged in the films *Rules and Displacement*

1:18

28 Mike Parr, quoted in Peter Thorn, "Stutterer on a Mountain – Bashlyk Self Portrait: An interview with Mike Parr", *Museum of Contemporary Art Members' Newsletter* (Sydney), May-June 1993, p.7.

29 Aleks Danko and Mike Parr, *Lafart Manifesto*, Tin Sheds, Sydney, 1975, unpaginated.

30 Aleks Danko and Mike Parr, *Lafart Manifesto*.

31 See Benjamin Buchloh, "Conceptual Art 1962-69: From the Aesthetic of Administration to the Critique of Institutions", *October* n.55, Winter 1990, p.138. As Benjamin Buchloh showed, Daniel Buren's 1969 essay, "*Limites Critiques*", was quite prescient, as was his 1970 essay, "Beware!". See Daniel Buren, "Beware!", *Studio International* v.179 n.920, March 1970, pp.100-104.

32 Catalano criticised Ian Burn and Mel Ramsden's Art & Language texts, accusing the two artists of pedantry and dubious philosophy. See Gary Catalano, *The Bandaged Image: A Study of Australian Artists' Books*, Hale & Iremonger, Sydney, 1983.

Activities: Parts 1, 2 and 3, 1973-85. The different versions of *Black Box* were linked in intricate ways to all of the artist's 1970s performances, and thus to the films that mediated this activity. The "Performance Room" versions of *Black Box: Theatre of Self Correction, Performances 1-6,* 1979, were made in conjunction with the artist's family, and marked a shift from earlier confrontations that had reflected the impact of the European improvisation and performance movement Fluxus. Parr was intensely aware of phenomenological and psychoanalytic theory but his work was also notable for its latent quest for integration, where violent acts foregrounded a stoic and heroic self.

If Parr's work was primarily autobiographical, it was also highly complex. Parr was aware of the contradictions inherent in the documentation of his performances, noting much later, in 1993, that:

> The idea of photodeath has to do with my looking at the documentation of the 1970s performances and becoming aware of the substitution of all the risk of the performance by the process of its representation. It's terribly ironic, in that the point of the performance was to destroy the static containment of the image, of the idea. That meaning can only be contained in that way, and that the only way in which we can recall these performances is by the process of this documentation is a typical double bind.[28]

Escaping didactic interpretation, his extraordinary later works on paper addressed the problems of subjectivity within less determined frameworks; these are examined in a later chapter.

Lafart versus Pluralism: Doubts about the Efficacy of Art

This double bind was clearly evident to artists. The *Lafart Manifesto,* 1975, was a sheet of red mimeographed paper with text by Mike Parr and Aleks Danko. It was plastered around Sydney in 1975 by the two artists' students at the Tin Sheds, and melodramatically announced: "We have decided to leave post-object art behind because it belongs to the past".[29] Words like "solidarity" reappeared all through the manifesto; in fact, it was a parody of Left political correctness and obviously issued from the experiences Danko, Parr and Tin Sheds colleague Noel Sheridan had accumulated in collective groups over the previous years. Danko and Parr mocked post-object art's timidity: "Post-object art is intolerable; when Klaus Rinke throws bed-pans of water he does so in galleries".[30] The manifesto reflected a general rhetoric of hostility to museums and commercial galleries during the period, but its humour represented something else as well.

Danko and Parr were alert to the potential importance of a critique of Duchamp, such as that made by Daniel Buren: the readymade's fallacy was its obscuring of the institutional and discursive framing conditions that, nevertheless, allowed shifts in the meanings and experiences of ready-made objects.[31] Post-object and conceptual art was vulnerable to two types of criticism: it was tautologous and it took for granted its own institutional neutrality.[32]

Australian art discourse during the 1970s was able to encompass a variety of imperatives. This heterogenous pluralism could become a problem: the evolution of that decade's practice and criticism amounted to a "legitimisation of the subversive". Did the pervasive rhetoric of dissent in art criticism amount to nothing? And who did it serve? Donald Brook, whose criticism was far ahead of its objects, retrospectively observed that art must "always either be compromised by assimilation into some progressive or

33 Donald Brook, "From the margin", in *The present and recent past of Australian art and criticism*, special supplement, *Agenda* n.2, p. 9.

34 Aleks Danko, interview with the author, January 1994.

35 Daniel Spoerri (trans. Emmett Williams), *An Anecdoted Topography of Chance (Re-Anecdoted Version)*, Something Else Press, New York, 1966.

36 Thomas McEvilley, "Great Walk Talk", in *The Lovers*, Stedelijk Museum, Amsterdam, 1989, p.76.

1:19

1:20

1:19 Aleks Danko, *Day to Day*, 1974, performance, Mrs Macquarie's Chair (shown) and five other locations around Sydney. Photograph: Louise Samuels. Courtesy Sutton Gallery, Melbourne and Bellas Gallery, Brisbane.

1:20 Aleks Danko, *Day to Day*, 1974, performance, underground walkway at Domain Parking Station (shown) and five other locations around Sydney. Photograph: Louise Samuels. Courtesy Sutton Gallery, Melbourne and Bellas Gallery, Brisbane.

1:21 Christo & Jeanne-Claude, *Wrapped Coast, Little Bay, One Million Square Feet, Sydney, Australia*, 1969, erosion control fabric and 36 miles of rope. Co-ordinator: John Kaldor. Photograph courtesy John Kaldor. © Christo 1969.

'Hegelian' doctrine of art history, or else it will be invisibly active in a manner transcending the scope of the art institution".[33]

This was the point at which artists stalled: art itself, as several participants have since noted, was perceived to have ended. Some artists moved into direct political action. Others, including Dale Hickey and Domenico de Clario, started painting again. Parr moved gradually into printmaking and drawing; Danko moved further into the exploration of alternative (often collaborative) modes of production. In *This performance is a mistake*, 1973, Julie Ewington, Robin Ravlich and Danko undressed and swapped clothes, describing their reactions to an audience of approximately 200 people. Danko remembers that although there was much haste and laughter during the event, the performers felt very little confusion because the process of cross-dressing was so matter-of-fact and impersonal.[34]

Danko's later artist's books, such as *Ian Bell will arrive in London January 3, 1974*, 1974, continued this search for the outer limits of personality through enumeration to the point of exhaustion. The book was a journal (one page per day for approximately three months until his friend Ian Bell arrived in London). It was printed on an early xerox copier; its grainy images were harsh and its descriptive soliloquies self-conscious. The relationship between word and image in *Ian Bell will arrive in London January 3, 1974* was initially arbitrary but became closer as the work continued and words became captions. The diary gradually became more formal and austere, until it began to resemble European artist Daniel Spoerri's book, *An Anecdoted Topography of Chance (Re-Anecdoted Version)*, where Spoerri applied the critical and scholarly apparatus of semiotics to the objects on a table.[35] *Ian Bell will arrive in London January 3, 1974* oscillated between two impulses. Art disappeared into life, leaving the work behind, and Danko's life became a marathon race as he sought to finish his journal so that it could become art.

Another book, *The Chair is not a Tourist*, 1975, documents five performances narrating Danko's doubts about the possibility and efficacy of communication. One of the performances was *Day to Day*, 1974, for which Danko sat blindfolded, gagged, and bound to a chair for one hour in each of six different Sydney city locations, including the underground walkway at The Domain. The book's photographs documented the reactions of passing pedestrians. Its recording of vulnerability had affinities with the mid-1970s performances of Marina Abramovic and Ulay, two European performance artists who visited Australia twice in the later 1970s, travelled in the outback and presented works in Sydney Biennales. In 1975, Marina Abramovic invited a randomly chosen audience from the street in Naples to "express themselves using her body".[36] The result was aggressive and violent: she was stripped, cut with a razor blade, punched, a gun nozzle was thrust into her mouth, and a fight broke out amongst the audience, clearing the hall. Danko did not sympathise with such mono-structural, cathartic performances, which were admired by his colleague Mike Parr, but agreed with the 1978 assertion of Parr that "In Australia I find little knowledge of Happenings and Fluxus. Performance art in the '70s must be seen against this background."[37]

Unlike Parr, Danko misused conceptual art. He did so not because of its potential for purity, but because of its literary possibilities: its useful impersonality; its Kafkaesque clerical bureaucratisation of art; and its near-total *nouveau roman* bracketing of expressive voices. Danko's interest in the preservation of narrative was also based on a revulsion from the monotonous nature of most performances. In the introduction to *Ian Bell will*

37 Mike Parr, "Beyond the Pale: Reflections on Performance Art", *Aspect* v.3 n.4, 1978, p. 6. Happenings were highly unstructured performance/installations; they became widely known in the work of American artist Alan Kaprow from the late 1950s. Fluxus was a loosely organised group of European and American artists, with strong links to avantgarde music, co-ordinated by American George Maciunus. Fluxus was more like a hidden web of connections between otherwise known artists than a conventional art movement. Fluxus artists organised happenings and "actions" – in 1964, for example, Maciunus threatened American police forces with the sabotage of the postal system, city-wide pickets and disruption of mass transit. Aleks Danko's work had many links with Fluxus.

38 Richard Kostelanetz, *Breakthrough Fictioneers*, Something Else Press, New York, 1973, quoted in Aleks Danko, *Ian Bell will arrive in London January 3, 1974*, artist's book, 1974, unpaginated.

39 Brett Whiteley, Tony Woods and William Pidgeon's collaborative painting, *Linked Portrait*, 1971, was an isolated and unusual work in the exhibition because of its figuration, each artist's relatively conservative aesthetic stance, and the fact (unusual in each artist's oeuvre) of its collaborative manufacture. In the early 1970s, Melbourne artist Guy Stuart produced a remarkable series of wall-hanging, net-like "installations", or Lattices, that await revaluation of their importance. *Lattice*, 1971, is titled *Pigment Catch* in Szeemann's catalogue.

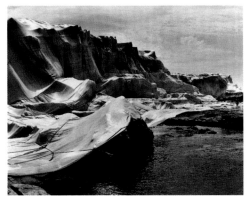

1:21

arrive in London January 3, 1974, Danko wrote evocatively about the potential of fiction. He quoted Richard Kostelanetz: "Fiction can be most generally defined as a frame filled with a circumscribed world of cohesively self-relating activity… within fictional art is usually some kind of movement from one point to another".[38]

Both Aleks Danko's later installations and Mike Parr's prints of the 1980s developed from a long and distinguished career with performances that were above all theatrical, because performance artists dealing with investigations and revelations of self are always "doing impressions", in the theatrical sense of that word. Parr's audiences, though, were forced into a different complicity – as either voyeurs or traumatised, terrorised subjects – in powerful performances that attempted to remake both artist and audience.

REMAKING INSTITUTIONS: IN OR OUT OF THE GALLERY?

Pluralism and Dependency

The art of the 1970s was characterised by pluralism, but the result of pluralism tended towards a dependence on institutions which were, in turn, occasionally forced to set aside inertia and conservatism to confront the new art. For example, John Kaldor's "Art Project 2", which followed his co-ordination of Christo and Jeanne-Claude's influential and spectacular *Wrapped Coast, Little Bay, One Million Square Feet, Sydney, Australia*, 1969, was a large exhibition selected by European curator Harald Szeemann and titled "I want to leave a nice well-done child here: 20 Australian artists". His exhibition opened at Sydney's Bonython Galleries in April 1971 and at the National Gallery of Victoria in June 1971. It included works as diverse as Brett Whiteley, Tony Woods and William Pidgeon's collaborative painting, *Linked Portrait*, 1971; Mike Parr's *String-Shadow Piece*, 1971; and Melbourne artist Guy Stuart's austere show-stopping wall of nylon and rubberised plastic, *Lattice Full of Holes*, 1971.[39] Public galleries such as the NGV were surprisingly quick to incorporate a few innovative projects like Kaldor's in order to confirm their own authority and prestige or in response to the fierce efforts of individual curators such as Brian Finemore, Daniel Thomas and Jennifer Phipps. Alternative spaces and organisations were allocated the role previously performed by museums or commercial spaces – the accreditation of untried artists. Only a few private galleries were able, gradually, to represent the elusive self surviving within 1970s art as a desirable commodity worthy of their collectors' attention. Art schools quickly adapted to the pluralist 1970s, forming newer academies without plaster casts and, often, without any consistent transmission of technical skills or art history at all; such was my own training at Melbourne's National Gallery School in the early 1970s.

If most experimental art was critical of the museum, it was equally true that much 1970s art could be seen as art only within the museum or the walls of commercial galleries, which were doggedly identified by artists as places where "anything goes". Art largely became what galleries and museums allowed inside their doors. The way this happened confirms the ideologies that underlie the industry of art.

Public Galleries: Representation and Exclusion of New Art

The most radical forms of 1970s art were shown in public gallery survey exhibitions and, more gradually, were promoted by commercial galleries. Certain categories of post-object art, such as installation, now seem more prescient than others in their affinities

1:22

40 Lizzie Borden, "Three modes of Conceptual Art", *Artforum* v.10 n.10, June 1972, p. 69.

41 Lizzie Borden, "Three modes", *Artforum* v.10 n.10, p. 69.

1:22 Guy Stuart, *Lattice Full of Holes*, 1971, mixed media, including rubberised material, glass fibre, pigments in casein, 350 x 525 cm. Collection: National Gallery of Victoria. Courtesy Australian Galleries, Melbourne.
This work was exhibited in "I want to leave a nice well-done child here: 20 Australian artists", curated by Harald Szeemann as John Kaldor's "Art Project 2", Bonython Galleries, Sydney, April 1971, and travelled to the National Gallery of Victoria, Melbourne, in June 1971.

with the art of the 1990s. Far from being too radical for exhibition, even this work was represented at the time as consistent with previous practice. Autonomous and self-contained, it conveniently seemed to resist precise definition. Critic, curator and film-director Lizzie Borden observed that the term "conceptual art" was an imprecise category for the multitude of works which claimed to elevate concept over material realisation.[40] She distinguished between different modes of dematerialised art: documentations of past actions; performances; and text-based art. Each of these forms was shown in public and commerical galleries. For example, Robert Rooney's documentations, *Scorched Almonds*, 1970, and *Holden Park 1 & 2*, 1970, were shown in the Art Gallery of New South Wales, as part of "Project 8: Robert Rooney", during 1975. A performance by Kevin Mortensen, *The Seagull Salesman, his stock and visitors*, was seen at Bruce Pollard's Melbourne gallery, Pinacotheca, during 1972. Terry Smith's and Robert Dixon's text-based Art & Language piece, *Project for a "Political Art" Poster*, 1974-75, was shown at the 1975 Mildura Sculpture Triennial Exhibition. The look of art was conferred on radical forms by the framing of the gallery space, which was itself used as a kind of "unique book", in Lizzie Borden's phrase.[41]

The state gallery or publicly funded art space, in particular, was neither neutral nor an innocent site and was far more than just a convenient forum. Performances made their appearance in place of pictures executed by hand. Instead of paintings, and at least as authoritative, the artist was available through documentations or, in performances, actually present. Documentations were occasionally collected by museums, and support seems to have been relatively consistent, if small in absolute size. Examination of accession dates for post-object art works in Australian collections shows a fairly constant purchase or donation pattern, even during the painting-dominated early 1980s. In fact, artists hoped that major survey shows would legitimise the status of radical art in the face of private-sector tardiness. From London, Charles Harrison observed in 1969 that:

Perhaps the London showing of "When Attitudes become Form" will act as an irritant and will serve to show how inadequately we are prepared to draw benefit from even the London-based exhibitors, let alone those American and Continental artists whose work we need so desperately to see in depth.[42]

The dominant style of the 1960s – formalist abstraction, which was also known as Colour Field painting – continued to be exhibited in local commercial galleries, as a survey of gallery notices demonstrates. This art looked alternately lofty, unintelligible and intimidating; or pretty and very up-to-date. It fitted well into large office buildings. In Melbourne, "The Field", the National Gallery of Victoria's inaugural 1968 exhibition at its new St Kilda Road site, marked the end of that style's exclusive interest to many participants. "The Field" included only two artists, Ian Burn and Mel Ramsden, whose work demonstrated the dematerialisation of the art object. However, neither their art nor mention of any such tendency appeared in the three exhibition catalogue essays. Before the NGV's commencement of the Survey program (of small-scale solo exhibitions by experimental artists) in 1978, the small gallery on its third floor was one of two principal public spaces for contemporary art in Melbourne. A low-ceilinged anteroom adjacent to the permanent collection, this space was best described as marginal; the institution, especially after 1977, implied that contemporary art – obstructed by pillars and compressed hanging – was by nature best confined to a cramped ivory tower.

The stylistic alibi of the 1970s in institutions was, fortuitously, Cool. Sensitive opacity masked artists' otherwise forbidden utterances, whether political or personal (and, remember, the political was personal). When political content could be neither trivialised nor controlled, or when gratuitous exclusion was allowed to disrupt the seamless neutrality of museums and commercial galleries, certain types of advanced art were shown the door. This was despite the efforts of patrons like John Kaldor or progressive curatorial staff like Jennifer Phipps at the National Gallery of Victoria and Tom McCullough at the Mildura Regional Gallery. Exclusion was based, according to gallery trustees, on aesthetic grounds: either artistic merit was the question, or the museum was deemed to be above politics. Appeals for pragmatism and common sense, the two favourite motifs, justified the withdrawal of support from the most radical contemporary art. A refusal to purchase the new art was also justified by its alleged unsuitability for museum display. Establishment critics attempted an immediate relegation of 1970s art forms to the past-tense basement. Reviewing the NGV's 1973 conceptual art exhibition, "Object and Idea", Patrick McCaughey asserted that it was "a pallid, provincial and undernourished cousin of New York art of two years ago and more … powered by a foreign rhetoric and irrelevant to present conditions in Australian art".[43]

In 1975, the Art & Language exhibitions at the Art Gallery of New South Wales and the National Gallery of Victoria were banned after protests from politicians and visiting American curators. The Art & Language exhibition in Melbourne was held instead at the adjoining National Gallery Art School, following threats from William Liebermann of the New York Museum of Modern Art, who was curating the concurrent touring Blockbuster "Modern Masters". These were memorable events, provoking debates about cultural imperialism in Art & Language's simultaneous forums. Later that year, as noted above, a Domenico de Clario installation was removed from the National Gallery of Victoria. Protests by artists in the Gallery foyer ensued, but it was doubtful whether any substan-

42 Charles Harrison, "Against Precedents", *Studio International* v.178 n.914, September 1969, p.94.

43 Patrick McCaughey, "If you call it art let it so be judged", *The Age*, September 12, 1973, p.2.

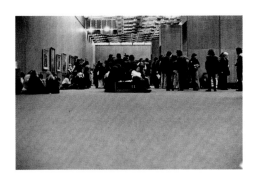

1:23

44 Bernice Murphy, "Australian Art Abroad",
Art and Australia v.3 n.4, April-June 1976, p. 332.

45 Clive Murray-White, quoted in Jonathan
Sweet, *Pinacotheca: 1967-73*, Prendergast,
Melbourne, 1989, p. 20.

1:23 Artists' sit-in at the National
Gallery of Victoria in 1975, following
the gallery's removal of Domenico de
Clario's installation, *Elemental
Landscapes*. Photograph: Brecon Walsh.

1:24-27 Kevin Mortensen, Mike Brown
and Russell Dreever, *The Opening Leg
Show Party Bizarre*, 1972, performance/
event, Pinacotheca, Melbourne.
Photograph: Ian Wallace.

1:28 Micky Allan, *The Live-In Show*,
installation/performance, Ewing and
George Paton Gallery, University of
Melbourne, 1978. Courtesy Watters
Gallery, Sydney.

1:29 Aleks Danko and Colin Little,
Laughing Wall, 1972, installation, Tin
Sheds, Sydney University. Photograph:
Sam Bienstock.

tial relationship between the Gallery and contemporary artists developed as a consequence, apart from the Survey shows mounted by new curator Robert Lindsay in the late 1970s. Certainly, the promised annexe for contemporary art never materialised.

It was also possible to present a picture of contemporary Australian art so partial and complacent as to misrepresent its direction. When the exhibition "Ten Australians" toured Europe in 1975, it included works by David Aspden, Sydney Ball, Fred Cress, Roger Kemp, Fred Williams, George Haynes, Donald Laycock, Michael Taylor, John Firth-Smith and Ron Robertson-Swann. Nine painters, one sculptor, no women, no post-object or radical art. Bernice Murphy reviewed the exhibition in justifiably scathing terms:

> The most distinctive recent features of Australian art in the mid-1970s – the widening of options, the dispersion of the avant-garde from any agreed location or similar objectives into a diaspora of various, and often mutually incompatible modes of activity – were quite obscured by this exhibition … I think that, ironically, even within the staked-out territory of the catalogue essay's discussion … the problem of exclusion still looms.[44]

To a significant extent, women were under-represented in major exhibitions in public galleries, though not to the degree indicated in "Ten Australians". Of the 40 artists in "The Field", three were women. In the 1981 Australian Sculpture Triennial, approximately 50 of the 220 invited artists were women. Protests connected with gender balance in the 1976 Sydney Biennale were partly responsible for the formation of the Artworkers Union. At the Art Gallery of New South Wales' "Australian Perspecta '81", curator Bernice Murphy included 23 women out of a total of 64 artists.

Commercial and Alternative Galleries: Exceptions in a Sea of Conservatism
Commercial galleries in Europe and America were able to represent artists working in virtually all advanced art forms. During the autumn of 1975, for example, Daniel Buren showed with John Weber, Joseph Beuys with Ronald Feldman, Hans Haacke with John Weber, Dan Flavin with Leo Castelli and Jannis Kounellis with Sonnabend. However in Australia, at approximately the same time, little post-object or alternative art was shown commercially to any great extent, except in Melbourne by Bruce Pollard at Pinacotheca and Georges Mora at Tolarno, and in Sydney by Geoffrey Legge and Frank Watters at Watters. Pinacotheca, as Clive Murray-White observed, had "the air of New York; if you took a photograph of your work, it would look like a major international avant-garde show".[45]

Other artists attempted to bypass both public galleries and commercial spaces, forming collectives and loose associations such as the Women's Art Movement in the mid-1970s and, later, the Artworkers Union. Co-operative galleries, like Inhibodress in Sydney between 1970 and 1972, and publicly-funded galleries, such as the George Paton Gallery at the Student Union of the University of Melbourne and the Experimental Art Foundation in Adelaide from the same time, identified themselves closely with alternative groups and their labyrinthine organisational processes. They established themselves, with Pinacotheca and Watters, as the most important venues for progressive art. Electronic media, video, and postal art (such as "Trans Art 3" at Inhibodress in 1972 or "The Letter Show" at the George Paton Gallery in 1974) were all utilised by a wide cross-section of artists.

The financial, logistical and emotional demands on artists participating in alternative

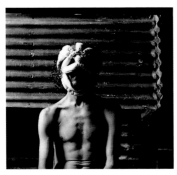

1:24

1:25

1:26

1:27

1:28

46 Author's conversation with Robert Rooney, November 1989. Author's conversation with Bruce Pollard, November 1989.

47 Patrick McCaughey, "University or Airport", *Age Monthly Review*, March 1986, p. 13.

1:29

organisations were often prohibitive. At Pinacotheca, Bruce Pollard experimented with collective direction, insisting that artists spend some time behind the gallery's front desk. In 1972 Pollard travelled overseas, leaving the running of the gallery and exhibition program to the artists. By all accounts, the experience was not completely positive. Robert Rooney remembers several terse encounters with the uninitiated and unfortunate members of the public who strayed up the narrow lane at Waltham Place, Richmond.[46] When Pollard returned, he canvassed the continuation of this policy. However, the artists, disenchanted with the grind, boredom and routine of gallery direction, preferred that he resume control.

For most artists, experiences with alternative spaces eventually led to mainstream gallery exposure in the following decade. These venues were, in effect, a showcase for artists and the hunting ground of curators and dealers. They were therefore tolerated by the art establishment: Patrick McCaughey referred approvingly to the George Paton as "a more effective irritant to the Establishment than other venues in Melbourne", and consistently defended the George Paton Gallery when it was under threat.[47] The Tin Sheds, where Mike Parr and Aleks Danko, amongst others, taught, occupied a similar role within the Power Institute at Sydney University. A crucial, and often aesthetically disastrous aspect of such spaces, was their striving for unmediated access to the public, often through confused, "democratic" exhibition selection by the artists themselves.

Public spaces such as the George Paton and Tin Sheds were conventionally considered peripheral to the state galleries in each capital city, as they constantly attempted to incorporate advanced art forms within a tradition which preferred "pure" aesthetic value. Alternative spaces were, however, by no means the preserve solely of artists working in post-object forms. A review of the 1970s exhibition records of the George Paton Gallery demonstrates that although painting exhibitions by young artists were in a distinct minority, the program was surprisingly eclectic.

Vivienne Binns: Community Art

Representation of new art forms by curators and galleries, while far from overwhelming, nevertheless diverted new art from more radical formations, including community art projects that removed the distinction between artist and unskilled amateur. Vivienne Binns and members of the Blacktown community collaborated on *Postcard Rack*, 1980; this work was extracted from a larger community project, *Mothers' Memories Others' Memories*. Executed in conjunction with 38 suburban women, it began when Binns and

1:30

48 Vivienne Binns, artist's statement, *Mothers'
Memories Others' Memories*, p. 2.

49 Vivienne Binns, quoted in Donald Brook,
"Socially Engaged Art – Nothing Special",
Artlink v.2 n.2, May/June 1982, p. 9.

1:30 Vivienne Binns and members
of the Blacktown, NSW, community,
Postcard Rack; *Mothers' Memories
Others' Memories*, 1981, wire, enamel,
steel, vitreous enamel, relief on photo-
screen, 90 x 27 x 27 cm. Presented to
the people of Blacktown. Collection:
Blacktown Library, Blacktown, NSW.
Courtesy Sutton Gallery, Melbourne.

1:31 Kevin Mortensen, *The
Delicatessen*, 1975, installation/perfor-
mance, 70 Langtree Avenue, Mildura,
1975 Mildura Sculpture Triennial.
Photograph: the artist.

a friend "had the idea of swapping mothers for a day. Instead of doing a duty call on our
own mother, we'd visit the other's mother".[48] This was an alternative way of exploring
mother/daughter relationships. Binns was aware of the way her work was subsumed
immediately into the very system she was manoeuvring outside; *Postcard Rack* was
acquired by the Australian National Gallery in 1982:

> The biggest contradiction that I operate in is that my work can be seen as very nicely sustain-
> ing the status quo. It can be a bleed-off for excess energy, or unhappiness, a Sunday after-
> noon activity, a very nice thing to do in your spare time. But on the other hand it can be the
> means by which people can have more access to their expression, their creativity, and I see
> that as enabling people to have more access to their own sense of power.[49]

Binns could see that art remained an object of cultural consumption, because gal-
leries and museums were able to offer an audience as well as patronage. Against the
grain of artists' radical intentions, art retained its "presence", and so the shape of history
retained its seamlessness. The assumption that the purchase of a work could disarm its
content was dubious. Artists in the late 1980s, like Peter Tyndall, would make the circu-
lation of their work, within the systems of private and public patronage, an important
element in their art.

The Mildura Sculpture Triennials: Encyclopedias of Confusion

Until the Sydney Biennales from 1979 onwards, the most important museum represen-
tations of advanced art were the Mildura Sculpture Triennials. Provincial collectors'
indifference meant that many artists, like Marr Grounds or John Davis, established major
critical reputations from shows like these long before they began to make large sales
through commercial galleries. Both were included in successive Mildura exhibitions.

Later observers noted the lack of discrimination in these encyclopedic shows. Co-
operation from officials and communities outside the Mildura Regional Gallery was
required for many projects realised under the auspices of the Triennials. Put together on
a tiny budget by Director Tom McCullough and overworked assistants, the Mildura
experience replicated other large sculpture surveys of the time, such as "Sonsbeek '71", at
Sonsbeek in the Netherlands. The Mildura Triennial was unruly and marked by confu-
sion; it also coincided with motorcycle races. Exhibitions like the Triennial were charac-
terised by distinct problems: they usually incurred massive budget over-runs; this meant
they often lacked adequate infrastructure to ensure proper installation or security. Thus,
they took place amidst an atmosphere of crisis and breakdown. Artists who participated
in such events received either a minimal fee or nothing at all. More often, they poured
their own money into ensuring the correct installation of their work, effectively subsidis-
ing the showing of advanced art. Museum spaces – outdoor or indoor – were unsuitable
for many site-specific works. In fact, the 1978 Triennial ended when the Director was
dramatically sacked by the local Mildura Council; the book McCullough had produced
on the Sculpturescape was burned.

Tom McCullough's removal from the directorship followed long-running local contro-
versy over inclusions in Sculpture Triennials, particularly works such as Kevin Morten-
sen's *Delicatessen*, the effect of which depended not only on a site in the town, but on
elaborate deception of its local audience. From the vantage-point of the media-aware,
mercantile 1990s, the Mildura Triennials marked a phase in the increasing public role of

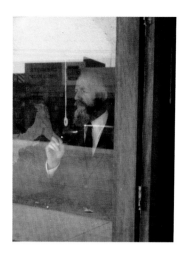

1:31

50 Alan McCulloch, "Letter from Australia", *Art International* v.14 n.6, Summer 1970, pp. 101-103.

51 Terry Smith published an influential article on Australian contemporary art and the problems of regionalism, "The Provincialism Problem", in *Artforum* v. 13 n.1, September 1974, pp. 54-59.

52 See Lucy Lippard, "Out of Control: Australian Art on the Left", *The Village Voice*, October 19, 1982, reprinted in her *Get the Message: A Decade of Art for Social Change*, New York, 1984, pp. 286-294. Lippard met Melbourne artists Jenny Watson, Isobel Davies and Lesley Dumbrell; in Sydney she formed a friendship with Peter Kennedy.

curators as mediators between artist and audience. This transition encouraged actively entrepreneurial taste-making.

Other Voices: The Limited Role of Art Magazines

Art journals played a surprisingly small role in the formation of 1970s discourse, except for the Melbourne-based feminist magazine *Lip*, which commenced publication in 1976. The Sydney-based, quarterly journal *Art and Australia*, was published from 1966 onwards, but its coverage, though wide-ranging, was invariably superficial and conservative. A Sydney journal, *Other Voices*, during 1970, and a mid-1970s publication, *Arts Melbourne*, surfaced only briefly. Neither the Sydney-based *Art Network* nor the South Australian publication *Artlink*, appeared until 1981. Australian art was represented in international publications intermittently. Alan McCulloch wrote substantial columns for several issues of *Art International*. In the Summer 1970 "Letter from Australia", McCulloch reviewed Leonard French, Sidney Nolan and the 1970 Mildura Sculpture Triennial, illustrating the latter with photographs of a Process Art work by Geoff Brown, a minimal construction by Don Driver, and a heavy-metal sculpture by Robert Parr.[50] Donald Brook contributed occasionally to *Studio International* during the early 1970s. Terry Smith and other members of Art & Language wrote for *Artforum*, but not specifically on Australian art.[51] The dramatic critical interventions of an important new magazine, *Art & Text*, from 1981 onwards, marked a transition to a recognisably 1980s discourse with clearly different and genuinely Cool aspirations, methods and moods. Art magazines, with their coteries of associated artists and writers, were much more important during the 1980s.

OUT THE DOOR: LEAVING THE 1970s

"Moving in crates of art-historical precedence": Form, Content and Recuperation

Ultimately, almost all artists were eventually incorporated into a more traditional order and economy of art whether they liked it or not. Mike Parr, Micky Allan, Virginia Coventry and Jill Orr were amongst the many artists exploring the new art forms in the 1970s who exhibited conventionally made paintings and drawings during the 1980s. Was this an eventual capitulation to more conventional means of self-expression?

I do not think so. However, political awareness in the 1970s often simply linked a partial rejection of commodity status to the expression of radical or feminised content. There was a sometimes confused connection between post-object artists' protective relationship to their intentions, their predominantly phenomenological orientation, and the persistence of the authorial status that insisted on individual texts. There was also relatively little critique of the role of art within culture, despite the work of community artists like Binns, the reassessments offered by the Women's Art Movement, the more conventionally "alternative" posters of the Earthworks Poster Collective and Chips MacKinolty, and the Fluxus-oriented, Wilhelm Reich-influenced performances of Mike Parr. Much of the art that was most radical in its intention – the sort of work that Lucy Lippard described in her 1982 report on Australian alternative art for *The Village Voice* – was determinedly traditional in its form, like Peter Kennedy's banner *November 11, 1975*, 1980-81.[52] Photographs such as Micky Allan's *Yooralla at 20 Past 3*, 1978, or *The Family Room*, 1982, represented one of the most interesting and complex areas of activity in the

1:32

1:33

53 Ian Burn, "Art market, affluence and degradation" [1975], in Amy Baker Sandback (ed.), *Looking Critically: 21 Years of Artforum*, UMI, Ann Arbor, 1984, p. 175.

54 Terry Smith, "Art Criticism/Self Criticism", in Tom McCullough (curator), *6th Mildura Sculpture Exhibition*, p. 5.

1:32 Micky Allan, *Yooralla at 20 Past 3*, 1978, silver gelatin photograph hand-tinted with water-colours and pencils, 27.7 x. 35.2 cm. Courtesy Watters Gallery, Sydney.

1:33 Micky Allan, *The Family Room*, 1982, oil on silver gelatin photograph, 300 x 100 cm. Courtesy Watters Gallery, Sydney.

1:34 Terry Smith and Robert Dixon, *Project for a "Political Art" poster*, 1974-75, mixed media on panel, 4 panels of 80 x 40 cm. This work was exhibited at the 1975 Mildura Sculpture Triennial.

1970s – a diaristic, often community-art oriented activity with strong links to counter- and sub-cultures – yet her choice of photographic means – collage, and hand-tinting with water-colours, oil-paint or pencils, onto silver gelatin prints – were essentially coloured by a feminist-influenced adaptation of previous genres in the history of photography. Aside from a refusal of the photographic community's exclusive demands for finely crafted prints, the most obvious aspect of such work was its attempt to reach a wider audience than the avant-garde and its friends.

Art & Language member Ian Burn argued in 1975 that truly radical art practice amounted to the dissolution of art, artists and authorship. "What can you expect to challenge in the real world with "colour", "edge", "process", systems, modules, etc., as your arguments? Can you be more than a manipulated puppet if these are your 'professional' arguments?"[53]

Burn emphasised the complicity of post-object artists in the perpetuation of a specialised luxury-goods industry. He accused young artists of careerism, of an acceptance of their alienated relationship to power, and of reification of myths about individuality which served to disguise late capitalism's functions. Terry Smith was just as hostile, accusing American minimalist megastars such as Donald Judd of subservience to craft values, Carl Andre of misunderstood Marxism, and Sol LeWitt of decorative formalism. Smith's essay for the 1975 Mildura Sculpture Triennial catalogue was aimed at an Australian audience; he was damning local artists by implication. He emphasised that post-object and conceptual art had not, despite its radical form, dealt with truly political issues: "Moving in crates of art-historical precedence doesn't alter your economic function, your base-structural relationship to your means of production and distribution, your predictability ..."[54]

Conceptual artists were guilty, as Smith observed, of confusing art with life. Frequent

RONALD
FELDMAN
FINE ARTS
INC.

BLUE POLES

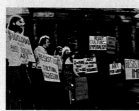

**Politische Plakate von
Klaus Staeck
Edition Staeck
69 Heidelberg
Postfach 471
Tel. 06221/2 47 53**

PROJECTS

complaints about the demand that art be overtly political in its signification testify to the frustration felt by other artists. Of radical 1970s culture, 1980s postmodern cultural theorist Meaghan Morris later remembered:

> a surveillance system so absolute that in the name of the personal-political, every-day life became a site of pure semiosis. And this monitoring system functioned constantly to determine what styles, which gestures, could count as good ("valid", "sound") politics, and which ones could not.[55]

This pervasive political correctness was to be replicated in the 1990s: *plus ça change …*

Out the Door: Do Artists Learn From History?

Did the arrival of New Wave, neo-expressionism and postmodern theory obliterate the 1970s? When Peter Cripps curated "Masterpieces Out of the Seventies: Tyndall; Tillers; Cripps; Nixon; Schoenbaum" at the Monash University Gallery in 1983, he observed wistfully that "Australian Art of the 1970s seems to be a difficult art for historians and one wonders whether it's to be forgotten".[56] With the arrival of neo-expressionism at the start of the 1980s, by contrast, conservative critics rejoiced that art was no longer obliged to wage an avant-garde struggle for ideological purity.

In 1984, Power Institute Professor Virginia Spate published a paper in *Art & Text* called "Whatever Happened to the Seventies?"[57] According to Spate, the rigorous, unassimilable issues raised by 1970s art were threatened by a mudslide of frivolous, latently formalist criticism and art, identified by the extremes of disco-oriented postmodernism and oil-paint dominated neo-expressionism. As Spate pointed out, many neo-expressionist strategies – quotation, parody, juxtaposition and disjunction – were the same forms used by socially critical artists of the 1970s such as the poster collectives with their populist, activist imagery – Redback Graphix, for example – and Micky Allan. Her criticism was directed at the promoters of heroic, usually male painters or imported celebrities like English neo-expressionist painter (and, for several years during the 1980s, Dean of the School of Art at Melbourne's Victorian College of the Arts) John Walker. More obliquely, she was addressing the sidelining of radical 1970s art which, she was aware, had been definitively effected by the discourse of *Art & Text* and its charismatic editor, Paul Taylor. Taylor, more than any other Australian critic, predicted the sea-changes of the 1980s through his understanding of the importance of Andy Warhol's postmodernity and his comprehension of the art world as a spectacle. The celebratory modes of 1970s feminism were swept aside by the postmodern criticism of the new decade.

At its most irresponsible end, the 1980s in Australian art saw the trivialisation of the previous decade's key debates, identifying them with "the past". Post-feminist [*sic*] filmmaker Lezli-Ann Barrett, for example, explained that "I don't want to be possessed by a man and I equally don't want to be possessed by feminism".[58] Most 1980s artists, better than their predecessors, recognised Donald Brook's valedictory 1982 comment on the 1970s: "art, as it is ordinarily conceived, does not have any prompting for social action".[59] Many were excessively eager to affirm the corollary – that institutional art, the art of galleries – had no special political role at all. This perverse aspiration, or its naive opposite, monopolised the 1980s but came into question again in the 1990s. Truly, progress is a myth. In the forest of signs, which is not neatly measured in decades, travellers perpetually reinvent truth.

55 Meaghan Morris, "Politics Now (Anxieties of a petty-bourgeois intellectual)", in her *The Pirate's Fiancée: Feminism, Reading, Post-Modernism*, Verso, London, 1988, p.178.

56 Peter Cripps, catalogue essay, in *Masterpieces Out of the Seventies: Tyndall; Tillers; Cripps; Nixon; Schoenbaum*, Monash University Gallery, Melbourne, 1983, unpaginated.

57 Virginia Spate, "Whatever Happened to the Seventies?", *Art & Text* n.14, Winter 1984, pp. 75-79.

58 Lezli-Ann Barrett, quoted in Deb Verhoeven, "Fostering Festering Feminisms", *Agenda* v.2 n.1, August 1988, p. 23.

59 Donald Brook, "Socially Engaged Art - Nothing Special", *Artlink* v.2 n.2, May/June 1982, p. 9.

Modernism's Afterglow: The Revival of Painting and the Survival of Abstraction

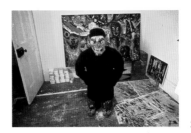

2:1

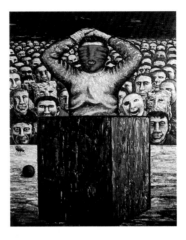

2:2

1 Robert Lindsay, interview with the author, Melbourne, 1987.

2 Patrick McCaughey, "The Transition from Field to Court", in Robert Lindsay (curator), *Field to Figuration*, National Gallery of Victoria, Melbourne, 1987, p.16. During the late 1960s, McCaughey became the chief provincial exponent of American formalist guru Clement Greenberg's theories. After his 1970 New York sojourn he became the influential and much-feared art critic for the Melbourne *Age*. He was the principal spokesman during the 1970s for conservative Colour Field abstractionists such as Sydney Ball and Fred Cress.

Previous page: detail from **2:19**.

2:1 Robert Rooney, *Portrait of Peter Booth #2*, 1978, cibachrome colour photograph, 20 x 30 cm. Courtesy Pinacotheca, Melbourne.

2:2 Peter Booth, *Painting 1981*, 1981, oil on canvas, 244 x 198 cm. Private collection. Courtesy Deutscher Fine Art, Melbourne.

2:3 Peter Booth, *Painting 1982*, 1982, oil on canvas, 197.7 x 274 cm. Collection: Art Gallery of South Australia, Adelaide, A. M. Ragless Bequest Fund. Courtesy Deutscher Fine Art, Melbourne.

SIMULATING HISTORY: SELECTIVE HISTORICAL CONSCIOUSNESS

The disappearance of the past and the simulation of history – both in the mass media and on the overcrowded walls of State galleries – and its replacement by nostalgia in the spectacle of large survey exhibitions is not merely a figure of speech: an accurate history of modern art has largely vanished from the memory of contemporary artists. It is indicated by the cavalier relationship of contemporary artists to their antecedents, and a highly selective historical consciousness. A longing for a lost authenticity (supposedly available during the early period of modern art) is, in Australia, combined with the anamorphic distortion of style created by distance from the international centres of world art.

During the 1980s, art history was raw material available for rewriting. On the one hand, artists and critics made the politics of visual representation the subject of both abstract and figurative contemporary art: this postmodern art is examined in following chapters. On the other hand, painting reappeared in two waves, each time reflecting a nostalgia for modernism: the first was that of neo-expressionism at the start of the decade; the second wave, towards the end of the 1980s, was of a revival of abstraction. The return to expressive painting and the survival of modernist abstraction through the later 1980s into the 1990s mark the stubborn, lingering twilight of an artistic movement – modernism – begun at the turn of the 20th century. Indebted to the example of European modernism, abstract and expressionist art at the periphery of world culture in countries like Australia has always been distinguished by its hybrid character. Australian art is simultaneously richer and less coherent than a mere provincial mirroring of overseas influences and art magazines.

THE RETURN TO PAINTING OF THE EARLY 1980s

Peter Booth, Davida Allen: The Arrival of Neo-expressionism

During the 1970s, painting was regarded as decidedly old-fashioned. Robert Lindsay, then a curator of contemporary art at the National Gallery of Victoria, remembered that the dominant stream of contemporary art seemed to be the "twigs and sand artists" such as Italian artist Mario Merz, who produced evocative *Arte Povera* installations of commonplace objects.[1] Patrick McCaughey later wrote that those artists who persisted with painting during the 1970s reflected the "post-minimal, post-modern kits and devices for making art [that] increasingly became the officially recognised new art of the seventies in Australia".[2]

At the end of the 1970s, painting indebted to the early phases of modernism re-entered the cultural stage. The art was called neo-expressionist; its practitioners, including Peter Booth, Davida Allen and David Larwill, shared the choices of large-scale, highly personal imagery, thick oil paint and a fascination with myth. Whether their paintings were a regressive throwback to European expressionism of the 1920s, or whether they represented the postmodern appropriation – a self-conscious, critical quotation – of such earlier styles, was a matter of heated debate.

Critics and curators such as McCaughey were delighted that the wheel of style had turned; their triumphalism, however, was unsophisticated in the extreme, and linked to conservative agendas of quality. There was absolutely no regional awareness of a neo-

expressionism more sophisticated than that of a simple "return to painting".

In works like *Painting 1977*, 1977, Peter Booth demonstrated some of the earliest experiments with mythic neo-expressionism in an ambiguous but crucial transition zone between modernism and postmodernism. However, there was no constructive critical context for these new figurative paintings of burning cities, haunted men and monstrous animals when they were first shown at Pinacotheca in 1977. Initial responses stressed that Booth's new paintings were career suicide: he had been considered one of Australia's most important artists, painting dark, minimal abstractions that looked like metaphysical doorways. The new pictures were considered neither part of an international trend nor an influence on young artists. Mary Eagle's comments for the *Age* in 1977 typify this sense of dismay: "It takes a brave artist to swing away from an approach which brought him praise early this year as 'Australia's best abstract painter'". She continued, "I don't care at all [for the paintings] but some images are undoubtedly gripping … the gingerbread people and Boydian dogs in the night are completely without concession to the artistry of drawing".[3] Booth's pictures were seen as isolated oddities. Few were aware of the dream-diary sources for his imagery; moreover, dreams, mysticism and cultural myth were relatively unfashionable sources for art at that time. It was only in the wake of trend-setting shows such as the 1980 Venice Biennale and "A New Spirit in Painting" in London during 1981 that such work drew local curatorial attention.[4] Neo-expressionism, in fact, emerged in Australia at the end of the 1970s as a personal stand by independent artists, not as part of the formation of a new orthodoxy. For the subsequent generation emerging from art schools, the neo-expressionism and postmodernity of the 1980s arrived with that decade's tidal waves of art magazines, and exhibitions such as the Sydney Biennales.

The internationally fashionable return to painting at the start of the 1980s meant that previous conceptions of advanced cultural practice – which had seen art as being politically radical and socially committed – were discounted. The 1982 Sydney Biennale introduced a pantheon of "new" foreign painters, including Lupertz, Paladino, Chia and Clemente. The Biennale also resurrected international father figures such as America's Phillip Guston, who had dramatically returned to an abrasive, home-made figuration after a respected career as an Abstract Expressionist during the 1960s, and Frank Auerbach, the English artist whose impastoed canvases of London life were rediscovered by international critics. Institutions and collectors in Australia, the United States and Europe were extremely supportive of painters like Chia, Clemente, Paladino and Kiefer, with the major art museums of Australia – including Sydney's Power Institute (later to become the Museum of Contemporary Art) – acquiring, from the early 1980s onwards, representative collections of the Italian *transavantgarde* and German neo-expressionism. The new painting was still regarded somewhat defensively, however. The 1982 Biennale's director, curator William Wright, hedged his bets, offering an equivocal opinion that the movement seemed both liberating and regressive: whether the new style was significant was a question "that hardly can be resolved".[5] And, as Robert Lindsay despairingly noted in 1987 at a forum called "Taste-makers for Posterity": "The thing is: which movements are the most important?"[6] The imagery of excessive self-confidence and bombastic rhetoric should not have been mistaken for naivety or real expressivity, even though in the rushed moment of its Antipodean dissemination, neo-expressionist or *transavantgarde* art was projected as a return to self-expression.

3 Mary Eagle, "Art: Newey's Coloured All-Sorts", *The Age*, November 9, 1977, p. 2.

4 In hindsight, one can see that major neo-expressionist artists like Anselm Kiefer and George Baselitz had exhibited consistently all through the 1970s, even though Kiefer, for example, was not incorporated in a major European survey show until 1977. German painter A. R. Penck was included in the 1979 Biennale of Sydney, yet according to both Paul Taylor and Robert Lindsay his works were not then given particular notice in Australia by either critics or curators. Such reactions were modified as a result of the arrival of the *transavantgarde* and its emphasis on the public spectacle of subjectivity.

5 William Wright, "Director's Statement", in *Vision in Disbelief: 4th Biennale of Sydney*, Art Gallery of NSW, Sydney, 1982, p.11.

6 Robert Lindsay, "Tastemakers for Posterity", seminar, Australian Centre for Contemporary Art, April 22, 1987, author's notes.

2:4 Davida Allen, *Figure No. 4*, 1979 oil on masonite with collage board, 167.5 x 115.5 cm. Collection: University Art Museum, University of Queensland, Brisbane. Courtesy Australian Galleries, Melbourne.

In the United States, these pictures encountered considerable critical resistance; in Australia they also met with great hostility from postmodern critics like *Art & Text*'s editor, Paul Taylor, who penned a furiously angry essay titled "Angst in My Pants".[7] Critics accused painters such as Chia and Booth of forced childishness, accusing them of reactionary appropriation directed by market-driven values and characterised by the glamorous context of an art-market boom, fashion-magazine coverage of artists' lifestyle excesses, SoHo loft-living, and the lionisation of New York art dealers like Mary Boone. Paul Taylor asserted that the marginalisation of advanced art was a real possibility, evidenced in the removal of acerbic Melbourne critic and painter Robert Rooney from the position of Melbourne *Age* art critic.[8] Neo-expressionist artists would suffer a considerable critical eclipse from the late 1980s onwards in a reaction against the artists' uncritical over-production and as the tidal wave of a return to painting subsided, certain attitudes were inevitably left stranded. Davida Allen's reputation, for example, was irreversibly hijacked by weekend-newspaper journalism. Allen's paintings were about her private life as a mother of several children and her stereotypical role as the crazy housewife-who-paints. She attracted considerable media attention, as if it was a miracle that a WASP housewife could be an artist – an occupation usually reserved for more bohemian players. She was, above all, a stereotypically autobiographical artist: painting like the most macho of neo-expressionists, she blocked out isolated, full-frontal figures in swathes of oil paint over thick fields of colour. Comic and satiric qualities, along with her cartoon-like illustration of dependency and sexuality (in her paintings of actor Sam Neill, for example), were easily overlooked in favour of an affirmative naivety.

The link between brushy rhetoric and autobiography was by the later 1980s such a cliché that artists who wished to demonstrate their awareness of the Self's erasure were expected to work clinically; confirming that the categories of wild, visionary and spectral were now *passé*. When the Art Gallery of South Australia imported an exhibition of German neo-expressionist painting for the 1986 Adelaide Festival, it was a little too late.

Salons for New Art: Roar Studios, 200 Gertrude Street

One group of young artists just out of college – the Roar Studios group, which included David Larwill, Judi Singleton and Sarah Faulkner – adopted a wildly eclectic modernism in keeping with the gritty bohemianism of their post-war School of Paris and COBRA models which were the thick, wildly impastoed, often whimsical paintings by artists such as Karel Appel. Roar Studios, in inner-suburban Melbourne, was the most notorious example of artist-run spaces during the early to mid-1980s. The Roar artists worked in a conservative, neo-expressionist idiom that was in itself never marginal: their intention was to exhibit their work without the constraints of curators' definitions and dealers' programs – outside the possible limitations of market forces but not outside the market. The bohemian, larrikin Roar artists were controversial only because they moved outside accepted channels of apprenticeship and patronage.

Another direction, which retrospectively seems more prophetic of international art's celebration of the commodity status of art in the late 1980s, was represented by an exhibition at the NGV in the summer of 1982 – Paul Taylor's "Popism" – which was based on postmodern theories of cultural appropriation, the elimination of divisions between "high" and "low" art, and image-scavenging. The show included already established artists such as Robert Rooney, and a collection of younger artists such as Maria Kozic

7 Paul Taylor, "Angst in my pants", *Art & Text* n.7, Spring 1982, pp. 48-60.

8 Paul Taylor, "Angst in my pants", *Art & Text* n.7. Rooney was replaced by academic Memory Holloway; she was eventually succeeded (in a peaceful hand-over) by poet Gary Catalano. Both writers were highly sympathetic to the new painting. Rooney subsequently became the *Australian*'s Melbourne art critic.

2:4

and Howard Arkley. Local theorists, especially those based in Sydney, had already judged that expressionist intentions and the manicured roughness of neo-expressionist paint-work precluded artistic and intellectual literacy. *Art & Text* wielded the tools of discourse with a verve and energy that recalled Clement Greenberg's critical axe 15 years before. Local neo-expressionism fell outside the rules limiting the acceptable content for postmodern painting: flaming landscapes and crazy dogs seemed to lack the necessary criticality.

A shift in the production and reception of art took place in the mid-1980s. In 1985 a Melbourne salon for emerging figurative and neo-expressionist painters was established at 200 Gertrude Street, Fitzroy – a few blocks from Roar Studios. 200 Gertrude Street generated intense interest, reflected in packed openings spilling onto the grimy pavements outside. The gallery and studio complex was the most important venue in the city for new (but not "raw") painters. Director Louise Neri and her selection committees carefully picked exhibiting and studio artists from the cream of Melbourne's art schools, thus defining their gallery against the unruly menagerie at Roar, which was based on collective membership that anyone could join.[9]

By 1985 the course art would take in the later 1980s was reasonably clear. The Australian art community – artists, critics, curators and gallery-goers – was more knowing, sophisticated and enthusiastic than in the 1970s. Important and innovative figurative painting had been absorbed into a conservative mainstream that produced very little work of real interest and in which the contradictory demands of internationalism, local identity and parochial patronage uneasily coexisted. The tension produced by the arbitration of quality in small fiefdoms, and the attempt to synthesise a nascent late modernism with postmodernism haunts Melbourne's art scene, and to a lesser degree that of other Australian centres, to this day.

THE SURVIVAL OF ABSTRACTION: IRONIC MINIMALISM

Dale Hickey: Illusionist Conceptualism

The paintings of Dale Hickey, Robert Hunter and Robert Rooney reflect a relationship to abstraction as least as distanced and self-conscious as that of younger "abstract" artists such as Paul Boston, Janet Burchill and Scott Redford, who all came to public attention in the later 1980s. A particular type of illusionism, disrupting the all-overness of so-called "advanced" abstract painting and existing in an uneasy relationship to doctrinaire formalism, distinguishes the work of these Australian painters, who first exhibited during the later 1960s and early 1970s, from their more conventional peers of the same period, artists such as David Aspden or Fred Cress. The ironic, reflexive minimalism of Hickey, Hunter and Rooney had much more in common with the post-object art of the 1970s. This emphasis was confirmed in the late 1960s by contact and co-operation with members of conceptual art collectives, including Art & Language.

Pinacotheca Gallery, the vast Richmond space in which their work was exhibited from the 1970 inaugural show onwards, was the centre of an extraordinarily disciplined Melbourne avant-garde. However, the artists of the Pinacotheca group were also familiar with the local tradition of modernist abstraction and aware, for example, of George Johnson's neglected geometric abstractions.[10] Figurative allusions informed the Pinacotheca artists' work, disrupting the appearance of highly accomplished Post-Painterly Abstraction. Their pictures even contradicted American critic Rosalind Krauss's asser-

9 Despite their flair for publicity, the Roar artists were able to by-pass such processes, yet still achieved considerable curatorial support outside Melbourne, for example, from James Mollison, then Director of the Australian National Gallery in Canberra; they represented a different, self-expressive and more bohemian idea of advanced art.

10 Author's interviews with Robert Rooney, Melbourne, October-November 1989. Johnson, an almost forgotten figure, showed his constructivist, iconic abstractions at the Charles Nodrum Gallery in Richmond during the later 1980s.

2:5 Dale Hickey, *Passion*, 1993, oil and enamel on canvas, 183 x 183 cm. Courtesy Robert Lindsay Gallery, Melbourne.

2:6 Dale Hickey, *Burst*, 1991, pastel on paper, 27 x 37 cm. Courtesy Robert Lindsay Gallery, Melbourne.

2:5

2:6

tion, at the time, that serial painting obliterated the aura of a work of art.

In 1970 Dale Hickey photographed 90 white walls and arranged the prints in a wooden box with index cards. *90 White Walls*, 1970, shows the idiosyncratic effects of Hickey's early contact with conceptual art. For Hickey, *90 White Walls* was a step in a two-decade transition – through an about-turn in the mid-1970s, when he painted Morandi-like suburban landscapes and the cup paintings described in the last chapter, to a series of studio interiors repeated through the 1980s. In these later paintings, easels and trestle tables were silhouetted against disturbingly opaque, glossy paint which cancelled deep space, returning the eye to the pictures' surfaces and subjects. Heavily outlined studio debris inhabited gaps in an impenetrable liquid zone of house enamel and bituminous black.

Hickey's exhibitions of the late 1980s and early 1990s were an examination of the processes of abstract painting through all its manifestations during Hickey's own contradictory career. The works were a literal-minded re-viewing of his paintings over the 30 years he had exhibited. Most of the 100 oil pastels in his 1990 Melbourne show were of one subject only: a painting against a shining white studio wall, above a sketchily drawn brown floor on which were scattered signs of activity – cans and brushes. Hickey's cursory rendering of shadows established a sparse illusionist description of space. His laconic titles underlined a cancellation of meaning, which had always been taken as the

sign of his existential denial of the real. The imaginary paintings within the drawings were fictional. They resembled works the artist might conceivably have completed years ago, during the 1960s, and followed the groupings of subjects that he explored: introspective examinations of mathematical proportions and signs, symbols, cups, landscapes and tables. The picture in *Dialogue (5A)*, 1991, alluded to Hickey's large abstract paintings during 1967-68, in which repetitive patterns based on air vents, quilts and sound baffles were repeated across the canvas like minimalist wallpaper. The abstraction within *Burst*, 1991, as well, existed in a particularly ambivalent relationship to the real, historical pictures that preceded it.

Hickey's abstraction was deliberately matter-of-fact. Just as the drawings and paintings simultaneously defied entry and speculation, they also constructed the subject as an inmate of the prison-house of language and his own art history, and posed themselves, for example in an almost unreadable large monochrome, *Passion*, 1993, as puzzles or theorems – in this case the *trompe l'oeil* of a black square with painted cast shadows posing as the painting of a painting. The conflicting claims of painting's ability to represent were enumerated in different styles and by the depiction of work and industry – thus the artist's emphasis on tools of measurement, paintbrushes and empty cans.

From the perspective of *90 White Walls'* clearly signalled conceptualism, it was obvious that Hickey had continually been aware of the arbitrary, mediated nature of visual signs. The vocabulary of his figuration since the early 1970s had therefore been a meta-language, rather like scientific formulae. In later exhibitions, Hickey's refusal to depict himself even indirectly suggested an art of deflection by a painter who had eliminated the signs of agitation and accentuated all evidence of inactivity: a refusal of the

2:7 Robert Rooney, *Variations Slippery Seal II*, 1967, synthetic polymer paint on canvas, 106.7 x 106.7 cm. Collection: Bruce Pollard. Courtesy Pinacotheca, Melbourne.

2:8 Robert Rooney, *After Colonial Cubism*, 1993, acrylic on canvas, 122 x 198 cm. Courtesy Pinacotheca, Melbourne.

2:7

2:8

traditional signs of "expression". Since they showed rather than told, Hickey's later paintings and drawings "ironised" the truth of representation.

Robert Rooney: Things

Dale Hickey's illusionist shadows turned pseudo-industrial grids and grilles into abstract patterns. Robert Rooney transformed equally banal sources such as the knitting patterns used as the origins of his Superknit paintings of 1969-70. Rooney's sophisticated paintings systematically eliminated almost everything except clichés and content; his formal methods were so rigorous that they allowed almost nothing other than an excess of contradictory clues.

Rooney reinvented himself several times after he first exhibited in 1960. He reincarnated as Francis Bacon, as an experimental musician, as one of the most important minimal painters of "The Field" in 1968, as a conceptual artist, as an accomplished portrait-photographer during the later 1970s and, finally, as critic Paul Taylor's exemplary "Popist" painter. Rooney's serial rhetoric, combined with deadpan, anarchic wit, intersected with a reputation for visual austerity so completely that he remained the most misunderstood artist of his generation. Greenberg's ghost still walks where art conforms to standards; Rooney's simultaneous refusal to play the painter, his anamorphic distortion of nostalgia and his rejection of a socially critical paradigm, explain an almost dysfunctional undervaluation of his work.

Rooney's paintings were confessional for two reasons. Firstly, their means were so sparse that they seemed too thin to bear the weight of their literary content. Flatly rendered, with minimal traces of expressive inflection and no reference to the now-familiar technocratic absence of aura, his hand-painted acrylic surfaces neither took advantage

of mechanical reproduction's necrophilic glamour, nor did they inscribe the recognisable signs of conventional subjectivity. Secondly, the symbolism of Rooney's paintings was at the same time hermetic, autobiographical and ordinary to the point of banality. Just as the well-known Superknit paintings were derived from knitting patterns but posed themselves as sombre serial abstractions, so the paintings of the later 1980s and early 1990s, the Infant Abstractions, for example, were alarmingly literal translations of abstract drawings Rooney made in high school. Others (the In Storyland paintings) were simplified, flattened versions of story-book illustrations for small children. *After Colonial Cubism*, 1993, perfectly demonstrated postcolonialism's perversion of modernism. Suburban perspectives were fractured by arbitrary division into a vorticist explosion of elegant, designer colours. The stylistically contrary signs of Synthetic Cubism (such as the conventionalised marks standing in for texture, and wandering black lines crossing spatial transitions) were undermined by a deliberate schoolroom academicism. The grey and black planes at the edge of the painting were replaced, as in a pure design exercise, with yellow and orange shapes at the picture's centre. The images' complicated origins emphasised the lengths to which Rooney went to render meaning opaque. Understanding his sources was no help at all, because of a third-degree irony that neutralised the nostalgia of 1950s references. Rooney's 1990s paintings demonstrated that his true antecedents were artist-librarians such as Marcel Broodthaers, and that his art was profoundly sensual and iconic.

Retrospectively, Melbourne minimalism – which included the works of Rooney, Hickey and others – seems weirder and weirder. This suggests that critical discussions about grids should have been replaced long ago, remembering the artists' autodidact readings and sophistication, by more literary inquisitions into the grotesque. The abstraction of these pictures existed in a particularly ambivalent relationship to late-modernist paintings, especially the Post-Painterly Abstraction such as that of Kenneth Noland, seen in the 1967 exhibition, "Two Decades of American Painting", at the National Gallery of Victoria.[11] Both Rooney and Hickey were always alert to the arbitrary, mediated nature of visual signs. The vocabulary of late-modernist abstraction in Melbourne, from the late 1960s onwards, was often a meta-language where representation and abstraction were satirically and certainly presciently juxtaposed.

THE SURVIVAL OF ABSTRACTION: TRANSCENDENTAL ABSTRACTION

Janenne Eaton: Austerity and Openness

A second, easily recognised, version of abstraction during the 1980s was characterised by iconic, symmetrical formats, an elimination of gestural brushwork, a reduction in colour values towards the monochromatic, and a rhetoric that emphasised, sometimes to the point of kitsch, the transcendental and the sublime. This type of painting was represented by artists such as Paul Boston, Rod McRae, James Clayden and Janenne Eaton. It was originally associated with the Tony Oliver, Verity Street and Pinacotheca galleries in Melbourne and Watters Gallery in Sydney, and later with Melbourne's Niagara Galleries.

In the mid-1980s, Janenne Eaton looked like yet another painter recycling images under the loose guise of a feminist reformulation of art history. In a major Sydney survey exhibition at that time, the 1986 Perspecta, she showed a painting modelled on Gau-

11 Like most Australian artists, Rooney and Hickey saw the exhibition "Two Decades of American Painting", curated by Waldo Rasmussen of the Museum of Modern Art, New York, which toured to the National Gallery of Victoria and the Art Gallery of New South Wales in 1967. The impact of this show is widely acknowledged. For example, see Margaret Plant, "Dale Hickey", in Margaret Rich (curator), *Dale Hickey*, City of Ballaarat Fine Art Gallery, Ballarat, 1988, p. 2.

2:9

2:9 Janenne Eaton, *Untitled*, 1993, electronic resistors and oil on canvas, 198 x 165 cm. Collection: National Gallery of Australia, Canberra. Courtesy the artist.

2:10 Janenne Eaton, *Sing the sailors*, 1990, oil on canvas, 232 x 174 cm. Private collection. Courtesy the artist.

2:12

2:13

guin's *Manao Tapapau*. Instead of the Tahitian girl lying on a bed, Eaton substituted a bound and gagged woman, watched from suburban Venetian blinds by a "spirit figure" drawn from a newspaper photograph of a Russian soldier in a gas mask. The most memorable feature of this painting was neither its play with then-fashionable tropes of the viewer's gaze, nor its choice of quotation, but the painter's stubborn, chalky technique. Contemplating the work was like looking at an inversion of American neo-expressionist painter Eric Fischl's *Bad Boy*, 1981. What appeared then as enigmatic open-ended narrative, proved with the hindsight prompted by her more recent large abstract canvases, and specifically those of the early 1990s dealing with Australia's convict past, to be a genuine fascination with the spirits of the dead. Irony was a passing phase.

Her paintings looked like 1960s British Op artist Bridget Riley meets American mystic minimalist painter Agnes Martin – an accurate assessment of Eaton's priorities. *Sing the sailors*, 1990, was an arrangement of repeated rows of monochromatic, moody greys resembling curtain folds. Backlit and graduated in tonal transition to white light, the forms could have been cellular structures or early minimal painting gone Tantric. Eaton escaped backwards from postmodernity towards the deceptive simplicity of iconic minimal abstraction. She refined single metaphoric images that hovered between nonobjectivity and an austere landscape of vacant openness. Like Agnes Martin, her impulse was towards the transcendental. During the late 1970s, Eaton spent time as an archaeologist in the "nowhere" of outback Western Australia; the psychological charge she discerned at night in that landscape appeared in her Canberra works of the late 1980s and early 1990s as an enforced, even violent, monastic dumbness.

Eaton's work required an understanding of the process of the mind of a believer who found the world's character inexplicable by any theory other than the psychic. This seemed an unnecessarily perverse complication of painting, but Eaton was clearly impelled to explain the world to herself, and was troubled by its disorder. In *Breaker*, 1989, black-on-black rectangles were edged by shafts of white paint. These framed a central image in which the artist's transcendental folds faded upwards into white blankness. *Breaker* was saved from the dual extremes of grandiosity and preciousness by the artist's hand-made geometry. Her irregular measurements, broken lines and imperfect tonal shifts constantly returned the viewer to the painting's surface. Attention wandered across and back into a picture space rather like the warp and woof of woven fabric; the travelling eye avoided the predictable strait-jacket of architectonic form. Eaton was interested in the experience implied in her shallow picture space, in the same way that a portraitist is interested in the character of a face. Her walls of light codified this attitude, and the resulting sense that there was more to her paintings than simple-minded form or equally obvious metaphysics was the key to their fascination. Her abstraction scrupulously respected its historical limits, foregoing both a neo-expressionist rhetoric of the expressive mark and the postmodern knowingness of style revisited in favour of a gradually evolving postcolonial awareness.

Paul Boston and Rod McRae: Sign Systems and Mixed Metaphors

Paul Boston's early experiences with Buddhism are persistently mentioned; as if "spirituality" explains his paintings and reliefs. Boston graduated from the Preston Institute in 1972. He lived in South East Asia and Japan for three years and, in 1980, he visited America and Europe. In the United States, Boston saw a Philip Guston retrospective at

2:11 Paul Boston, *Man in a Landscape I*, 1983, mixed media. Courtesy Niagara Galleries, Melbourne and Annandale Galleries, Sydney.

2:12 Paul Boston, *Untitled*, 1985, ink and charcoal on paper. Courtesy Niagara Galleries, Melbourne and Annandale Galleries, Sydney.

2:13 Paul Boston, *Painting No. 3*, 1991, oil on linen. Collection: National Gallery of Victoria, Melbourne. Courtesy Niagara Galleries, Melbourne and Annandale Galleries, Sydney.

12 Christopher Heathcote, "Concerning the Spiritual in Art", *Art Monthly* n.28, March 1990, p. 13.

13 Paul Boston, in unpublished interview with Ashley Crawford, 1989.

14 Paul Boston, in unpublished interview with Ashley Crawford, 1989.

15 Paul Boston, in unpublished interview with Ashley Crawford, 1989.

2:14 Rod McRae, *Pale Waters Still,* 1987, oil on canvas, 165 x 205 cm. Collection: Bruce Pollard.

2:14

the San Francisco Museum of Contemporary Art, and the rough-hewn figuration of Guston's later paintings profoundly affected the course of his work. Irresistibly metaphoric and suggestive, the paintings that he produced over the following decade were usually associated with transcendental values because of Boston's stubborn repetition and revision of unitary iconic images and abbreviated fields of void-like openness.[12] A number of recurring, easily recognisable figurative motifs appeared – lamps, candles, ships and the human head. These deliberately hermetic, monochrome paintings attracted considerable attention.

Sign systems other than writing, such as directories and road signs, were important as models to explain Boston's works. Other new abstractionists, such as Melbourne artist Elizabeth Newman, attempted to subvert the same tropes valued by Boston and Eaton in deliberately mismanaged pastiches of Abstract Expressionist painters such as Mark Rothko. In Boston's collections of symbols, the head was significant as the receptacle of thought. This emphasis on the symbolic was identified with profundity, as were painterly, impastoed monochromes and tonally ambiguous figure-ground relationships. Boston, however, was more complex than a naive transcendental abstractionist. He did not appear to be particularly interested in portrayals of a sublime absolute, noting that "It's like a reconciliation of contradiction and using that as a basic method to get to the point where *nothing* really exists".[13] Like all Boston's works, *Painting No. 3*, 1991, presented viewers with an accomplished formalist abstraction destabilised by cryptic figurative references. His calculated cultivation of the ambiguous in painting was like a cartoonist's loving caricature of contemporary art. His interest in the cancellation of signification was both poetic and conceptual. For Boston, his painting "works as a vehicle for cancellation in a total way – you've got nowhere to move if it works right ... it stops the mind".[14] He also asserted in 1989 that:

> In my most grandiose of moods I think that a great painting in the vein of the work that I am doing would be like a hole in meaning, would be like a hole in the world, would be like ... everything else is reading very clearly and exactly, but this thing is unreadable, but engaging.[15]

Boston's abstraction was synthetic – an amalgam of cues and clues. They were similar to the complicated, labyrinthine monochromes of Rod McRae, whose large paintings demanded at one moment to be read as an aerial view of fantastic rocky landscapes and at another coalesced into ghosts from a medical textbook floating in a shallow cubist space. His pictures, like those of Janenne Eaton and Paul Boston, often hovered on the edge of simplified figuration and made use of conventional signs and symbols instead of assuming the formal operation of a "language of abstraction". All these artists' early 1990s exhibitions demonstrated the involuntary tendency of Melbourne painters to project a landscape-derived romanticism into their dialogues. Their work was also far from unsophisticated, displaying an awareness, through a cultivated ambiguity and artificiality, of the world of gallery openings and art magazines. Neo-conceptual artists had noted abstraction's particular affinity with this complicity: abstract art was not subversive in itself. It was just as easily complicit with, and involved in the same operations as, all elite culture. The signs of sincerity were the same as those of deception. Boston, McRae and Eaton, like their American contemporary Ross Bleckner, were interested in the ambiguities inherent in an overtly "morally serious" abstraction.

The Revival of Modernism in the Late 1980s: The New Abstraction

The persistent impulse to revive early modernism's charismatic idealism reappeared in the later 1980s as a rehabilitation of abstract painting. The new abstraction was presented by young artists and curators as a somehow "resistant" and socially aware artistic idiom. It thus represented the revival of early-modernist attitudes towards non-objective art, which envisaged an artistic language capable of communicating transcendent truths unmediated by social codes. This revival was potentially incompatible with both the postmodern art scene of the 1980s and the lingering legacy of 1970s art, for it represented something else altogether: the survival of avant-garde longings for social relevance and engagement. There appeared to be, at first sight, a vast difference between self-consciously postmodern art (the art described in the next chapters) and neo-modernist abstraction. This abstraction attempted to synthesise contemporary postmodern awareness and avant-garde rhetoric.[16]

Alternative spaces, founded by young artists in Sydney, Melbourne and Brisbane, provided a focus almost exclusively for abstract painters who owed a considerable artistic debt to painter John Nixon (whose mid-1970s installation, *Blast*, was discussed in the last chapter). Nixon's art was pivotal in the formation of the new abstraction that appeared in Australian alternative spaces; many younger artists were affected by his example, both through his teaching and through identification with his strategic rejections and alliances with commercial and institutional galleries, including his work at the Institute of Modern Art in Brisbane. Throughout his career, after graduation from Melbourne's National Gallery School in 1970, Nixon attempted to directly control the interpretation of his non-objective paintings and installations. In the mid-1970s he initiated Art Projects, a highly significant alternative gallery in a run-down office building on Melbourne's Lonsdale Street that exhibited a wide range of non-commercial works by artists as diverse as Peter Tyndall, John Davis, Bonita Ely, Jenny Watson and Nixon himself. Tireless in his activity as exhibition organiser and self-publicist, he continued to be a role-model for a newer conception of the impresario artist.

The establishment late in the decade of active, artist-controlled exhibition spaces in Sydney and Melbourne, as well as a desire by some younger artists to define themselves against the recent past through non-objective works, reflected Nixon's aesthetic and entrepreneurial influence. Melbourne's Store 5 was initially set up by young Melbourne artists Melinda Harper and Gary Wilson in order to show and promote the work of recent graduates from Melbourne art schools – primarily from the Victorian College of the Arts and from Victoria College, Prahran. Operating on a tiny budget from a small store-room off a dilapidated warehouse courtyard, Store 5 opened each week for a few hours, with a new show every Saturday afternoon. Many younger painters had been attracted by cheap rents and their slightly seedy ambience to such dusty, decrepit spaces above shops along the adjacent Chapel Street, Prahran. Store 5 was one of a group of initiatives taken by art students in the late 1980s in Melbourne; another was Supporting Women Image Makers (SWIM) – a feminist discussion group originating at Prahran College. With a considerable sense of disenfranchisement, these artists realised that their slightly older peers' easy experience gaining gallery representation would not be repeated, that women would continue to find establishment of an artistic career more difficult than men, and that the boom in collecting art by young artists was winding down. This dissatisfaction was not altogether warranted: from graduation, the Store 5

16 Such reconciliations were inevitably riddled with contradictions. During the mid-1980s, for example, similar efforts by New York "Neo-Geo" abstract painters such as Peter Halley and Philip Taaffe were immediately and critically interrogated by suspicious writers such as Thomas Crow and Yves-Alain Bois. See Yve-Alain Bois, "Painting: The Task of Mourning", in David Joselit and Elisabeth Sussman (eds.), *Endgame: Reference and Simulation in Recent Painting and Sculpture,* Institute of Contemporary Art, Boston, 1987, pp. 29-50. Neo-Geo painting's claims to difference rested on its simulation and parodic intentions; Crow and Bois, however, judged Neo-Geo to be merely pastiche. In 1988, Melbourne curator Juliana Engberg expressed her relief that Australian art seemed to have been spared an invasion of Neo-Geo painting. See Juliana Engberg, discussion during the seminar "The Concept of Avant-Garde: From the Modern to the Postmodern", quoted in *The present and recent past of Australian art and criticism,* special supplement, *Agenda* n.2, p. 26. By 1994, however, the success and belated proliferation of local exponents of similar painting was so complete as to represent a new orthodoxy.

2:15

17 The new abstractionists defined them-
selves quite simply. The commentary surround-
ing their work was largely written by the artists'
friends, themselves, or by curators eager to
establish the painters' importance. Therefore,
it was supportive, uncritical and reflected the
artists' own perception of their work and its
significance. The Store 5 artists were intensely
serious, even when they employed parodic
visual images. They defined themselves as
excluded from the "art establishment", assert-
ing their vanguard role and seeking to estab-
lish a "socially critical" role for art. According
to 200 Gertrude Street Director Rose Lang, an

artists received considerable support, in the form of inclusion in curated group shows, from the directors at the George Paton Gallery and their associated journal, *Agenda*. The paintings from Store 5 found early acceptance at 200 Gertrude Street and space was readily made available, initially in an exhibition called "Resistance", curated by Melinda Harper in 1989.

In Sydney, First Draft West provided a similar focus. This gallery was the successor to First Draft, which had been founded in 1987 in a shop-front on Sydney's busy Parramatta Road, in Chippendale. The co-Directors of First Draft West initially included Narelle Jubelin and, later, Justin Trendall and Helga Groves. First Draft West was surrounded by used-car yards and was at first quite isolated, except for the Mori Gallery further out at Leichhardt, from the city's main gallery district in Paddington. First Draft West had a similar but slightly more heterodox exhibition policy to Store 5, and some members of the Melbourne group also exhibited with First Draft West. Many of the young Sydney artists were painters, working with similar small, systematic, serial formats to the young Melbourne abstractionists.

Underlying the formation of these spaces was a recurrence of the periodic upheavals in which young artists attempted to side-step the Establishment. The new abstractionists wished to establish reputations on their own terms.[17] They also believed – whether cyni-cally or not – that their serial, roughly-made hermetic work necessitated, in the cryptic words of one supporter, "the frequent and sustained exposure required for project-based practice in the existing system".[18] In other words, the neo-modernist artists wished to avoid the usual long gallery lead-times between planning and exhibition. They also wished to minimise, by short exhibition periods, the interval between different artists' exhibitions and thus, most importantly, maximise the sense of a committed self-perceived avant-garde grouping of young artists – a warehouse Bohemia. Critics stressed the self-consciously workman-like, humble, often awkward manufacture of the new

2:16

early supporter, the abstract painting of the Store 5 group was, by virtue of its imputed difficulty, severity, austerity and seriousness, somehow "resistant". Of course, this severity did not prevent the artists' easy and fast incorporation into the most entrepreneurial and energetic commercial galleries in Melbourne and Sydney.

18 Rose Lang, catalogue essay, *Language, Faith and Possibilities*, 200 Gertrude Street Artists Space, Melbourne, 1990, unpaginated.

19 Natalie King (curator), *The Sub.vêr'sive Stitch*, Monash University Gallery, Melbourne, September 1991, p. 6.
Lesley Dumbrell was a formalist painter of large, highly accomplished decorative abstractions who came to critical attention in the early 1970s. Her trademarks were small Op Art-like bars, arranged in repetitive patterns across uninflected grounds of bright saturated colour.

20 Rose Lang, *Language, Faith and Possibilities*.

2:17

2:15 Stephen Bram, *Untitled*, 1993, oil on canvas, 40.5 x 30.5 cm. Courtesy Anna Schwartz Gallery, Melbourne.

2:16 Constanze Zikos, *Your Lifetime Icon x 6*, 1992, enamel on laminex, 150 x 320 cm. Collection: Art Gallery of New South Wales, Sydney. Photograph: Kenneth Pleban. Courtesy the artist.

2:17 Debra Dawes, *Gingham (Grey)*, 1991, oil on canvas, 60 x 150 cm. Photo: Kalev Maevali. Courtesy Robert Lindsay Gallery, Melbourne.

2:18 Debra Dawes, *Large Verticals #s 8, 9*, from the Houndstooth series (installation view), 1991, oil on canvas, each 180 x 120 cm. Photograph: Kalev Maevali. Courtesy Robert Lindsay Gallery, Melbourne.

2:18

abstraction, noting its links with craft genres. Since much Store 5 abstraction, such as Anne-Marie May's repetitive panel of sewn fabric, *Untitled (Constructions of Grey Rays)*, 1991, emphasised labour and materials, critics drew affinities with the Women's Art Movement's interest in embroidery and quilts during the 1970s. From this perspective, May was like a latter-day Lesley Dumbrell, producing small but labour-intensive works, though avoiding the shimmering opticality of Dumbrell's decorative abstractions in favour of domestically-scaled work with a "subversive stitch".[19] Common fabrics and textile techniques thus parodied and mimicked the lofty forms of modernist abstraction. Other younger abstractionists similarly felt that mimicry possessed an anti-authoritarian quality. For example, Elizabeth Newman wrote cryptic inscriptions across under-sized Colour Field paintings. Newman and Angela Brennan, both Melbourne artists, mimicked the apolitical formalism of the 1960s, turning its grand gestures into thrift-shop fashion.

The desire to establish differences extended to postmodern painting. Rose Lang, speaking on behalf of the Store 5 artists, characterised postmodern painting as "elegant revelations of a deathly nihilism".[20] According to Lang, younger abstract painters were repelled by the melancholic language and slick, easily marketable styles of 1980s postmodernism, presumably implying that the young abstract painters represented a reaction against theoretically inclined artists like Imants Tillers (whose work is examined in the next chapter). However, such artists – most notably Tony Clark – were much admired mentors of the Store 5 artists. Given the radical examinations of art, museums and commodification by slightly older postmodern artists such as Clark, the program of the Store 5/First Draft group suggested a considerable degree of either naivety or neo-conservative nostalgia. Natalie King, another young curator closely identified with the group, noted that although the new abstractionists publicly resisted the romantic view of abstraction as a privileged site of pure meaning, untrammelled by materiality or technique, they also exhibited a conflicting fascination with that same ideology and its austere romanticism. Neo-modernist abstraction, in fact, was profoundly contradictory, assuming that there was such a thing as an *a priori* "language of abstraction" uncontaminated by the (presumably different) *a priori* truths they despised. The new abstractionists explored, almost in spite of themselves, signifying practices at the borderline between figuration and abstraction, treating abstract painting as a period style, available for fashionable revival like cover versions in the mass culture pop-music industry. They thus demonstrated clear affinities with the work of the older postmodern artists mentioned before.

2:19

The validity of the idea of "resistance" and "subversion", embodied in relatively small-scale abstract paintings exhibited to a very small audience, remained untested by most critics, who simply repeated the artists' claims. The distinctions between the most thoughtful of the new abstractionists and their modernist and postmodernist antecedents was in fact more generational than stylistic; Stephen Bram, Debra Dawes and Constanze Zikos produced paintings that had the same sophisticated, ironic minimalism as those of Robert Rooney and Dale Hickey. Zikos' formalist abstractions, such as *Your Lifetime Icon x 6*, 1992, were made from kitchen laminex; Rooney had based a late 1960s series on breakfast cereal packets. Dawes' pictures, like Hickey's, were both geometric abstractions and second-order critiques, lovingly executed, of historically distant styles. All these artists' works were based on systems and structures so familiar that they could not be read as anything other than clichés: squares; horizontal sections; or asymmetrical divisions of a vertical rectangle. The younger artists' detachment from their antecedents was symptomatic of the widening gulf between contemporary abstraction and its sources.

On the one hand, Dawes' black and white rectangles and Zikos' laminex simulacra of Colour Field painting offered themselves as objects of self-sufficient contemplation. Zikos' *Your Lifetime Icon x 6* resisted simple appreciation and, in its colour-saturated blankness, allowed a state of bodily awareness similar to the experience of minimal art. On the other hand, this contemplative intention was subverted by the particularly self-conscious character of its manufacture from household laminex. Dawes' *Large Verticals #s 8, 9,* 1991, exhibited a double allegiance: all the pleasures of a detailed inspection of truly sensuous paintwork and the rigour of a serial installation's minimal imagery. The artist's large rectangles of black or white were carefully spaced and edged to create optical after-images. Final closure on either aspect – intellectual citation of historical reference or handmade pleasure – was blocked. Neither the overall field of formal relationships nor the minute play of handmade difference was allowed to dominate. This refusal was quite obvious: like the Pinacotheca painters mentioned before, Dawes' paintings and Zikos' panels were in no way informative. The artists' contradictory signals defeated references to the inflected field of landscape and to the utopian spaces of formalist abstraction.

The Crisis in Geometry: The Persistent Authority of Modernist Mythology

During the 1980s, critics and artists consistently conflated all the different strands within modernism and constructed a falsely monolithic, exclusively authoritarian picture of that movement. One of the reasons for this was modernism's appearance as an imported authoritarian idiom. Younger artists saw that late 1960s formalist painters such as Michael Johnson, David Aspden and Sydney Ball had been almost immediately absorbed

2:19 Tony Clark, *Kufic Landscape,* 1991, acrylic on canvasboards, 61 x 370 cm. Courtesy Anna Schwartz Gallery, Melbourne.

2:20 Dale Frank, *The Big Daddy Painting,* 1990, acrylic and oil on canvas, 230 x 180 cm. Courtesy Karyn Lovegrove Gallery, Melbourne.

and patronised by institutions and art schools. In fact, Australian art students during the 1980s were taught by a disproportionately large number of tenured, male abstractionists whose work had come to prominence in the late 1960s and early 1970s.

Modernist abstraction had become a symbol of cultural, economic and social power: it had been an emblem of privilege and cultural hegemony. Its symbolism had been analysed and recycled in the United States by Neo-Geo painter Peter Halley, whose essays explained the iconic meaning of abstract painting during late capitalism.[21] Halley's critical attitude could be detected in the Australian paintings of many abstract artists, including Elizabeth Newman. Young abstract painters displayed a deeply ambivalent "anxiety of influence" typified by amnesia towards their local heritage, and specifically towards artists such as Hickey and Rooney. Australian art had never been a pallid reflection of international influence. The persistent, infantile promotional preference for the "Next Wave" on the part of art magazines, critics and curators papered over the internal contradictions between artists' works and critics' explanations.

The new abstraction produced by Generation X artists was fragmenting by 1993 as its inherent contradictions and the differences between artists became evident.[22] Although they attained national institutional acceptance very quickly (as seen in the drop-dead elegance of the 1993 Australian Perspecta survey at the Art Gallery of New South Wales), the new abstractionists did so without articulating any particular theory other than inconsistent avant-garde sentiments and vague utopian longings.

On the other hand, photographer Graeme Hare, film-maker Andrew Frost and older painters such as Dale Frank, Richard Dunn and Tony Clark adapted and analysed modernist tropes such as avant-garde "subversion" into far more interesting works without the same simple-minded nostalgia. Through an often deliberately cursory replication of the look of non-objective painting, Frank, Dunn and Clark created a generalised resemblance to specific historical references – respectively, to French Tachism, post-War American painting and 1920s European neo-classicism. Through deliberately *faux-naïf* illusionism and allusions to early Matisse, Tony Clark's later paintings (for example *Kufic Landscape*, 1991) turned Arabic script into landscape forms belying the diminutive size of his work's small panels. Having thoroughly absorbed the postmodern critique of modernism into their work, these artists were particularly interested in the persistent authority of modernist mythologies. Profoundly aware of the relativity of style and the eccentric tyranny of distance, they deployed modernist abstraction as part of a deeper conceptual strategy.

21 Peter Halley, "The Crisis in Geometry", in his *Collected Essays 1981-87*, Gallery Bruno Bischofberger, Zurich, 1988, pp. 74-106.

22 For a brilliant indictment of the conflation of formalism and stagnant modernism see Rex Butler, "Nixon's Watergate", *Agenda* n.37, July 1994, pp. 10-11.
Although Butler's article is about the art of John Nixon, his lucid argments about the modernist-as-poor-victim syndrome, Nixon's inability to grasp the institutional and historical recuperation of modernist ideas about art-as-work, and the importance of refusing to exempt artists' subjectivities from critical analysis are equally relevant to the neo-modernist painters under discussion in this chapter. Many Australian artists, and not necessarily the artists discussed here, simply refused to understand that the control of critical discourse leads in the long run to the impoverishment of their own critical reputations. I would agree with Butler's placement of Nixon, and hence many of the younger abstractionists, in the recent and interesting tradition that includes mainly European artists such as John Armleder.

The Island of the Dead: Postmodernism and the early 1980s

THE ISLAND OF THE DEAD: POSTMODERNISM AND THE EARLY 1980s

Modernism and Postmodernism: Defining Change

Modernism defined itself, against an inert, conservative past, through a stream of famous works that commenced with the School of Paris painters before the turn of the century and found its apotheosis in New York after World War II. A rupture occurred in the 1970s between two previously indivisible terms – modernism and formalism. The split between formalism (and its belief in quality) and modernist ideology (with its belief in change) was especially relevant in the 1980s and 1990s because it enabled art forms such as post-object and minimal art to be recycled without the increasingly rigid, teleological cultural baggage of modernist dogma.[1] The result of this rupture was a rehabilitation of formalism by many young artists during the revival in abstract painting of the late 1980s, as was discussed in the last chapter.

Postmodernism, too, relied upon an avant-garde imperative; it was a judgement upon the recent past and a declaration of independence. The attempts this century by both capitalists and the Left to remake society – the former through commodity consumption and the latter through social engineering – had, by the 1960s, led to profound fractures in both bourgeois liberalism and Leftist solidarity, resulting in a near-complete loss of faith in the earthly utopia that both had promised. Appropriately, then, fragmentation was a prime subject of postmodern art during the 1980s and early 1990s informing, most tellingly, the collaged spaces of Juan Davila's and Imants Tillers' paintings.

Where did postmodernism come from? Various intellectual currents – of structural anthropology, Lacanian psychoanalysis, film theory, formalist linguistics, French post-structural philosophy, and the new, hybrid, discipline of cultural studies – were crucial in its formation, usually grouped together under the rubric of Theory. The crucial influence of feminist precedents is often over-looked, but feminist art of the 1970s laid much of the groundwork for postmodern art in Australia. Feminist artists maintained that all art has a political dimension; feminist thinkers questioned established institutions and reasserted the role of the intellect in art, over dogmas of supposedly self-evident "creativity". In a new wave of criticism and theory in the 1980s, gay, lesbian and feminist writers analysed the representation of gender in the mass media and visual art. They realised that oppression was inherent in the very structures of language and codes of visual representation, and appropriated the discourse of psychoanalysis to explain the way that this worked.

Postmodern art of the 1980s oscillated between the extravagant, virulent mappings of art-historical hegemony and modernist domination seen in the paintings of Davila or Tillers, and a more nostalgic awareness of the fragility and multivalent character of the same modernism. These two artists demonstrated a critical relationship to modernism; each was a conceptual painter, employing paint on canvas instead of neon tubes or performances.

IMANTS TILLERS: THE ISLAND OF THE DEAD

Appropriation, Intertextuality and a Counter-history of Modernism

Imants Tillers has been an extraordinarily influential artist. With prescient intelligence, his paintings of the early 1980s either prefigured or summarised other artists' concerns: they took the history of art as both subject and language; they described the gap

1 This complicated process was examined by many critics, including Canadian writer Thierry de Duve and, in Australia, Ian Burn and Rex Butler. See Thierry de Duve, "The Monochrome and the Blank Canvas", in Serge Guilbaut (ed.), *Reconstructing Modernism: Art in New York, Paris and Montreal*, MIT Press, Boston, 1989, pp. 244-310 and Rex Butler, "Generic Abstraction", *West* v.3 n.2, December 1991, pp. 49-57.

Previous page: detail of **3:1**.

3:1 Imants Tillers, *The Hyperborean and the Speluncar*, 1986, oil, oilstick and synthetic polymer paint on 130 canvas-boards, 279 x 462 cm. Courtesy Karyn Lovegrove Gallery, Melbourne and Sherman Galleries, Sydney.

3:1

between the periphery and the centre. Since these were relationships of intense longing for most mainstream Australian artists, and the object of desire – membership of the great metropolitan centres of the art world such as New York – was imbued with such a fatal attraction, Tillers' paintings became a widely accepted Australian reference-point for postmodern art. His working method was quotation; he copied other artists' work. Tillers' appropriations were, however, based on his unexpectedly traditional view of art as a continuum and thus his copies had a timeless quality, rather like the borrowings of pre-modernist artists from Classical models.

Tillers' *The Hyperborean and the Speluncar*, 1986, was one of a group of paintings exhibited as the Australian offering at the 1986 Venice Biennale, the world's foremost showcase for contemporary art. Like many of the artist's works from this period, the painting was a magisterial, seamless fusion of contemporary art's most glamorous icons with Tillers' own previous hermetic productions, which were often fastidious exercises in the reproduction of other reproductions, whether of amateur landscapes or of out-of-register postcards. As with all his pictures since 1981, *The Hyperborean and the Speluncar* was composed of an accumulated grid of small canvasboards, similar to those used by amateur painters but arranged to form a large, spectacular whole. The images were all copies, derived from art reproductions in magazines or books, or references to Tillers' own earlier work. These gridded sources were transferred, square by square, to the canvasboards. The process was not rigidly mechanical, so that the quotations emerged, when arranged together, in a painterly fashion and, through the mistakes and hesitations in the copying process, textures and brushstrokes accrued. Tillers restricted his borrowing to an easily identifiable range of images, like other postmodern artists who relied on the appropriation of pre-existing sources from the media. Tillers described his working method thus:

> The new paintings for this exhibition continue the process I have been using since 1981. Each painting derives wholly or partially from reproduced images found in magazines and catalogues. The found images are gridded up and then painted piece by piece, square by square onto small rectangular canvas boards. The canvas boards are all numbered as I paint them in a continuous sequence from one to infinity – and any one of them can be recombined to form a new work. In this way an area of failed painting is never wasted but can become ground in another subsequent work …[2]

2 Imants Tillers, "Statement by the artist, February 1986," in *Origins Originality + Beyond*, 6th Biennale of Sydney, Art Gallery of New South Wales, Sydney, 1986, p.270.

Regardless of his matter-of-fact tone, *The Hyperborean and the Speluncar* was an enigmatic image: a horse's head composed of classical buildings; a woman, overshadowed by a monstrous dark form, collecting shells on a beach; classical columns floating in a vast atmospheric sea that merges into pink sky; the whole overlaid with a semi-random dot screen, truncated at the top left corner by a flat field of grey. Each of the parts came from somewhere else: the animal head was borrowed from a painting by the Italian Metaphysical painter Giorgio de Chirico (Tillers' picture was signed "de Chirico, 1975"); the woman was borrowed from a painting by the 19th-century English Academician Lord Leighton; the flat corner was a reference to formalist painting; the columns were reminiscent of neo-expressionist painting (that of Sandro Chia and Enzo Cucchi) current in the early 1980s; the sea of colour and dots referred to German neo-expressionist Sigmar Polke.

De Chirico's interest in determinedly anti-modern modes of representation, his

repeated copying of his earlier works, and his hybrid, semi-Academic, semi-Metaphysical late works were an important example for Tillers, whose paintings functioned rather like one of the Italian artist's composite images: the "face" (the appearance of an integrated image) of a painting was composed out of parts taken from other people's art. A large part of the experience of Tillers' painting lay in a similar type of reading – the recognition of the artist's sources and the correlation of our own knowledge with Tillers' deformations. Imants Tillers' animal head (indeed the whole picture) belonged to this category. Assembled out of a landslide of recognisable or hermetic components, *The Hyperborean and the Speluncar* cohered into the shape of a painting, but also dissolved into a cross-cultural amalgam of incidents that could be read like a map. Each element was double-coded, carrying two (or more) meanings and dependent on an awareness of its eclecticism and our commentary on those references. The juxtapositions were cryptic and arbitrary: the space was fractured and discontinuous, sliding from formal abstraction to the dream-space of surrealism. *The Hyperborean and the Speluncar,* for all its cumbersome production, or perhaps because of it, had a contradictory, sensuous surreality and extravagance that probably exceeded the artist's own intentions.

Imants Tillers' painting was a compendium of postmodern art. Its relation to sources and inspiration was pluralist and eclectic to the point of parody. Moreover, Tillers' paintings took as their point of departure the idea that postmodernity represented the terminal crisis of 20th century modernisation and a general loss of faith in progress. The most cursory survey of popular commentary at the end of the 20th century showed widespread realisation of the gap between the optimistic ideas of modernity at the start of the century and the contemporary reality of acid rain, AIDS, nuclear pollution and urban decay. Postmodern culture had little faith in progress, science and the dogma that "new is best". This widespread pessimism was reflected in the writing of postmodern theorists like Jean-François Lyotard, who observed that "the nineteenth and twentieth centuries have given us as much terror as we can take".[3]

Postmodernism, therefore, was one result of the cultural crisis of modernism. Tillers was clearly aware of that crisis; thus his adoption of de Chirico, a renegade modernist turned academician, as model. He was also conscious that his position as an artist of Latvian origins, working at a desk in a small studio in Sydney, was evidence that "our" culture was not homogeneous. When he borrowed images from international artists such as Anselm Kiefer or Sigmar Polke, Tillers asked his audience both to recognise the other artists' images and to see that, in the act of copying, something else had been added. His borrowing had clear implications in New York and, in such centres, it represented a questioning of originality and the illustration of intertextuality. At the periphery, in Australia, it had other implications. Tillers stated:

> There are different issues at work, say in America or Australia, although we're all subject to the same bombardment of images. In Australia I still feel a sense of isolation, whether its real or not, and a feeling of marginality and provincialism.[4]

If Imants Tillers' painting was a critique of modernism, as he maintained, what were the main points of this postmodern inquiry? First, the hollowness of modernist authority and its associated, often commercially-driven, mythologies, such as the romantic privilege of genius, implied the end of artistic progress. This, in turn, exposed the fallacy of avant-garde art at the cutting edge as necessarily subversive of established cultural orders: truly

3 Jean-François Lyotard (trans. Geoff Bennington and Brian Massumi), *The Postmodern Condition: A Report on Knowledge,* Manchester University Press, Manchester, 1984, p. 81. Also see pp. 78-79.

4 Imants Tillers, interview, in Sandy Nairne, *State of the Art: Ideas and Images in the 1980s,* Chatto & Windus, London, 1987, p. 224.

marginal groups – gays, women, ethnic minorities and people of colour – were not often included in avant-garde coteries in any equitable way. *The Hyperborean and the Speluncar* obviously took apart the idea of artistic mastery, implying that terms like genius, originality and heroic individualism were neither necessary nor value-free.

Appropriation as a strategy had a long history: before the age of mechanical reproduction, painted copies had the dual functions of replicas and reinterpretations. Changing historical connotations of "imitation" were crucial to an understanding of the role of appropriation. During the 19th century the meaning of the word "imitation" shifted from "invention" to "facsimile"; at the same time, copying was an artistic method of learning and could provide a replica of an absent masterpiece. Modernist painters and theorists later shifted their attention from the ideas represented in the work of art, to the artists' means of representation, through radical (and hence original) reinterpretations.

Tillers reversed this equation; his theorisation of synchronicity and coincidence replaced personal choice and style with the impersonal guidance of destiny and synchronicity. Because he blurred the division between straightforward statement, parody and pastiche in his paintings and in comments about his work, his own belief in the supernatural agency of fate (Tillers was always careful to distinguish his own interest *in* occult agencies from identification *with* them) was less relevant than his cultivation of ambiguity. It was, then, no accident that Tillers' most important artistic model was de Chirico, since Classicism offered an equally timeless, synchronistic view of artistic style and invention: its theorists assumed that the Self would naturally appear in all faithful copies. Widespread deference to art as a transcendental category of experience, at the height of modernism, went hand in hand with an almost religious faith in originality and authenticity. Efficient reproduction of the category "art", however, was now enough to generate deference, as Tillers' painting showed. Originality could be fabricated, but remained important to many people.

The Book of Power: From Little Bay to Latvia

Imants Tillers' early works were installations; their concern with laborious process and carefully planned intellectual schema reflected his university training in architecture and his 1969 experience as a young assistant during Christo and Jeanne-Claude's famous wrapping of Sydney's Little Bay. *Conversations with the Bride*, 1975, was an installation of enamelled metal miniatures set on music-stands. On exhibition in Melbourne at Storey Hall, it was surrounded by an arrangement of notebooks. The work was an attempt to surpass Marcel Duchamp's famous *Large Glass*, 1915-23. On each small enamelled painting, Tillers montaged parts of three images onto each other: *Summer*, 1909, a traditional landscape by Hans Heysen; a half-tone photograph of a eucalypt from a textbook on Australian trees; and details from the *Large Glass*. The images of collision were, according to Tillers' notebooks, the manifestation of a shadow cast onto three-dimensional space by a mysterious four-dimensional figure. Duchamp's *Large Glass* had been the result of one miraculous communication; Tillers' work was another.

In late 1981 Tillers commenced work on the canvasboard paintings for which he is now best known. They were marked by two obvious characteristics: his adaptation of reproduced images by other artists and the layering of these second-hand, mechanically reproduced sources on top of each other, like transparencies, so that several images coexisted in the same ambiguous space. Tillers identified Australia as a postmodern

3:2 Imants Tillers, *Mount Analogue*, 1985, oilstick, synthetic polymer paint on 165 canvasboards, 279 x 571 cm. Photo: Fern Hinchcliff. Courtesy Karyn Lovegrove Gallery, Melbourne and Sherman Galleries, Sydney.

graveyard of reproduced images. The landscape described by his appropriations was, therefore, an "Island of the Dead".

In assessing both the meaning of Tillers' juxtapositions and their logic, the role of coincidence and free association must be emphasised. Tillers' oeuvre proceeded according to the logic of synchronicity – of the simultaneous occurrence of unrelated events – yet he always attached hermetic significations to these coincidences so that they appeared with the aura of destiny shaped by hidden forces.[5] Similarly, Tillers conceived his canvasboard paintings as components of one vast and ever-expanding work, The Book of Power. Tillers' curator and companion, Jennifer Slatyer, observed in 1988 that Tillers saw his work "in terms of [an] huge all-inclusive book where each canvasboard panel is a page in the book and each page is numbered from one to infinity. In fact at this moment you are at the page marked 17187 and there is a long way to go."[6] By 1992, Slatyer's count was 200 canvasboard works and 33794 panels or "pages".

Tillers' works of the early 1980s were unforgettable for the range of their references and sheer ambition. *Mount Analogue*, 1985, imitated Eugene von Guerard's *North-East View from the Northern Top of Mount Kosciusko*, 1863; the title was a reference to René Daumal's book of the same name. Daumal recounted the story of a band of explorers in search of the mountain view from which the secrets of the universe would be revealed; ironically, the author died in 1944 before the work was finished. This hermetic reference and the picture's mural-like sweep assured a grandeur that quite overpowered any ironic reading and forever rewrote the original. With *Heart of the Wood*, 1985, Tillers restaged Anselm Kiefer's early *Germany's Spiritual Heroes*, 1973, replacing Kiefer's funerary torches in the attic's sweeping space with Margaret Preston's 1930s banksia paintings (emblems of a nascent Australian nationalism). Some of Tillers' artistic "heroes" (Böcklin, for example) were also Kiefer's, and Tillers' name was emblazoned across the attic ceiling of the German artist's Hall of Fame. The dialogue with Kiefer and Preston, which relied on our prior knowledge of Tillers' models, was as complicated as *Conversations with the Bride*. Kiefer treated his (German) public's deification of heroes with considerable irony; Tillers

5 "In June 1989, while Tillers was dining with Arakawa and Madeleine Gins at Rocco's, a once-fashionable restaurant on Thomson Street in New York's SoHo, the conversation inevitably turned to de Chirico and their meeting with him in New York, seventeen years earlier. As Arakawa's memory slowly returns he recalls that they had also taken de Chirico to Rocco's. In fact they have sat at the same table that they were sitting at now and after a thoughtful pause and smile he added – yes, indeed Giorgio de Chirico had once occupied that same chair in which Tillers now found himself seated."
Recounted in Jennifer Slatyer, "The Enigma of Imitation: The Metaphysical Paintings of Imants Tillers", in *A Life of Blank: works by Imants Tillers*, Plimsoll Gallery, Centre for the Arts, Hobart, February 1992, p.17.

6 Jennifer Slatyer, "The Life-Motif: Interview with Imants Tillers", *Art Monthly* n.9, April 1988, p.1.

3:3 Imants Tillers, *Heart of the Wood*, 1985, oilstick, charcoal, oil, synthetic polymer paint on 388 canvasboards, 280 x 648 cm. Collection: Museum of Contemporary Art, Sydney. Courtesy Karyn Lovegrove Gallery, Melbourne and Sherman Galleries, Sydney.

3:3

incorporated himself into Kiefer's tableau, achieving a weird disjunction – Tillers became the object of Kiefer's irony rather than the other way round; this paradox was surpassed in the early 1990s by Gordon Bennett's annexation and liquidation of Tillers' white Aboriginality.

Tillers was an articulate artist who wrote several influential essays including, in 1984, "In Perpetual Mourning". He described Australian culture as the "Island of the Dead" in an attempt to explain that the Australian condition was paradigmatically postmodern: "In this sense mechanical reproduction is a purgatory or limbo for image patterns. Like disembodied souls floating textureless in books, they are waiting to be reborn, to be recreated, to feel the actuality of their reality."[7] Here, he alluded to Walter Benjamin's highly influential essay "The Work of Art in the Age of Mechanical Reproduction".[8] Thus, the proliferation of art books dramatically changed our relationship to works of art. Since reproduction, according to Benjamin, robbed art of its uniqueness and stripped it of its aura, for Tillers art existed primarily as mechanical copies. Tillers' insight into the regional application of Benjamin's thesis was also his trademark. The practice of copying became, for Tillers, both subject matter and method; everything in his pictures was copied. The equivalence of mechanical reproduction made images far more susceptible to local readings. Tillers' argument, if not his art, was dependent on a certain elegant casuistry. He was based in Sydney, where the dominance of the art book was more or less true. In Melbourne, however, young artists were exposed to a significant collection of Old Master paintings at the National Gallery of Victoria. From the 1950s onwards, as well, major international travelling exhibitions toured Australian capital cities with sufficient frequency to belie Tillers' argument.

In an elegant essay, "Panorama: The Live, The Dead and the Living", Meaghan Morris pointed out that the postmodern rhetoric of death, divide and distance had acute relevance for Australia, since it spelt, literally, the terms of Australian history.[9] This particular identification – Island of the Dead – appealed to many critics, since it appeared to confer upon Australian artists and theorists a unique advantage in the formation of a postmodern critique of world culture. The assumption, of course, was that Australian experience was depthless because so new, that an apparent lack of history could be synthesised with a hyper-real postmodern condition. Of course, all this depthlessness was neither completely true nor unquestioned. Sydney art critic Pam Hansford disagreed, writing that:

> Whereas American and European experiences proceed from the recent memory of operational and then dwindling avant-gardes, there is a real sense in which Australia has never had an avant-garde tradition with its emphasis on self-conscious failure and nihilism, and hence presumably has nothing to mourn.[10]

What did it mean to have a longing to be part of something that was dead? Hansford warned that ideas imported whole from Europe and America would be inadequate to describe Australian art. Seeing provincialism as an advantage rather than a curse obscured what she described as "the problem of the copying instinct which has traditionally beleaguered debates about an Australian creativity".[11] This phenomenon was described by art historians who, following Bernard Smith, traced the half-digested influence of European and American art in Australian art. Australian artists were frequently described as working in a state of formlessness – through a curious inversion of the European situation, they were oppressed by a lack, rather than a surfeit, of tradition. Thus,

7 Imants Tillers, "In Perpetual Mourning", *ZG/Art & Text*, Summer 1984, reprinted in Kerry Crowley (ed.), *Imants Tillers*, Venice Biennale, Australian Pavilion exhibition catalogue, Art Gallery of South Australia and Visual Arts Board, Adelaide and Sydney, 1986, p.19.

8 Walter Benjamin, "The Work of Art in the Age of Mechanical Reproduction" [1935], in Hannah Arendt (ed.) (trans. Harry Zohn), *Illuminations*, Schoken Books, New York, 1969, pp. 217-251.

9 Meaghan Morris, "Panorama: The Live, The Dead and the Living", in Paul Foss (ed.), *Island in the Stream*, Pluto Press, Sydney, 1988, p.164.

10 Pam Hansford, "An Invented Melancholia or ... How Weakness Becomes Strength", in *The present and recent past of Australian art and criticism*, special supplement, *Agenda* n.2, p.24.

11 Hansford, "An Invented Melancholia", *Agenda* n.2, p.25.

during the 1970s, artists such as Michael Johnson and critics like Patrick McCaughey pinned their ambitions on increasing ties with the metropolis, through frequent visits to New York and exhibitions overseas, to cancel out the embarrassing differences between centre and periphery. For Tillers, however, the twice-removed Australian experience of art was an advantage, because the contemporary Australian artist was absolutely at home in a postmodern morass of copies, fakes, kitsch, and the unattainable. Whether this celebration eliminated the melancholic longing to be up there with the big players of the international art world was debatable; Tillers was, somewhat ironically, one of a group of Australian artists, including Mike Parr, Jenny Watson and Juan Davila, to attain European and American gallery profiles during the 1980s.

Given its ambitiousness, Tillers' work achieved notoriety at a particularly appropriate time – during the 1980s art market boom. During those years, admission to the cosmopolitan gallery and museum circuit in the United States and Europe (a periodic fantasy of enterprising Australian artists) actually seemed possible because of a combination of circumstances which included a buoyant market and continual government support, through exhibitions and grants sponsored by the Australia Council. The centre, however, was reluctant to acknowledge Tillers' sophistication. Donald Kuspit reviewed the artist's 1984 New York show thus: "Taken together, the paintings in this exhibition constitute a super parody which reveals the limits of parody: the joke may have been on the joker".[12] The artist played upon his actual membership of our exotic Other. He exaggerated the degree of alienation involved in the production of his images until the multiple ironies of his best works were so coded that they became illegible.

With Tillers, as with many artists whether at the centre or the periphery, the wide impact of postmodernism was reflected in the production of hybrid paintings. He attempted a synthesis of many styles, and sought to demarcate a critical difference between his simulations and their models. The most salient feature of his works was, initially, their ability to be read internationally as Australian-yet-interesting, rather like *Crocodile Dundee*. The textuality of Tillers' complex paintings, though, was more that of a library – a fantastic library like the one described in Umberto Eco's *The Name of the Rose*. They also embodied a type of mystical, cosmopolitan nomadism which proceeded like surrealist automatism, tracing an unreliable, imaginary map of the complicated secret histories of culture. Critic Gary Catalano ignored the metaphoric richness in Tillers' constructed worlds when he described him as "little more than a *pompier* for the pseudo-intellectuals".[13]

A decade or more later, Tillers' state of "perpetual mourning" can be seen to reflect several hypermannerist assumptions. For Melbourne artists especially, the presence of many major examples of European art in the National Gallery of Victoria always affected the course of their development. More importantly, representation did not make all images equivalent in quite the way Tillers saw, since local misreadings were far from random. Instead, they reflected the same secret histories and underground networks of synchronicity used by Tillers. His essays reflect the over-valuation of deadness that afflicted much of the 1980s. The conception of an overarching Book of Power was far more interesting than his artificial attempt to level inter-cultural experience.

Imants Tillers' most obvious achievement was his renegotiation of the tired old provincialism debate, so that the perceived Australian weakness of isolation was transformed into strength. Tillers' appropriation of contemporary art depended upon his citizenship

12 Donald Kuspit, "Imants Tillers at Bess Cutler", *Art in America* v. 73 n. 3, March 1985, p. 159.

13 Gary Catalano, "I will not make any more boring art", *The Age*, March 14, 1990, p.14.

3:4 Imants Tillers, *Izkliede*, 1994, gouache, synthetic polymer paint, oilstick on 292 canvasboards, 305 x 914 cm. Photograph: Paul Green. Courtesy Karyn Lovegrove Gallery, Melbourne and Sherman Galleries, Sydney.

3:4

of far-away Australia, the graveyard of images. From this distance he participated in the recirculation of Latvian and contemporary art world imagery. Tillers implied that Australian provincialism should be emphasised, exaggerating the natural tendency towards mimicry. The pattern of obsessive consumption and regurgitation of images that resulted in a fragmentation of authorship – once an indication of over-compensation and insecurity – could now be turned to local advantage. He anticipated many arguments about mimicry and postcolonialism that were to absorb younger artists several years later; in his superb large paintings of the mid-1990s these issues would surface again.

THEORY: THE HERMETIC DISCIPLINE

Theory and Fashion: The Sources of Postmodernism

Where did the theory of postmodern culture, so amply demonstrated in Tillers' paintings, come from? What was the intellectual context for his work? Postmodernism was a series of speculations on the totalities and fragmentation of present-day culture; it had a critical relation to recent history and art. It was influenced by an eclectic mix of many different, often contradictory theories. During the 1980s, artists, critics and art schools in Australia placed a high value on what was generically called postmodern theory, but which was in reality a disparate collection of philosophical texts translated from a number of French writers, including Michel Foucault, Jacques Derrida, Julia Kristeva, Jean Baudrillard, Jacques Lacan, Gilles Deleuze, and Luce Irigaray. Architectural and literary critics, amongst whom were architect Robert Venturi, architectural historian Charles Jencks and cultural theorist Ibn Hassan, were also influential.[14]

The link between the studio and the lecture theatre became a highly lauded attribute of advanced art. Many writers emphasised the inextricable identity of language and meaning; the self was seen as a social construction, woven from discourse and language. For art, this implied a fragmentation of authorship: if meaning was always dependent on the traces of other thoughts, and all authenticity derived from other structures, then artistic meanings were just as arbitrary and constructed, taking shape through the chance distinctions assigned by history.

14 For a brief account of the French thought that had considerable impact on Australian art during the 1980s, see Elizabeth Grosz, "French Feminisms and Representation", in Harriet Edquist (ed.), *Reasons to be cheerful #1*, George Paton Gallery, Melbourne, 1988.

The Arrival of Theory: The Academy and Jean Baudrillard

Postmodernism was simultaneously a cultural phenomenon of widespread interest to artists and writers and a hermetic intellectual discipline. Artists were faced during the 1980s by postmodern theories of representation and gender, and the obvious relevance of these theories to contemporary culture. They were aware of the importance of art criticism and postmodern theory, even if reluctantly and dismissively. Postmodern debate had considerable impact on younger artists. This was demonstrated by attendance at artists' forums about art criticism and theory organised by the curators of contemporary art spaces, and also by the short-lived prosperity of art magazines, such as *Tension*, which focused almost exclusively on contemporary postmodern artists.

The postmodernism that appeared both hermetic and alluring to artists was linked with the arrival of art criticism and art from Europe or the United States which was, in turn, influenced by post-structural philosophy. This art was sighted in Australian journals, specifically in *Art & Text*, *Agenda*, *Eyeline*, *West*, *Praxis M*, *Tension*, *On the Beach* and *Antithesis* from the early 1980s onwards. It was adopted with particular enthusiasm in Sydney. The art criticism was difficult, opaque and complicated; it was modelled on French post-structuralism, which had considerable influence on Australian art during the 1980s through the impact of charismatic feminist thinkers, including Sydney-based Elizabeth Grosz, who spoke at many forums organised for artists (for example at the George Paton Gallery, Melbourne, in 1988). One of the first conferences on French structural and post-structural theory to attract attention outside academic circles was held in 1981; "Foreign Bodies: Semiotics in/and Australia" included papers by Paul Foss, Meaghan Morris and Edward Colless.[15]

There was a wide, lively and well-informed audience keen to engage with a wide range of visiting theorists, published translations and theoretically-informed artists, many of whom travelled and lectured widely during the 1980s. When, for example, popular French cultural theorist Jean Baudrillard visited Australia in 1984 for the Futur*Fall Conference in Sydney, he was mobbed by admiring audiences of several hundred people.[16] Organised by Elizabeth Grosz, Alan Cholodenko, Edward Colless and Terry Threadgold, the conference also featured the equally important postcolonial feminist theorist and Derrida translator, Gayatri Chakravorty Spivak. In another example, American artist Barbara Kruger spoke in 1988 at Melbourne University to a large lecture theatre filled to capacity. Kruger remarked on the astounding enthusiasm for seminars like hers; she noted that the well-known Dia Foundation "Discussions in Contemporary Culture" forums in New York had attracted an audience only a fraction of that size.[17] Kruger's importance and celebrity had been established through theory-based art criticism; for all her obvious literacy and clear grasp of those issues, she was most animated and interested in questions about the specifics of her practice and images, and seemed almost impatient with the expectation that she would be a surrogate philosopher. A series of public forums on visual art organised during the Australian Bicentennial celebrations, in 1988, attracted sizeable audiences in Melbourne to hear speakers like Mike Parr, Jacques Delaruelle and David Bromfield cross rhetorical swords. As late as 1988, ten years after the initial impact of critical theory on contemporary artists, Melbourne art space 200 Gertrude Street saw younger artists turn out in considerable numbers to attend a series of difficult, often obscure, public lectures on contemporary French philosophers including Derrida, Kristeva, Blanchot and Barthes. These lectures, organised by

15 The conference papers were collected in *Foreign Bodies: Semiotics in/and Australia*, Local Consumption Collective, Sydney, 1981.

16 Baudrillard returned to Australia in April 1994 on the occasion of the exhibition of his photographs, again lecturing to overflow audiences. Australian customs officials impounded his photographs pending payment of duty; under Australian law, photographs are not designated as art and thus require a surprisingly large excise fee. Brisbane critic and Baudrillard expert Nicholas Zurbrugg commented: "The man who said art was dead then became a (photographic) artist, but when his art got to Australia the Customs said 'Your art isn't art'. Perhaps they've read him." Quoted in Matt Robbins, "Philosopher's art escapes the duty of reality", *The Australian*, April 22, 1994.

17 Barbara Kruger, conversation with the author, Melbourne, 1988.

18 For an unfair but entertaining account of the incorporation of theory into art-world discourse as what was cynically termed "Artspeak", see Edward Colless, "The Imaginary Hyper-Mannerist", *Art & Text* n.31, December 1988, or "That's amoré", in Sally Couacoud (curator), *Amoré*, Artspace, Sydney, November 1990. For a short Melbourne article of a distinctly hostile persuasion, see Christopher Heathcote, "Anxiety and after – where are artists heading now?", *The Age*, January 9, 1991, p.12. For an overseas example, see George Steiner, *Real Presences*, Faber & Faber, London, 1989.

19 Jean Baudrillard, "The Precession of Simulacra" (trans. Paul Foss and Paul Patton), *Art & Text* 11, Spring 1983, pp.3-47. Reprinted in Brian Wallis (ed.), *Art After Modernism*, New Museum of Contemporary Art, New York, 1984, pp. 253-281.

Melbourne cultural theorist Kevin Murray, were collectively titled "The Judgement of Paris". As theory was incorporated into art-world discourse, it was cynically labelled "Artspeak". In Melbourne, the art critics for the *Age* – first Gary Catalano and, later, a similarly sceptical Christopher Heathcote – pilloried the importation of postmodern theory in their reviews, dismissed by Heathcote in one review headline with the taunt, "Anxiety and after – where are artists heading now?"[18] In Sydney their views were mirrored by John McDonald, art critic for the *Sydney Morning Herald*.

Theory was, by now, a cultural phenomenon of considerable influence and notoriety. This progress was epitomised by the fashionability of Jean Baudrillard. Baudrillard was a Professor of Sociology at the University of Paris, although his chief claim to fame was as a seminal, often-quoted theoretician. He was, for a short time in the early 1980s, the hero of a generation of young artists and critics, in Australia somewhat earlier than overseas. Baudrillard had cult status in Australia, where Paul Foss and Paul Patton translated his writings into English for magazines such as *Art & Text*. Although his key essay "*La préces-sion des simulacres*" was published in 1978, the first English translation – "The Precession of Simulacra" – appeared in *Art & Text,* during 1983.[19] Despite their incoherence, his essays were nonetheless extremely seductive to art-world audiences. In New York's gallery precincts, his books were displayed next to bookshop cash registers. His writing occupied an ambivalent but typical position within critical theory, since he produced nei-ther philosophical commentaries, as did Jacques Derrida, nor was he a historian of institu-tions and ideas, like Michel Foucault. Describing the cultural condition of the present, his writing was an amalgam of travelogue, philosophical musing and social theory.

"The Precession of Simulacra" was an elegant evocation of a contemporary world of simulation resembling science fiction, where pure images floated adrift from referents, and the real was superseded by sheer spectacle. The word "simulacrum" means likeness, phantom or shadow; in Baudrillard's diagnosis of contemporary reality, simulacra pre-ceded reality. Baudrillard posited the end of the real, of the social and of the political. His essay was so cryptic that it was difficult to define its ideas without adopting his language; the concept of simulation was, however, central to an understanding of the art of appro-priation, as practiced by artists such as Tillers, Juan Davila and, later, Susan Norrie. Appropriation was represented as a self-conscious critique of culture and society. These claims were based on an elision and denial of copying practices in the more distant past and, to explain this, the intertwined relationship of theory, art criticism and fashion must be remembered at all times. Artists during the 1980s demonstrated a touching conviction that there was a truth to discover in every discourse, even in a postmodernism that denied its very existence.

JUAN DAVILA: THE PERVERTED CENTRE

Language is a Virus: Cultural Critique

If a virus is a poisonous agent that spreads contagious disease and an influence that leads to corruption, then language is a virus. In the opinion of many critics, Juan Davila produced the most virulent postmodern paintings to emerge from the furious 1980s cri-tique of modernism. Davila's paintings were based on the assumption that visual lan-guage could have the power of a virus. Because of his works' sheer intensity, Davila's mapping of art-historical hegemony during the early 1980s constituted a magnetic essay

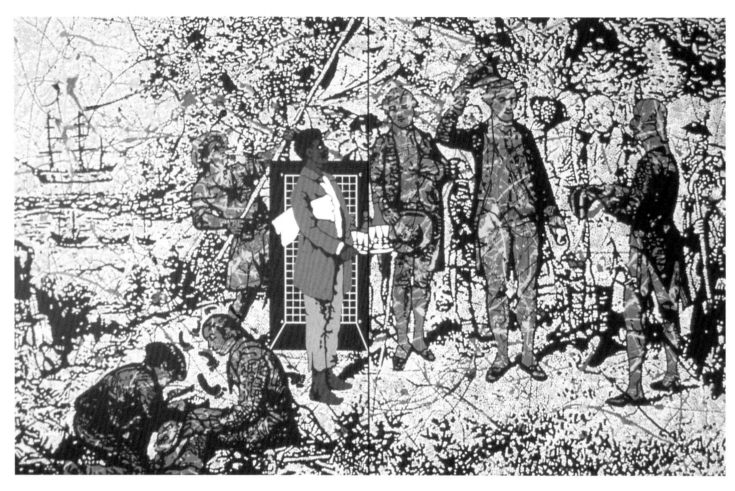

3:5

on the postmodern themes traced so far. His convictions about artists' moral rights and the importance of their ability to control the publication of their work were answered in the high recognition accorded his work – both elements of this equation are indicated in this book's scarcity of illustrations of Davila's paintings and in its extended commentary on the artist.

Davila's works exemplify the postmodern themes that we have previously noted. These could be summarised as follows: the metropolitan centre's authority had become problematic; the personal self had been shown to be a construction woven from language and discourse; and the difference between private and public life had evaporated (an issue of particular importance in Juan Davila's work). As with Tillers, Davila's primary artistic method was appropriation: he borrowed images from high art, the mass media, science fiction, homosexual pornography and the cultures of Latin America. His painting was virulent because he copied his models with violent intent, corrupting their original meanings. Davila's works were linked to modernism because this idea of copying – as the means of possessing and altering an original so that it could never be seen in the same way again – was common amongst modernist artists such as Picasso in the early 20th century. Both Davila and Tillers were highly conscious of their positions at the margins of world art. Whereas Tillers' politics remained grounded in the discourse of art, Davila's paintings were edged with a hostility and anger produced by the radical politics of his Chilean origins and coloured by his representation of homosexual desire.

These themes appeared in an exaggerated form in Davila's paintings of the early 1980s. In his four-part polyptych, *The Fable of Australian Painting*, 1983, Davila parodied the styles and emblematic motifs of Australia's most celebrated artists, representing Sidney Nolan's Ned Kelly masks and Albert Tucker's encrusted bush faces as figures of utter contempt. Nolan's helmeted hero rode off into a luminous Rothko sunset; the panel was split by a Kenneth Noland chevron.[20]

Stupid as a Painter: The Perverse Marriage of Postmodernism and Modernism

In his notorious *Stupid as a Painter*, 1981, Davila quoted typical trademark images of famous international contemporary artists including Roy Lichtenstein's cartoon signs, Valerio Adami's diagrammatic cut-out figures, and Andy Warhol's Marilyn Monroe face. He montaged these images beside and over each other, combining recent art history with homoerotic cartoon comics, a Manhattan skyscraper background and a running commentary scrawled across the surface of the picture. *Stupid as a Painter* was genuinely confrontational.[21] Its eroticism appeared transgressive because the imagery was determinedly homosexual. This transgression in itself was not particularly shocking, since the delicate tastes of gallery-goers were habituated to the "normal" transgressions of heterosexuality (those, for example, suggested by Brett Whiteley's *Self Portrait in the Studio*). Nor, I think, were viewers as offended by the representation of homosexuality as by its interpolation into the canon of great art. Davila offended because he mocked the ability of the art-lover to adjust to avant-garde languages. These, after all, were reclaimed by ordinary viewers into the acceptable category of great art with surprising semantic agility. Many people believe that art and politics, like sport and politics, should not mix. Davila's crime was to insist on their coexistence; every image was political. And, in fact, his paintings provoked strong reactions: in several years of excursions to galleries with art students, the only official complaint I ever received was the result of a Juan Davila painting.

20 Noland was a protégé of formalist guru Clement Greenberg during the 1960s, when he was acclaimed as a leading Colour Field abstractionist. Many young Australian painters of the time, amongst whom were Sydney Ball, David Aspden and Michael Johnson, had attempted cosmopolitan pastiches of this rather arid style.

21 See Paul Foss and Juan Davila, *The Mutilated Pieta*, Artspace, Sydney, 1985; Paul Carter, "A Blatant Rip-off", *Age Monthly Review* v.5 n.9, Febuary 1986, pp.14-15. Displayed under R-certificate restrictions at the 1982 Sydney Biennale, the painting was seized by the New South Wales Police Vice Squad acting on a complaint from the Reverend Fred Nile, a notoriously conservative Christian fundamentalist. *Stupid as a Painter* was returned to Davila's gallery, Roslyn Oxley9, on NSW Premier Neville Wran's orders after a public outcry, and was finally displayed at Sydney University's Power Institute Gallery.

3:5 Gordon Bennett, *Possession Island*, 1991, oil and acrylic on 2 canvas panels, 162 x 260 cm. Photograph: Xavier Lavictoire. Courtesy Bellas Gallery, Brisbane and Sutton Gallery, Melbourne.

Stupid as a Painter presented a delirium of sexual activity or, to be more precise, a parade of figures posturing in poses of sexual availability and arousal. On the right-hand side panels, a uniformed man lubricated another's anus with an oil-can, whilst his companion was penetrated by the erect penis of a transvestite figure (the Spider Woman, who reappears in several Davila paintings) and threatened by a chain-saw blade. Davila recycled mythic, ambivalent figures from homosexual and heterosexual imagery – the sailor, the biker, Marilyn, the transvestite, the Big Apple – adorning them with identity tags (usually Davila's invented *alter egos*) and gender-twisting details. According to Paul Foss, Davila's paintings imaged perversity because perverse works affronted the sense of self-sufficient identity and completeness by making the violence of the viewer's gaze evident. Diagrammatic lines joined subject's gaze to object's body in many works, just as Davila often marked the figures' eyes with an erasure sign or cross as a token of their inability to return the voyeuristic glance. In *Ratman*, 1980, a man (marked "Davila" in the picture's accompanying style guide) gazed at a woman's crotch. She was painted in the sexist, fetishising style of German Pop artist Richard Lindner; her genitals were marked by another erasure sign.

Davila saw pornography as a disruptive sign language which would facilitate the subversion of mainstream art and its traditions. His apparent aim was to discredit art. Most of his published statements insisted on this subversive role. However, he noted of his painting method that: "It has nothing to do with psychoanalysis; I am concerned with problems specific to art and I operate within these parameters".[22]

The artist's works of the early 1980s, such as *Ratman*, appeared pornographic but were not particularly seductive. As Paul Carter observed, Davila's pictures refused to allow any prolonged sense of identification and enjoyment; they denied the vicarious sense of entering a dream-world. Because he rejected the pleasures of self-forgetfulness and absorption, the viewer was unable to identify completely with his imaginary images. This self-consciousness was forced on the viewer with enormous single-mindedness. The psychology of a distanced, one-dimensional view of identity, exclusively determined by adversarial hostility, reduced characters to ciphers. This deliberately hyper-real psychology was the result of Davila's refusal to make pictures anything less than repulsive, although their crudity did not emerge in reproduction. The pictures truly looked as if they belonged in museums and a decade after they were painted, *Stupid as a Painter* and *Ratman* seemed less and less like aesthetic terrorism.

Stupid as a Painter was an angry painting, desperately articulate in its analysis of the obscene ways in which visual images circulate in heterocentric society. Its anger, however, did not make it effective propaganda nor, for all its virulence, did the picture constitute an effective instrument for social change, even within the narrow coteries frequenting art galleries. The question of avant-garde art's subversive function haunted postmodern art, and particularly that of Davila, for the remainder of the decade. For many academic postmodernists, ideas were merely the material of citation; in the case of Juan Davila, however, the tension between subversive desire and the limits of painting was productive. His art came to seem extraordinarily nostalgic and poignant even if, in reality, the exposed patches of raw canvas looked tatty and the matte colours were alternatively flat, raw, stained or simply muddy. The artist sacrificed any semblance of atmospheric space to achieve the garish immediacy of a comic strip. His pictures exhibited the lack of subtlety typical of paintings in acrylic because Davila contrived the appearance

22 Juan Davila, quoted in Paul Carter, "A Blatant Rip-off", *Age Monthly Review* v.5 n.9, p.14.

3:6 Juan Davila, *Retablo*, 1989, oil on canvas, 300 x 300 cm. Courtesy Tolarno Galleries, Melbourne.

3:6

23 Roy Davila, "Popular Art", in Juan Davila
and Jan Minchin, *Popular Art: Graphic Work
1958-1992*, Tolarno Galleries, Melbourne,
1992, unpaginated.

of easy, unscholarly, unpretentious cheapness with great care.

Davila's paintings of the early 1980s were representations of taboo images: a bourgeois audience's worst fears of violation were realised through the desecration of its iconic images by figures from gay and marginal mythology. More importantly, his images were allegorical enactments of a critique of modernist art and, in particular, of late-modernist, formalist abstraction. They were an indictment of the great American and European museums and their innocent-seeming, carefully constructed, illusory neutrality. In an essay by Roy Davila (one of Davila's many pseudonyms), the artist observed: "The images that are most effective turn out to be excluded from museums".[23]

Echo: An Art of the Museums

Davila's images eventually became more seductive and ambiguous, often drenched in light or submerged in shadow. From the mid-1980s, in works such as the monumental, mural-size (274 by 822 centimetres) *Echo*, 1986, Davila created an illusion of intense but bizarre naturalness and free-floating space, akin to the science fiction that his works often cited. As the disorganisation of perception in science fiction enabled the reader to recognise unexpected aspects of the present through images of the future, so Davila's canvas juxtaposed different types of sign, ranging from *trompe l'oeil* framing, diagrams,

abstract marks and words, to iconic symbols such as the swastika. Because his figures were so aggressively and significantly asserted – because they had enormous penises or were juxtaposed with political symbols – they became allegorical, combining the conceptual legitimacy of 20th-century art with the natural power of recognisable objects. Everything was double-coded and everything, because of the increasingly traditional painterly illusionism, appeared familiar, like a bad dream.

Although many critics spoke of such works as subversive exposés, I think that their quality lay more in their ability to conjure up ghosts. Davila's work of this period, including *Echo*, should thus be linked with contemporaneous works by Anselm Kiefer, for example *Shulamite*, 1983. Both artists recognised that the power of art to alter and disrupt society was neutralised by incorporation in museums. Both created paintings that were only really suited to museum display. Juan Davila's pictures, if they were to be taken as anything more than simple-minded protests, depended upon a knowledgeable viewer's appreciation of the disjunction between word and image or between rhetoric and intention.[24] *Echo* recreated the aesthetic lure of semi-Fascist delirium and forced the viewer to contemplate his or her own complicity in what he or she would ordinarily condemn. Davila's simulations of other artists' work and depictions of 20th-century history looked like a public execution; many of his paintings featured scenes of desecration, rape and violence, referring to government repression in Chile.

Davila demonstrated two tendencies: the perverse stylistic marriage of postmodernism and modernism; and the violent disfiguring of abstraction, seen in the obliteration of distinctions between figurative and non-figurative motifs within the space of science fiction. For Davila, the margins became more than Other and more than an image of the heart of darkness. His achievement was to create an art of the museums (to borrow Cézanne's phrase) outside the mythologies and dependencies of European and American centres. Although Davila cannibalised the body of art, his paintings did not show art consumed by desire, but desire consumed by art.

By the end of the decade, Davila's pictures became the enactment of filmic postcolonial narratives about sexual desire and punishment, populated by characters from Latin American cultural mythology and caricatures of personalities from the Australian art world. These developments will be explored in Chapter 6.

Commentary on Davila, like that on Tillers, was flawed by its fixation on his appropriative method. His appropriation should have been distinguished from quotation and more accurately described as citation. In his paintings, sexual fantasy appeared as permanent reality – the way the world would be if it was ordered like William Burroughs' apocalyptic narratives. The setting for Davila's fantasies was the artist's studio and sex was the centre of its universe. The studio was the locus of culture, as in Courbet's famous painting, and stood in for (even contained) all of culture. Despite his rhetorical populism, viewing Davila's paintings was like being admitted to a very select club and then wondering what all the famous people were really like. The answer, of course, was that personages on museum walls have no character of their own at all; Davila's corruption of meaning was a particularly bleak and ruthless form of truth-telling.

24 The process is elegantly described in Andreas Huyssen's *October* essay on the German artist's notoriety and his indebtedness to the art of the 1960s and 1970s: Kiefer is a post-Conceptual artist. See Andreas Huyssen, "Anselm Kiefer: the Terror of History, the Temptation of Myth", *October* n. 48, Spring 1989, pp. 25-46.

Metropolis: Postmodernism and the late 1980s

METROPOLIS: POSTMODERNISM AND THE LATE 1980s

Metropolis: Artificiality, Disorganisation and the Transnational Marketplace

Contemporary Australian art exists as part of an alluring transnational marketplace which, like a postmodern Metropolis, is characterised by speed and disorganisation. This marketplace flows across national borders because of its global interdependency, assuming the image and function of an organised international market linked by electronic technologies that abolish time and space.[1] The network of ideas and information transmitted by the dominant economies of the West constitutes, as Raymond Williams observed, the true contemporary metropolis.[2] The "centre" is not a single city as such but the network of international institutions based in cities such as New York.

If the multi-sited metropolis of international art was characterised by artificiality and speed, it also resonated, in the late 1980s and early 1990s, with nostalgia for an earlier modernist stage of urban experience – for the 1920s, for example, when Berlin was the avant-garde crossroads of Europe, and Moscow was the locus of the future. In 1990 Christos Joachimedes and Norman Rosenthal, curators of the influential 1982 exhibition, "Zeitgeist", staged its sequel, "Metropolis" (a title bringing to mind Fritz Lang's expressionist film), attempting an overview of contemporary art. The motifs of artificiality in "Metropolis", like other international surveys of contemporary art, were exclusively those of urban experience rather than art about the natural world.[3] The postmodern insistence on artificiality converted metropolitan life into images of almost exclusively ironic experience and this same artificiality reassembled the second-hand reality communicated by the mass media and mechanical reproductions. The art in such international exhibitions was marked by the impact of urban life and the dominating influence of information media such as television. This influence was deliberately reflected in an all-pervasive irony and materialism. The subject and form of this art was passivity, exhaustion and consumption. The art of "Metropolis" and, in an Australian equivalent, that of the 1993 Perspecta exhibition at the Art Gallery of New South Wales, often resembled transmogrified furniture, reflected consumer and leisure interests, and adapted retail display techniques in the pursuit of spectacle.

The desire for a pure language of painting had been internationally replaced in the late 1980s by the desire to surpass "natural" meaning. This excess was sought by incorporating the signification of consumption – by collectors, museums and art magazines – inside the frame of the art object. Aleks Danko was a particularly important artist because his works bridged the gap between the 1970s and the present, and between the most crucial aspects of international and Australian art. The conceptual operations of his works recapitulated the radical dilemmas and weighed the consequences of the representational violence that marked the "end of art" in the late 1960s. On the other hand, they asserted his absolute awareness of the place of art in the cultural food chain.

International and Australian art during the later 1980s was similarly self-reflexive; as well as an obsession with artificiality the decade saw artists such as Peter Tyndall agonise over the heightened awareness of art's status as a luxury commodity. Whereas this self-consciousness had previously been of incidental interest, except to artists like Aleks Danko, it now became one of contemporary art's main motifs. Susan Norrie's paintings exemplified the resolution of this cultural dilemma through the hyperalertness of consumer fetishism.

1 For an account of electronic, urban disorganisation see Paul Virilio, "The Overexposed City", *Zone v.1 n.2*, 1987, pp. 14-31.

2 Raymond Williams, "Metropolitan Perceptions and the Emergence of Modernism" [1985], reprinted in his *The Politics of Modernism: Against the New Conformists*, Verso, London, 1989, p. 38.

3 See Paul Virilio, "Perspectives of Real Time", in Christos Joachimedes and Norman Rosenthal (curators), *Metropolis: International Art Exhibition*, Berlin, 1991, Rizzoli, New York, 1991, pp. 59-64.

Previous page: detail of **4:2**.

4:1 Aleks Danko, *"What are you doing boy?"*, 1991, installation, Australian Centre for Contemporary Art, Melbourne. Photograph: Warwick Page. Courtesy Sutton Gallery, Melbourne.

4:1

4:2

Aleks Danko: Travesties of the Museum

Aleks Danko's art was profoundly and precociously shaped in the late 1960s and early 1970s, and from that period onwards he elaborated certain themes with enormous consistency and will. If he located very early, in the works discussed in Chapter 1, the issues that he would then persistently address, his later works were equally marked by their origin in the "Year Zero" of culture's crisis in the late 1960s.

Much of Danko's work was a dramatisation of crisis in visual form. The resolution that this enactment took was intimately connected with artistic strategies of deception centred upon the economy of the museum – whether present or in hiding – and thus upon the establishment, conservation and dissipation of cultural capital and value.[4] Thus, Aleks Danko neither accepted the illusion of art's ability to perpetually reinvent itself, nor did he assume the false consciousness of the avant-garde's continued relevance. He made outsider art.

Danko's iconography was dominated by motifs of vulnerability, fiction, deceit and, above all, humour. He noted that "Humour is a very trusted servant. It allows the audience a point of entry; it means they can come to the party and not know why."[5] The paradoxical combination of near-total museological professionalism with a fluid notion of identity was seen in the artist's erratic relationship to the more conventional signs of

4　See Benjamin H. D. Buchloh's marvellous "Conceptual Art 1962-69: From the Aesthetic of Administration to the Critique of Institutions", *October* n.55, Winter 1990, pp.105-143.

5　Aleks Danko, interview with the author, December 1993.

4:2　Aleks Danko, *Pomona 1957*, 1992, installation, Noosa Regional Art Gallery, Noosa. Photograph: Mark Oss-Emer. Courtesy Sutton Gallery, Melbourne.

authorship (editioning and signing). Danko did not sign his works until the mid-1990s.

The quotes of *To Give Pleasure, 1985*, 1985, were drawn from texts by Alain Robbe-Grillet and reappeared in a 1994 installation, *Zen Made in Australia*, which also incorporated images from a turn-of-the-century window-dresser's manual that taught the procedures for manufacturing *papier mâché* columns and rabbits. *To Give Pleasure* also contained two portraits in installation form of close friends and artists with whom Danko had taught: *John Nixon (Portrait), 1985*, 1985, and *In the Absence of Folly (for Tony Clark)*, 1985. If Sydney critic John McDonald, in an on-going feud with Nixon, identified Danko's simulations with the disrespect of travesty, he underestimated the sincere ambivalence and complexity of Danko's intentions.[6] Danko responded with a letter to *Art Monthly*'s editor, which commented of the *John Nixon (Portrait), 1985*, that "The work is composed of a series of borrowings from his work and is composed in such a way as to re-echo his strategies".[7]

The simulation of his friends' art was consistent with an understanding that there were no new objects to be made. A reconstruction of works by Nixon and Clark enabled Danko to borrow two diametrically different conceptions of originality and history within one over-arching installation. The elements in *No 28 – from Dialogues with a New Window-Dresser – Harvest*, 1989, at Store 5 in Melbourne, represented a catalogue of abstract painting's neo-modernist tropes and, implicitly, an oblique commentary on the history of installation art. The tiny alternative space's half-open door represented the supposed dialectical inclusiveness of avant-garde art. A pitchfork piercing the blue painting signalled the modernist monochrome. A drawing of a cow on brown paper with its head framed by rifle sights and framed by real brooms alluded to 1980s critiques of representational modes. An empty picture frame represented the conceptual boundaries suggested by the importation into art of motifs from theory such as French deconstructionist Jacques Derrida's *parergon*, or frame. Finally, a cup filled with smelly creosote suggested *Arte Povera* and installation art.

Danko's later installations, such as *What are you doing boy?*, 1991, reflect Daniel Spoerri's 1960s domestic Fluxus topography in *An Anecdoted Topography of Chance (Re-Anecdoted Version)*. The format of the enlarged illustrations mirrored the typography and drawings in Spoerri's book.[8] Around three walls, mural-sized red-edged copies of the illustrations from a Russian school textbook showed a schoolboy at play and school. Blackboards, chairs and the boy in knickerbockers suggested a view from childhood: the discipline imposed on children; a conflict between the exile culture of his Ukrainian parents and the Anglicised Adelaide where he grew up.[9]

Danko can be compared to American conceptual artist Bruce Nauman. The artists' combinations of black humour, parody, minimalism and pain required deliberate stylistic inconsistency. Nauman videoed himself dressed as a tortured clown and constructed time-based neon sculptures; the Airwick air-fresheners of a room in Danko's installation, *Pomona 1957*, 1992, fulfilled the same function as, in another installation, diagrams borrowed from William Hogarth's *Analysis of Beauty*. This unequivocal inconsistency allowed an intuition of the nexus between aesthetics and power, and was the reason for both Nauman's and Danko's interest in the idea of "taste": the consumption of art was, after all, inextricably caught up with systems of power, social class and gender. The site of these intersections was the museum of art.

The artist's Melbourne installation, *Taste*, 1988, overlaid an identification of aesthetic

6 John McDonald, "Is there no serious criticism here?", *Art Monthly* n.1, June 1987, pp. 4-6.

7 Aleks Danko, unpublished letter to the editor, Peter Townsend, June 4 , 1987, artist's copy.

8 Daniel Spoerri, *An Anecdoted Topography of Chance (Re-Anecdoted Version)*.

9 For an illuminating assesment of this work, see Robert Rooney, "The eyes of childhood", *The Weekend Australian*, August 24-25, 1991.

hierarchies with a subliminal historical pedigree from academic art history. The collection of comic heads on stands contemplating a funky fluorescent sculpture was, in fact, a reference to Hogarth's description of aesthetic hierarchies in *The Analysis of Beauty*. The cartoon face (which also appeared on Danko's business card) was a detail from the border of a Hogarth engraving.[10] In the central tableau, sculpted figures crowded a workshop. Different types of figurative language were on display: masterpieces of ancient sculpture; odd assortments of figures; anatomical diagrams; and a story-board sequence of a human head drawn in different ways (one of which was the cartoon head). Hogarth's assertion that he and the connoisseurs were at war took on contemporary currency; according to Danko, Hogarth's drawing immediately reminded him of the paintings of Jenny Watson, Jean-Michel Basquiat and A. R. Penck.[11] If there was no clear-cut division between modes of representation, then Danko's installations were, from the 1980s onwards, saturated with images of rhetoric and battle.

Danko's works became progressively more single-minded, allowing him to present ideas with the calculated violence that perfectly mimicked the late 20th century. In *Pomona 1957*, an erotic Mills & Boon-style catalogue essay combined with air fresheners in a symbolic economy of hygiene and evacuation. Danko's consumer syntax and interventions at the entrance and exit to the Noosa Regional Gallery, where the work was installed, suggested the logic of this enterprise – the construction of a temple of thought to mask a violent interrogation of our sense of location in the world. Reason did not eradicate darkness because, clearly, the flip side of Virtue's coin was Terror.

Aleks Danko's works gradually distanced themselves from the orthodoxy of the ready-made. *Zen Made in Australia*, 1994, alluded, of course, to the question of whether installation can ever be more than window-dressing. Installed at the University of Melbourne Museum of Art in 1994, the use of objects from the University's collection (including applied art such as furniture) raised the same issue: was installation no more than a covert simulation of curating? This uncertainty disguised Danko's contamination of the gallery. He mimicked art to liquidate the remnants of traditional aesthetic experience. He constructed a travesty of the art institution just as he fabricated, without malice, imitations of the art of his friends. His mimicry was a twisted version of minimalism – an endpoint in the immensely complicated dematerialisation of meaning.

Aleks Danko's installations referred to a crisis in representation, well rehearsed in much current art and paramount in art since the late 1960s. Did Danko aspire to the systematic presentation of a system of knowledge or theory? I think, instead, that his world was regimented by signs illustrating the arbitrariness of aesthetic taste and that its visuality was linked with violence. The over-riding metaphors in *Zen Made in Australia* were of darkness, misrecognition and reading – the responses of an intellectual in exile. The art museum's invaluable institutional structures and resources were incorporated into a single-minded, insistently resonant fragmentation of vision.

Peter Tyndall: The Circulation of Art

Tyndall's subject was the circulation of art; his installations and paintings described the way we look at art in galleries and, more recently, in the forums of international museums. His project – to render visible the viewer's relation to art – was similar to Danko's and his belief in the critical reconstruction of culture was utopian. Tyndall's work, therefore, was both modernist in its gently dated, didactic optimism and postmodern in its awareness

10 Danko found this image in Joseph Burke (ed. and introduction), *William Hogarth: Analysis of Beauty*, Oxford University Press, Oxford, 1955, p. 65.

11 Aleks Danko, interview with the author, December 1993.

4:3
Title: *detail*
 A Person Looks At A Work Of Art/
 someone looks at something …
Medium: *A Person Looks At A Work Of Art/*
 someone looks at something …
 CULTURAL CONSUMPTION PRODUCTION
Date: – 1988–1990 –
Artist: Peter Tyndall
Courtesy: Anna Schwartz Gallery

Peter Tyndall's installation appeared as part of an exhibition, titled *¡Relax!*, at Sydney's Yuill/Crowley Gallery in 1990.

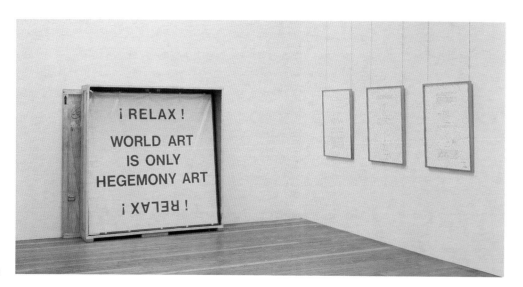

4:3

of limits. Peter Tyndall's 1990 installation at Yuill/Crowley Gallery in Sydney included abstract motifs and typographical forms from Russian Revolutionary art as a component in a satirical fantasy on the international art market and its Documentas, and on his experience as a participant in the 1988 Venice Biennale. *¡Relax!*, 1988-90, was typically mordant. His installation knowingly utilised the aesthetic commandments most valued during the 1980s afterglow of avant-garde rhetoric. It was a prayer of postmodernity: to undermine, destabilise and transgress. In most of his works, Tyndall alluded to populist complaints about the Art Cult (of contemporary art) and based his text-dominated paintings around the idea of a "secret society" of culture. He incorporated dreams into his works as a way of obliquely commenting on cultural consumption and power.

¡Relax! comprised several works that mimicked the appearance of paintings. By adopting an eclectic role of cultural anthropologist, employing several styles and media, Tyndall circumvented categorisation. Thus, for over two decades, he deliberately titled all his works *detail: A Person Looks At A Work Of Art/ someone looks at something*. His work for Aperto, the survey exhibition of the 1988 Venice Biennale, was subtitled *The right-angle giver*, 1988; it combined an image of Christ with a carpenter's tool (the spirit level) as a metaphor for cultural purity and control. In *¡Relax!*, a painting with the words "¡Relax! World art is only hegemony art" was wrapped in plastic, leaning inside an opened crate ready for shipping. Alongside hung the silk-screened enlargement of a hand-written notation which described the appearance, on August 8, 1990, of the National Gallery of Victoria, Australia, in a scene from the television series *Mission Impossible*, as the Manhattan Museum of Art. The last piece in the show was the most complex: a triptych of text relating a long dream about Tyndall's imaginary inclusion at a Documenta exhibition. During nocturnal explorations through a huge exhibition pavilion, the artist stumbled into a Piranesian metropolis of activity: "As far as the eye could see the night lights flooded a vast scene of endless structure-building. This was the American contingent. These were Americans".[12] In the dream he then revised his planned piece. Tyndall's ambivalence about his own artistic innocence surfaced at the dream's conclusion. The artist's insistence throughout the dream that Australian "honey" (symbolising Tyndall's intentions) was "pure" was finally contradicted.

In *¡Relax!* Tyndall completed a decade-long transition from a 1970s textbook concern

12 Wall-text by Peter Tyndall for his 1990 exhibition at Yuill/Crowley Gallery, Sydney.

4:4

with epistemology into an apparently more political and satirical voice. If his desire to extract cultural leverage from a provincial location seemed bleak, desperation was mirrored in his insistence on identical titles for every work; titles were "the one piece of writing that the gallery system feels obliged to honour". However, his overdetermined dreams about art also suggested cynicism's opposite. Conversational commentary, endless bracketing of self-expression and Glenn Baxter-like humour together constructed the consistent feeling of a world-view grounded in common sense. Tyndall once published a newspaper comic strip, "Culture Corner with Uncle Pete", which was heavily indebted to Marcel Duchamp, whose influence alerted viewers to the understanding that Tyndall's installation was a matter of considerable refinement and distillation. The artist was absolutely determined to persuade us of his ordinariness. His imagination was pulled leftwards and downwards by a fastidious political undertow. Since his intention was clearly not polemic, Peter Tyndall was imaging a personal Temptation; the romanticism of such an enterprise and the attraction of World Art (the art of the metropolitan centre) was subverted by carefully rationed factuality and humour.

Self-consciousness strengthened the tendency of contemporary art towards a display of refinement, evident in Tyndall's extraordinarily accomplished return to painting in a 1994 Melbourne exhibition. Although the differences between Aleks Danko's and Peter Tyndall's installations appeared great, they were linked by their reflexiveness, their extreme self-consciousness and their knowing, ambivalent understanding of the world of international art – the only art, according to those metropolitan centres, that is authentically contemporary.

Susan Norrie: Signs of Cultural Consumption

In the late 1980s many younger artists as dissimilar as Susan Norrie, Janet Burchill and Jon Cattapan stripped their works of overtly regional references. They did not necessarily share any visual language, but were all self-consciously "international" artists, making art about the televisual worlds of consumer pleasure, adapting retail sales methods and

4:4
Title: *detail*
 A Person Looks At A Work Of Art/
 someone looks at something …
 LOGOS /HAHA
Medium: *A Person Looks At A Work Of Art/*
 someone looks at something …
 CULTURAL CONSUMPTION PRODUCTION
Date: – 1994–
Artist: Peter Tyndall
Collection: Vizard Foundation (on loan to
 the University of Melbourne)

4:5 Jon Cattapan, *Rising Tide*, 1989, oil on linen, 195 x 230 cm. Courtesy Sutton Gallery, Melbourne; Annandale Galleries, Sydney; and Bellas Gallery, Brisbane.

4:5

levelling cultures (high or low, East and West) without apparent comment. Jon Cattapan transformed his paintings from an accomplished regional surrealism into luminous landscapes of global capital. The key to understanding such artists' works was an awareness of the techniques of simulation where, in contrast with the paintings of Tillers and Davila, clear signals of regional dissent were eliminated. To compensate for this erasure, they incorporated the signs of material and cultural consumption.

Since contemporary Australia seemed, at the start of that prosperous time (during a credit boom preceding the stock-market crash of 1988 and the art-market collapse of 1991) to offer a quintessential experience of postmodernism, they were clearly affected by a particular *zeitgeist*, characterised by the artificial, the fake and an ironic, ambivalent reverence for the idea of art.

Susan Norrie painted Walt Disney characters and iconic representations of consumer identity. Her abstract expressionist simulations were substituted for authentic, expressive gestures. Norrie maintained in 1990 that painting "is quite bankrupted now".[13] In her paintings, the universe looked like the realisation of human desires: this was a long way from allowing the existence of any "authentic" experience at all.

fête, 1986, was a painting of picture-postcard references in which signs of the profound and the sublime were quoted, neutralised and reduced. The impact of her pictures resulted from Norrie's intense sense of the contemporary while, paradoxically, her sources were often antique objects from museums. The co-option of museum culture in *fête* embodied many widely shared notions of dislocation; she dramatised this free-floating disequilibrium in her late 1980s paintings to the point of parody. In *fête*, Norrie confiscated museum and popular imagery in a blurry, "mix'n'match" sludge of high art, mass culture and individual production through which she signified the deliberate tragic frivolity of "modern times". *fête* was tinged with malevolence: images of decay were paired with the most sumptuous surfaces. Mickey Mouse was portrayed as an amphetamined, grinning Pierrot in yellow gloves, silk-suited frills and fancy slippers – an image adapted from a painting by French Rococo artist Watteau. Adrift in a miasma of aquatic, slimy, gestural abstraction, the mouse gestured downwards into inky pits of paint. In this murky space floated the signs of high culture: a yellow *tachiste* crown; blotchy, half-glimpsed courtiers strayed from another Watteau painting; the divine sphere of Platonic measurement. The mouse looked sideways at chair-lift cabins appropriated from an amusement park or a World Fair; Norrie mixed references to leisure, television and Disneyland with historical citations (from Watteau) and modernist allusions (the overblown gestural New York School rhetoric of Hans Hofmann). The painting was heavily indebted to Robert Rauschenberg's early canvases, such as *Tracer*, 1964, and both works reflected a mobile, restless idea of personal identity based on scavenging and shopping for old and new images, juxtaposing them amidst messy abstract marks and passages of more precise figuration. *fête* was an image of cultural transaction and its ambiguous shapes were deliberately imprecise; Mickey Mouse was set loose in an endless chain of desire-driven transactions. Norrie observed: "The female situation is often that of a perpetual state of shopping. Also, my father was involved in department stores which is why, I suppose, the notion of retail is important to me."[14]

fête won Norrie the inaugural Moët & Chandon Art Foundation award in 1987. The Moët & Chandon award, which was restricted to artists aged less than 35 years, was one of the richest art prizes in Australia. The inaugural exhibition was dominated by

4:6

13 Susan Norrie, quoted in Jennifer Stevenson, "Art Trade", *Vogue Australia*, May 1990, p. 146.

14 Susan Norrie, quoted in "Susan Norrie: French Polish", *Good Weekend*, February 26, 1988, p. 22. Her father was the Deputy Chairman of Grace Brothers Department Stores in Sydney.

4:6 Susan Norrie, *fête*, 1986, oil on plywood, 213 x 152.5 cm. Collection: Moët & Chandon, Epernay, France. Photograph: Robert Walker. Courtesy Mori Gallery, Sydney.

polarised conceptions of personal style, ranging from the self-conscious, clinical "deconstructive" scientific diagrams of Jan Nelson, and the overblown, finger-painted neo-expressionism of Jonathan Throsby to the more conservative modernist figure paintings of Joe Furlonger (who won the prize the following year). *fête* correctly established Norrie's public reputation as both a traditional *auteur* (the sensuous paint quality of the picture was much admired by conservative critics) and a supremely Cool postmodern stylist, aware of and ironically distanced from the theatricality of her painting, which would surface again in a later Sydney Artspace installation, *Error of Closure*, 1994, and her large survey at the Art Gallery of New South Wales at the end of 1994.

The Tall Tales & True series, which included *fête*, was a turning-point for Norrie. In earlier paintings, such as the Lavished Living series, which was shown at New York's Guggenheim Museum as part of a 1984 Australian survey exhibition, Norrie reworked traditions of Australian landscape painting, hiding von Guerard-like pastoral scenes behind anthropomorphic rocks. Norrie observed:

> I choose objects out of the landscape, certain rocks and land formations, and use them as metaphors, juxtaposing them with the woman – whom I've deliberately clad in 18th century garments, a reference to being out of time, to the sense of our being pioneers.[15]

From these works onwards, her self-consciously regional metaphors mutated into images of metropolitan origin. Her early interest in Australian national symbols, which was similar in inflection to Imants Tillers' ironic adoration of museums, was displaced by a deliberately cosmopolitan vocabulary of forms. Norrie's *The Sublime and the Ridiculous*, 1985, was an encyclopedic compendium of visual clichés from Old Master painting in museums and from B-grade horror movies. Everything was either flawed or a metamorphosed version of something else. The picture's techniques, which included *tachiste* mark-making, feathery brushstrokes and dark, enamelled glazes, were appropriated from the history of pre-modern painting and then cursorily reproduced so that signs of painterly originality were exploited as deliberate, luscious ugliness.

The Sublime and the Ridiculous existed in two versions; one was a smaller copy of the other in an inversion of the usual romantic image of spontaneous inspiration. A precipitous vertiginous viewpoint reinforced the sense of inaccessibility, just as Norrie's juxtaposition of cheap *grand guignol* with great art suggested that a spontaneous relationship to beauty was a thing of the past. The equivalence of images from high art with the signs of mass culture was, she implied, the fate of masterpieces in an age of mechanical reproduction. In *The Sublime and the Ridiculous*, kitsch and fantasy were treated with an art-critical seriousness so that the traditional notion of the artist as an authentic, original *auteur* was replaced with a manipulative identity borrowed from popular culture – Walt Disney's idea of the cartoon animator as an "imagineer".[16] Norrie observed that American imperialism, cultural colonialism and the history of its impact on Australian art informed the Tall Tales & True series. Her paintings of this period included Disney figures such as Goofy and Mickey Mouse set amongst abstract expressionist blocks of colour and expressionist drips. They were infected by a ghoulish fascination with decay, kitsch and *fin-de-siècle* ambivalence.

Norrie highlighted the gendered implications of abstract signs in a feminist examination of modernism. Her attitude to subject matter both excited and troubled Melbourne *Age* critic Gary Catalano: "Norrie's paintings all betray a preoccupation with sentimentality

15 Susan Norrie, quoted in "The Artist Exposed", *Vogue Living*, October 1984, p. 82.

16 See Jo Holder, "Conditional Tales and Truths", in *Susan Norrie*, University Gallery, University of Melbourne, Melbourne, 1986, p. 6.

17 Gary Catalano, "A display of perplexity", *The Age*, October 22, 1986, p. 14.

18 Benjamin Buchloh, "Allegorical Procedures: Appropriation and Montage In Contemporary Art", *Artforum* v.21 n.1, September 1982, pp. 43-56. Walter Benjamin's seminal text, "The Work of Art in the Age of Mechanical Reproduction", expands on this idea.
This depletion, Buchloh explains, occurs when appropriation effects a separation of the signified from its signifier, rather than enhancing a distant original. A visual text is superimposed with or doubled by a second text. The reading is shifted to an examination of the object's framing device, which determines its pictorial sign.

19 Jean-François Lyotard, *The Postmodern Condition*, pp. 78-79.

4:7 Susan Norrie, *The Sublime and the Ridiculous*, 1985, oil on plywood, 240 x 180 cm. Collection: National Gallery of Australia, Canberra. Photograph: Kalev Maevali. Courtesy Mori Gallery, Sydney.

and kitsch. The ambivalent attractions of standardised or second-hand emotions is the governing theme of Norrie's art".[17] She had embraced Pop Art's imagery of mass culture, production and consumption with the most inappropriate, anachronistic techniques of easel painting. Her ability to create seductive, *trompe l'oeil* effects of considerable beauty was disorienting because the effects existed only for intellectual purposes. The originals that she copied seemed not to hold any interest for her and traditional ideas of originality found only the most fugitive place. The canons of Academic copying had privileged certain originals as special signs of heritage and tradition; while she still cited these canons, she patently doubted their validity. Copying Old Masters had, until the 19th century, asserted a sense of continuity and allegiances with earlier artists. However, in her works, copying was the sign of her own and her viewers' alienation from cultural models. The cathedral in *The Sublime and the Ridiculous* was detached from its inherent value as a sign of culture and belief. Continuity with the past had been eliminated, despite all the painterly scumbles and glazes. Whilst 1980s photography took the depletion of art's aura as its starting-point, Norrie's appropriations always referred to the accumulation of value, whether monetary or cultural.[18] Her borrowings were agonisingly suspended between the critical and the collusive.

Suspension and incorporation became obvious devices in Norrie's next two series. The PÉRIPHERIQUE paintings, such as *Debit*, 1988, and *Credit*, 1988, featured words rendered in elegant cursive script. The iconic vocabulary of economics appeared emblazoned, multiplied, inverted, fragmented and camouflaged in lurid pinks and reds. Their "all-overness" implied infinite extension and the repeated applications of script were virtually illegible. The thinly stencilled text was suspended and embossed in glossy layers of liquid brushstrokes, repeated decorative flourishes and rich surfaces, which deliberately signified nothing except surface effect and foregrounded painterliness as a commercially marketable, mechanical process. As in her earlier pictures, painterly virtuosity produced deliberate confections; the viewer was left unable to feel any real empathy other than admiration at the spectacle of a collapse of meaning and ascendancy of the market. The repeated cursive flourishes were expressive of "style" rather than content, as were the elegantly messy brush marks of the Tall Tales & True series.

Norrie's "abstraction" represented a considered historical passivity; her simulation of non-objective painting reflected an interest in the persistent authority of modernist mythologies. She adapted and analysed avant-garde strategies that had become clichés, such as the idea of "subversive" art, by emptying the significations of texts and images from her pictures. Norrie's paintings illustrated, quite deliberately, the complicity between high art, mass culture and the art market.

What was gained by this so-called recognition of complicity, and why was modernist art, particularly its most emblematic genre – abstraction – so victimised by artists such as Norrie? According to French postmodern theorist Jean-François Lyotard, "the various avant-gardes have, so to speak, humbled and disqualified reality by examining the pictorial techniques which are so many devices to make us believe in it".[19] Norrie, like Juan Davila and Peter Tyndall, was suspicious of both the reductive modern presentation of the unpresentable and the deliberately constrained artistic vocabulary that had come to represent little more than a mystification of artistic means posing as universal truth. Susan Norrie's progression mimicked the teleological reduction of formal means and vocabulary; she eliminated the signs of figuration during a decade of her work. Her

4:7

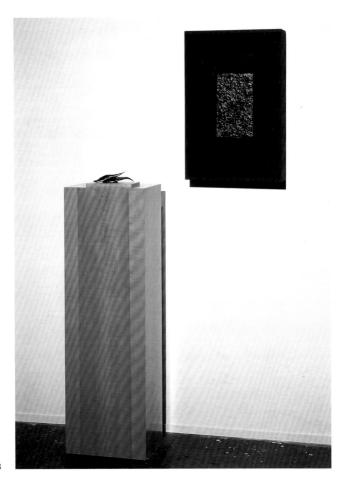

4:8

images, though, were neither entirely emptied of meaning nor as banal as critics asserted. The mass production suggested in *Debit* was belied by the end result. Off-register, blurred, unevenly painted and arbitrarily coloured, like postmodern wallpaper, her pictures were more atmospheric than a deadpan posture required. The PÉRIPHERIQUE paintings implied the confinement of knowledge and artistic resources within the prison of received images.

In *Ensemble*, 1990, three large, wood-veneer cabinets housed small paintings. Cabinet-making became her carefully over-literal representation of a concept: veneer cabinets enclosed smaller pictures like works within works, establishing the viewers' position at a distant remove like a window-shopper. Such display techniques also subsumed one aesthetic object inside another, as in an installation. Her allusion to retail display highlighted her affinity with postmodern American artists such as Richard Artschwager and Sherrie Levine, and with early conceptual art by Donald Judd. Like these artists, she alluded to the picture-frame's aesthetic function as the demarcation zone for art. She placed herself within the tradition of conceptual art initiated by Marcel Duchamp.

Norrie's career moved rapidly into the institutions of fame and fashion: from the much-deserved Moët & Chandon prize to New York exhibitions. Her work described the decadent economy of images analysed by Jean Baudrillard and thus her paintings' hypermannerism was clearly legible in the hyper-reality of New York. She saw the viewer as consumer, and therefore affirmed and exploited painting's place as an eminently desirable commodity. Susan Norrie's paintings embalmed sickly glamour and the

4:8 Susan Norrie, *Model Two* (detail from the *Error of Closure* installation), 1994, oil on canvas, linen-covered frame, wooden object on veneered stand. Collection: the artist. Photograph: Peter Smart. Courtesy Mori Gallery, Sydney.

evaporation of profundity, as if she wished to force upon her viewers a reflection of their own profound narcissism.

Mistaking Culture for its Signs: The Achievement of Postmodern Art

During the 1980s, postmodern artists, critics and journals occupied positions of authority and prestige in Australian cultural institutions, exercising a benevolent cultural hegemony. The editorial bias of Australian art magazines, including *Art & Text, Tension, Agenda, Eyeline* and even, on occasions, the relatively long-established *Art and Australia*, reflected a commitment to the sympathetic coverage of experimental and postmodern art. The programs of contemporary art spaces like the Australian Centre for Contemporary Art in Melbourne, the Institute of Modern Art in Brisbane and Artspace in Sydney privileged similar forms. On the other hand, alternative artist-run spaces as different as Roar Studios, in the early 1980s, and Store 5, later in the decade, had adopted the rhetoric of an oppositional modernist revival, hostile to institutions and ostensibly wary of recuperation into the mainstream. These were superficial differences, incorporated with relative ease into institutions and commercial galleries during the boom of the late 1980s, when contemporary art, for once, was both fashionable and profitable. There was a boom in sales of art and, like the general 1980s return to painting, this reflected conservative times. Dealers and curators demonstrated a keen interest in the promotion of new artists, who received extensive attention in commercial galleries and in survey exhibitions such as Perspectas and Biennales. There was an expansion in the enthusiasm and the composition of contemporary art's audience. A plethora of newspaper articles about the boom, art investment, lifestyle enhancement opportunities in art, and gossip about artists' shifting allegiances from gallery to gallery attended the boom from 1986 until 1990. Melbourne's Australian Centre for Contemporary Art was able to attract private sponsorship from the Smorgon family to build a spacious new wing, opening with a large exhibition of Imants Tillers' paintings at the start of 1987. By 1990 there had been a considerable redefinition of the characters – artists, dealers, curators, the art press and audiences – in contemporary art's narrative.

Museums, magazines and galleries were the most important spaces in which art was seen and in which artistic success was brokered. Unlike the Dada artists of World War I Europe, who measured their success by their exclusion from museums, Australian avant-gardists did not bite the hands that fed them.

Charisma and glamour had become for younger artists in the 1980s both a spiritual aspiration (in the case of American artist Jeff Koons) and a way of mediating reality. According to founding editor of *Art & Text*, Paul Taylor, writing in an *Art in America* special issue on money, it was the artists, by and large, who talked about their bank balances and tax.[20]

The work of Australian postmodern artists in the 1980s was marked by an awareness, discussed in the last chapter, of their peripheral location in regard to the centres of world art. This consciousness was developed further in the late 1980s and early 1990s by artists such as Susan Norrie, who blurred the division between art and history, mimicking and recapitulating, by their stylishness, the end of modern art in a postmodern period.

Danko and Norrie, however, were characterised by a fitful desire located around the most persistent wish of the avant-garde – an ambition to see the end of the institution of art. Their paintings and installations, like postmodern (and, often, modernist) art gener-

20 Paul Taylor, interview in Nancy Princenthal and Deborah Drier, "Critics and the Market-place", *Art in America* v.76 n.7, July 1988, pp. 108-109.

ally, were predatory (the artists' preyed upon other artists' works by exploiting copying traditions), oedipal (the meanings that they perverted were central to the art they grew up with), ironic (their pictures perverted previously simple meanings), and alienated (endless resuscitations of style proved that every good idea had clearly already been had).

Susan Norrie, Aleks Danko and Peter Tyndall created works intentionally lacking in emotional depth. They deliberately mistook modernism for its signs, in order to make the "purely plastic" language of modernism available for interrogation. The regional and historical references of Australian postmodern artists were combined with recycled modernist strategies, including the enervated avant-garde desire to "subvert", but in a much more complex, ironic and layered way than the new abstractionists of an earlier chapter. During the consumer boom that would end disastrously in the recession of the early 1990s, postmodern art communicated the absolute desirability of the commodity fetish through the manipulation of media spectacle and the reception of art. Art in the 1980s, as these artists understood, was intensely theatrical and its stage was usually the gallery or art museum. Abandoning the idea of an eternal, archetypal museum without walls, this postmodernism was also confronted by the loss of the elusive promise, sought by socially committed artists of earlier decades, of a place for art outside the museum.

The Expanded Field: Alternative Art Forms in the 1990s

Bleak Cities: Recession and an Altered Art Landscape

This chapter maps a renewed interest in hybrid art forms: in the early 1990s installation, photography, video and performance had gained a relevance that reflected dramatic alterations in the art world and models of artistic practice.

If a belief in positive change temporarily reclaimed its place in discourse, as first China, then the whole of Eastern Europe, exploded in 1989, the expectation that the 1990s would be a "caring" rerun of the idealistic 1960s was easily shed in the face of the global recession, Tiananmen Square massacre and feudal tragedies that followed.

The economic boom of the 1980s, which had exaggerated the most mercantile tendencies of contemporary art in an expansive bedlam, failed. The collapse of the art market from 1990 onwards, and the closures of many commercial galleries throughout Australia, were accompanied by a reaction against the conservatising expectations of commercial spaces and art museums over the previous decade and a questioning of art and its institutions. The underlying reality of the economy of art remained conditioned by Cold War certitudes and by art's post-World War II merger with the entertainment industry.

The recession produced an altered landscape in which many commercial spaces foundered. Leading Sydney, Melbourne, Canberra and Brisbane galleries of the 1980s vanished or "downsized": in Melbourne, Powell Street, Realities, Girgis & Klym, Judith Pugh and Gore Street galleries closed, as the gallery district contracted to inner-suburban Richmond and Fitzroy; in Sydney, Garry Anderson and Macquarie galleries disappeared. Commercial galleries saw their clientele shrink to a few well-known corporations, idealistic private collectors and institutions. Other corporations that had patronised contemporary artists during the 1980s sold their collections: the Budget corporation, for example, was bankrupted, selling its collection at auction and absorbing considerable losses in the works' value. Low-rental alternatives reflected the inability of the commercial system to meet young artists' aspirations or to show more than a tiny fraction of the artists left unrepresented by gallery closures. These alternatives ranged from co-operative spaces such as Sydney's Pendulum, CBD and Selenium or Melbourne's Temple Studio and ether ohnetitel, to public access programs like Melbourne's Artroundtown and No Vacancy, which featured disused shopfronts filled by young artists.

Sydney's Museum of Contemporary Art was finally opened during this period. From 1991, the MCA housed Sydney University's Power Bequest collection and a large program of temporary exhibitions from overseas and Australia in a magnificent Art Deco building located on Circular Quay. Private sponsorship raised a significant proportion of the MCA's money, attracted by the possession of a prestigious collection. The alternative museum option, attempted by other spaces such as PICA in Perth, ACCA in Melbourne, and Artspace in Sydney, was that of the *kunstverein* – an accommodation for cutting-edge art and changing exhibitions that could develop without the responsibilities or advantages of significant collections. These now sought to present difficult art in a period of uncertain funding. Most contemporary art spaces wanted state funding, even if both the MCA and the Melbourne Museum of Modern Art at the new, expanded Heide had been extraordinarily successful in garnering corporate support. The problem of fickle funding from both governments and private donors, combined with heightened artist

Previous page: detail from **5:25**.

5:1 Bill Henson, *Untitled*, 1979, b&w photograph. Courtesy Deutscher Fine Art, Melbourne and Roslyn Oxley9 Gallery, Sydney.

and audience expectations, haunted all museums during the 1990s.

At the same time as the art world began to collapse, artists were redefining the edges of art. As in the 1970s, they moved outside the boundaries of galleries, institutions and an unchanging economy of art, questioning not just what was acceptable as art but also whether art should survive at all. Unlike artists during previous centuries who earned their livelihood by specialising in one of a defined group of artistic genres (for example, landscape or portrait painting), many contemporary artists worked across mediums and genres. For several reasons, photography was central to this shift, both because of its iconic status within postmodernism – as the medium supremely able to describe and quote from other mediums – and because of its apparently self-evident capacity to objectively record.

The next section describes artists such as collaborative team Rose Farrell & George Parkin, and Bill Henson, who took photographs but, unlike earlier generations of photographers, neither printed their own images in a darkroom nor attached importance to the traditions of vintage photography or photojournalism. Instead, their works belonged to an increasingly heterodox mainstream of art that was no longer composed of paintings and sculptures but in which the division between opposites such as photography and performance art became blurred. Artists including Mike Parr, Joan Grounds and Lyndal Jones, whose work is discussed below, purposefully alternated between temporal forms, such as performance, and static, even conventional, installations. The last section of the chapter looks at Domenico de Clario and Jennifer Turpin, who often moved outside conventional galleries altogether, reconfiguring spaces with hybrid installations.

PHOTOGRAPHY, PRINTMAKING AND PERFORMANCE: CROSSING MEDIA

Postmodernism and the Importance of Photography

Photography was one of the means by which artists reflected a decay and fragmentation that now, at the start of the 1990s, took on the suspicious appearance of a *zeitgeist*. The elevation of the medium had been accomplished during the 1980s. According to many critics, photography had been the key medium in understanding postmodern art.[1] The

1 Abigail Solomon Godeau, "Photography after Art Photography", in Brian Wallis (ed.), *Art after Modernism; Rethinking Representation*, New Museum, New York, 1984, p. 80. Also see Douglas Crimp, "Pictures", *October* n.8, Spring 1979, pp. 75-88.

Here, I briefly recapitulate the arguments of American critics Douglas Crimp and Craig Owens. Both wrote in the early 1980s for the influential journal *October*. They theorised postmodern photography in essays that established the importance of a generation of artists including Cindy Sherman, Sherrie Levine and Richard Prince.

To Donald Kuspit, however, in "Flak from the Radicals", also in Brian Wallis (ed.), *Art after Modernism*, pp. 137-151, postmodern painting was best explained as a reaction *against* photography.

5:1

5:2

5:3

5:4

5:2-4 Bill Henson, *Untitled*, 1983-84, Type C photograph. Courtesy Deutscher Fine Art, Melbourne and Roslyn Oxley9 Gallery, Sydney.

5:5 Bill Henson, *Untitled*, 1985-86, Type C photograph. Courtesy Deutscher Fine Art, Melbourne and Roslyn Oxley9 Gallery, Sydney.

5:6 Bill Henson, *The Paris Opera Project*, 1991, Type C photograph. Courtesy Deutscher Fine Art, Melbourne and Roslyn Oxley9 Gallery, Sydney.

theories behind the art discussed in the previous two chapters had been heavily influenced by a revaluation, in the United States, Europe and Australia, of the properties of photography. This conjunction of photography and theory was important because changing definitions of identity were central to the postmodern period. Postmodern art in the 1980s had taken on the qualities of photography. In the early 1990s, exhibitions of photographs – especially when presented as installations – were particularly favoured by contemporary art spaces and curators. Their selection by curators for large international survey exhibitions, including the Sydney Biennales, usually required the demonstration of an appropriation of authorship, a descent from post-object forms and an analysis of representation. Drawing on a postmodern analysis of photography such as Douglas Crimp's, artistic identity was seen as the effect of social forces and was marked by the diffusion of authority.

The disruption of canons of quality by error, the disorderly proliferation of originals and the unsurpassed ability of photographic and reproductive technologies to collapse the differences between high and low culture had been of considerable interest to *October* writers such as Douglas Crimp and Craig Owens, and to the Australian critics centred around Paul Taylor's *Art & Text*. Photography, according to Crimp and Owens, disrupted conventional notions of originality through its ability to reproduce already existing images. Photographs had documentary functions at odds with connoisseurship and the world of traditional art; they blurred the division between popular and elite culture. Photography, like video, was thus suited to the documentation of post-object forms as artists decisively turned towards transitory, temporary art forms such as performance and installation during the 1990s. The next few pages describe art that inhabited the zone between documentation and performance.

Bill Henson: The Portraiture of Affect

The wide impact of Bill Henson's photographs was due in part to his intense sense of the contemporary and his understanding that photographs were themselves now seen differently, as a result of the critical transformations sketched above. He constructed an overwhelming sense of the contemporary – of history acting in the present – through the

2 Bill Henson, quoted in "Bill Henson's Life in Venice", *Artforce n.84*, June 1994, p.7.

5:5

5:6

presentation of subjects at the effect of, or subject to, overwhelming social and cultural forces; his particular genius was to present this as the *gravitas* of our age and his work therefore epitomised the status and ambition of postmodern photography. As Henson observed: "I see photography as just another medium. I don't like the idea of a photography ghetto."[2] His photographs presented imagery that symbolised the particular qualities and defects of our age: magisterial size, brittle beauty and melodramatic hyperreality. They were elaborately staged and, even when they appeared to be documentary records, were highly contrived and severely self-reflexive. He was one of Australia's best-known artists, showing with considerable critical success in many European galleries and selected to represent Australia at the 1995 Venice Biennale.

Henson's earlier photographs of figures standing in crowds were seen at the Guggenheim in 1984; they were a catalogue of urban resignation. His highly sensational polyptychs of young girls, junkies and naked street children, juxtaposed with views of Baroque palaces, were shown at the 1988 Venice Biennale. Later, Henson exhibited large montages of prostitutes, emergency workers and aerial New York views. More recently, he cut, slashed and reassembled enormous montages from photographs of young people lost in a post-Apocalypse wilderness of car yards and forests (their Eden resembled the paradise of French film-maker Jean-Luc Godard's cannibal hippies in his late 1960s film, *Weekend*). Henson's desire to image a particular quality – the contemporary – was clearly that of an artist attached to the anachronistic identities of *flâneur* and voyeur. His subjects were often beautiful, glamorous young women, photographed as if unaware of the camera. The historical impropriety of such flattery, in a period where most artists were aware of the politics and sexuality of representation, was artistically perverse and partly explained the wide appeal of his work. His political incorrectness was so conscious that it evaded straightforward criticism and discouraged easy imitation.

Henson's gravely elegant photographs insisted on the conundrum of self-possession, asserting a relation between vitrinous space, pathos and exaggerated chiaroscuro. His photographic series, *The Paris Opera Project*, 1991, exemplified a continuing deflection of photographic signs from social and political possibility. Instead, Henson's photographs aspired to mystery. This was achieved by prodigiously accomplished theatricality: outsized Type C prints were arranged in polyptych groups across darkened gallery walls. Pictures of men and women in evening dress, presumably members of an opera audience, were glimpsed in semi-darkness. These images alternated with luminous photographs of clouds at dusk, taken from the streets of an outer Melbourne suburb. The tableaux of opera patrons appeared to be staged; the darkness and their impassivity, as they acted out varying degrees of attentiveness and self-forgetfulness, ensured their detachment from our gaze. Like the performances they attended, Henson's subjects were idealised and theatrical. They were *types*. This emphasis was deliberate; Henson saturated colour, deepened tones and blurred focus. He suffused his images with an eroticism, similar to that of French painter Balthus, that led one to find voyeuristic *double entendres* everywhere, even, for example, in the repose of a young woman cradled in the lap of an older man who was, perhaps, her father.

If the photographs were an attempt to image the essence of modern life, then the carefully edited gestures stood for a symbolism of appearance. To what extent could audiences now empathise with such an abstraction of art from life and such wild claims for art? Henson's extraordinary aestheticisation was seen in the systematic deformation

and reformation of subjects. The characteristics of Type C enlargement – diffuse particles of colour and disconnected illusion that come together at a distance – were also the methods of painters. His photograph of a woman's face emerging from darkness seemed drained of colour; she was distorted by shimmering light and obliterating dark. In Henson's *grand guignol*, white skin and expensive cloth dissolved into sensuous darkness and clusters of luminous colour.

The self-possessed subjects of *The Paris Opera Project* were also actors. Though equally drenched in darkness, unlike Henson's subjects in previous series they declared their threatening and bloodless status as alluring representations. He represented extreme types and classes of people. His photographs begged many moralistic and political questions. The earlier juxtapositions of a sexual underworld with the art of museums embodied a widely shared notion of cultural dislocation. In the darkening, millennial worlds of the 1990s, did images of richly dressed men and women present anything more than the individuality accessible to a privileged class seen through Henson's virtuosic manipulation of the cult of the individual? If blurred and darkened photographs often represent the dissolution of individual identity, then Henson's painterly works deliberately suppressed political difference by the appropriation of the social in an aesthetic cult of the spectacle.

5:7

5:7 Rose Farrell & George Parkin, *Terra Firma 1616*, 1992, Type C colour prints (5 panels), 122 x 460 cm. Courtesy Michael Wardell Gallery, Melbourne.

5:8 Rose Farrell & George Parkin, *A Passion for Maladies #3*, 1990, Type C colour photograph, 240 x 240 cm. Courtesy Michael Wardell Gallery, Melbourne.

Rose Farrell & George Parkin: Installation, Photography and Artistic Collaboration

Similarly, the collaborative works of Rose Farrell and George Parkin combined the veracity of photography and the cultural authority of painting. Farrell & Parkin's work was a hybrid type of photography where spatial anomalies and positions became incredibly ambiguous. They made mural-sized photographs documenting bizarre installations built solely for the photographs, populated with costumed actors and then destroyed.

The installation in their enormous work, *Terra Firma 1616*, 1992, resembled a kind of reconstructed world, like a diorama. Each element in *Terra Firma 1616* was assembled from historical sources: 1616 was the date of Australia's "discovery" by Dutch explorer Dirk Hartog; William Shakespeare died; an obscure but important alchemical text had just been published; and a traditional street procession in provincial Germany was recorded by a book engraver. Real drapery in *Terra Firma 1616* was double-coded with its graphic representation; the actors' skin was so pallid with pancake make-up that startlingly bloodshot eyes and a single patch of gold leapt out in an otherwise monochromatic expanse of copper-toned black and white. The microcosmic clarity of their vast photographs overloaded the eye; the space, therefore, of the panoramic historical

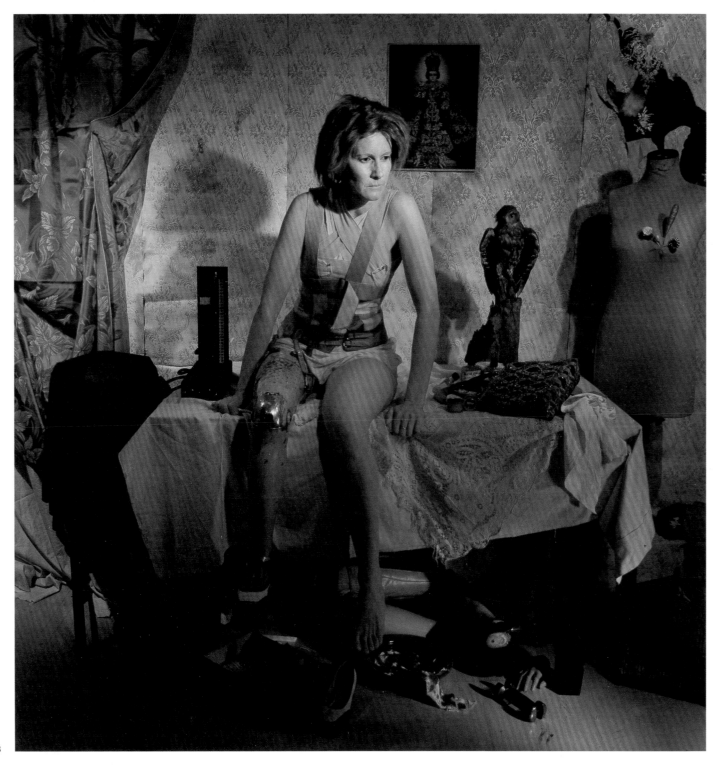

tableau collapsed like a ruined Potemkin village of images that seemed familiar but was not at all. The haloes of saints and angels in Farrell & Parkin's earlier photographs signalled the edges of presence and beauty. An increasingly didactic luminism, confirmed by obviously engraved pictorial sources and studio lighting, led in *Terra Firma 1616* to the appearance, but not necessarily the experience, of a spatial plenitude.

Although at first sight seamless, *Terra Firma 1616* was a collection of separate descriptions. Several perspectives, anamorphic distortions and light sources were montaged together. Deep space collapsed into shallow distance; four monstrous constructed heads intruded frontally into our space and, overall, proportions did not match. The razor's edge between passionate belief and credulity was the key to the significance of their photograph.

Farrell & Parkin recreated European metaphysics, science and alchemy at the periphery – specifically, at the Antipodes where everything was supposed to be upside-down or reversed. Their relationship to culture was anamorphic and traced a history of psychic pain through a parallax lens. Farrell's early photographs looked like film stills from a documentary history of modernist historical catastrophe, such as the Chinese Cultural Revolution. The collaborative Baroque figure compositions of 1988 featured tortured saints on grisaille rocks. *A Passion for Maladies*, 1990-91, was an extraordinary series of portraits of imaginary people in mute pain set amongst weird, Keinholz-like interiors. The figures were neither portraits nor ciphers, but punctuations and historical aberrations rendered in excruciatingly compelling detail.

The two artists collaborated on two types of phantom: firstly, a curatorial *corpus* of undefined gender; secondly, ghost-like bodies defined by surroundings and props. The studied, rebus-like appearance of the artists' scenes indicated deliberate over-calculation. Just as deep space collapsed into shallow distance, Farrell & Parkin depicted the emblems of civilisation as violent but fragile illusions.

Mike Parr: Printmaking and the Return to Performance

The lush historical consciousness of Henson's and Farrell & Parkin's photographs represented an ambitiousness for photography beyond its tradition of craft-conscious vintage prints. This tendency was extended in performance artists' appropriations of more permanent reproductive mediums such as photography and printmaking. Frequently, the intersection of documentation and event allowed an amplification of experience as significant as the performance itself.

Since the connotations of impression were so suggestive, it was probably inevitable that Mike Parr would turn first to large-scale drawing, which he included in complex installations, and then, decisively, to printmaking. His early performances were an exploration of the ambiguous edges of a Self which could be defined by marks – made on the world, or made on the body, quite literally, when the artist scarred himself with burning fuse wire. This fleeting condition could be provisionally resolved or recorded by marks on paper. Parr's self-portraits, such as *No 1*, from *12 Untitled Self Portraits Set II*, 1989, were not revelations of the Self through printmaking. They did not disclose much by way of individual character, personality or even the artist's physique. They were, instead, an aggrandisement of conventional conceptions of the Self to the point that they defeated the idea of a unique personality. Mike Parr did versions of himself. The subject – his face – initially suggested an affirmation of self-expressive subjectivity. However, the

5:9

5:9 Mike Parr, *No 2*, from *12 Untitled Self Portraits Set II*, 1990, suite of drypoint etchings, printer John Loane, 108 x 78 cm. Photograph: Gary Sommerfeld. Courtesy the artist and Viridian Press.

5:10 Mike Parr, *100 Breaths*, 1992-93, from *(Alphabet/Haemorrhage) Black Box of 100 Self-Portrait Etchings 2*, 1993, performance, Henderson Road, Alexandria. Photograph: Paul Green. Courtesy the artist.

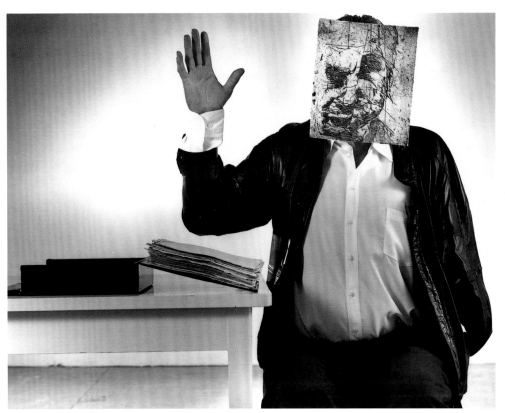

5:10

artist repeated his self-image in prints so often and so compulsively that it lost this naive signification. The face became an interrogation of his audience as much as a disclosure. The full force of repetition experienced in his long performances was made readily available through the production of reproducible but "unique" prints.

Parr thus took advantage of the authenticity of printmaking, which was established by the artist's signature and by his long-term collaboration with Melbourne master-printer John Loane. Credible identity was therefore deliberately constructed out of the curatorial activity of the print industry and the association with Loane's highly organised, entrepreneurial atelier. Printmaking was involved involuntarily in an unsettling game – the dismantling of familiar signs of originality. The virtuoso self-expression of Parr's individual prints was revealed as an arbitrary construction through extreme, spellbinding repetition: this was the antithesis of the familiar Romantic idea of paper as a *tabula rasa*, awaiting the unique imprint of the artist.

From 1992 onwards, Parr began to restage earlier works and initiate new performances. Like Jill Orr, whose performances were documented by photographers of exceptional sensitivity and who privately restaged public performances for these photographers, Parr was fortunate enough to collaborate with remarkable peers. *100 Breaths*, 1992-93, from *(Alphabet/Haemorrhage) Black Box of 100 Self-Portrait Etchings 2*, 1993, was recorded by Paul Green in photographs that recapitulated the evolution of Parr's performances into prints. Green's photographs documented successive moments as the artist lifted his self-portrait etchings from a solander box and, one by one, held them to his face, drawing in his breath, suspending the print in mid-air as he absorbed his own representation. The photographs documented a trajectory away from print-

5:11

making into performances based on a *détournement* – a displacement of the meaning of Parr's collaboration with printmaker John Loane. Mike Parr's 1993 performance in Melbourne at Anna Schwartz Gallery included a retrospective enactment of his 1970s' performances. In what must have been an out-of-body experience for Parr, a counter-tenor stood in for the artist who, with his audience, watched the singer enunciate Parr's original words.

In a decade attracted to grunge, quick results and low-rent artistic options, the history of performance had become influential in a double-edged way. Not surprisingly, there-fore, a fascination with death, cruelty and decay amongst young artists compelled a rereading of Mike Parr's performances and installations, and the recognition, in works such as *Minotaur the Lost Leader (Remnants of the Self Portrait Project) II*, 1994, that he was one of the most significant artists working in Australia from the 1970s onwards.

Joan Grounds: Fixing Ephemeral Sculpture

Since performances are ephemeral, they survive in photographs, videos and written descriptions; they linger in archives and artists' cupboards as props and memories. Performance artists Lyndal Jones and Joan Grounds were able to span and reconcile both 1970s feminist practices and the ambiguities of the 1990s; at the same time, they mapped out more inclusive forms of experimental art suggesting a spectrum of author/artists and a variety of artistic methods.

Joan Grounds began to incorporate the element of gradual change into her painstak-ing, beautiful installations. Grounds created sculptures, installations and films (including a collaboration with Aleks Danko, David Lourie and David Stewart, *we should call it a living room*, 1975) that incorporated significant performative aspects and, therefore, she continually blurred the boundaries of "performance artist". In a 1990 installation, *Bridge*, created over three weeks at Melbourne's 200 Gertrude Street Artists' Space, she built an environmental sculpture. The construction in the main space resembled a half-finished, suburban, plywood *merzbau*; in the gallery's second space, behind the shop-front window, she gradually reshaped a peat earthwork and adjusted the position of a partly dismembered violin. The work grew and changed over the exhibition's duration without ever apparently arriving at a definitive end.

Lyndal Jones: The Prediction Pieces

Lyndal Jones' performances dramatised a feminist and post-structural analysis of a trou-bled society. Her Prediction Pieces comprised ten performances produced over a decade in Australia, Tokyo, Los Angeles and Edinburgh. All used techniques of prediction – tarot, dice, weather forecasts – in performances involving slide projections, taped sound, television, dancers and actors.

More austere and self-reflexive than later works, the early Prediction Pieces intro-duced several motifs: fortune-tellers; video clips of the British royal wedding; weather reports; and a series of projected messages. Each performance began with the phrase "And as the sun sets slowly on the West". Warnings and jokes were interpolated through-out: "watch this space"; "forewarned is fore-armed"; "you will see stars"; "the end is very near". The messages operated on several levels. The sinking sun referred to the West's decay (several performances imaged the ascendancy of Japan or China); it also invoked the suspension of time, as in the now-generic story-teller's opening ("It was a dark and

5:11 Mike Parr, *Minotaur the Lost Leader (Remnants of the Self Portrait Project) II*, 1994, suite of colour etching and relief printing from steel, painted chair, printer John Loane, each image 108 x 78 cm. Photograph: Gary Sommerfeld. Courtesy the artist and Viridian Press.

5:12

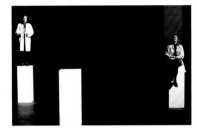

5:13

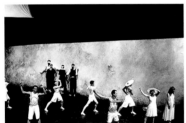

5:14

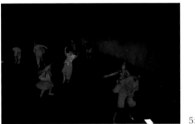

5:15

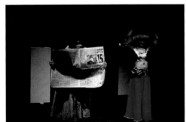

5:16

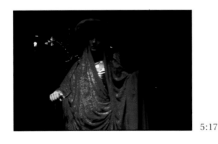

5:17

stormy night ..."). *Prediction Piece 6: Pipe Dreaming*, 1988-89, examined representations of optimism but was fractured by the sounds of gunshots (coincidentally, the Tiananmen massacre occurred three weeks after its first performance). The first half of *Pipe Dreaming* was a highly romantic representation of revolution: Peking Opera costume dancing and actors declaiming Situationist speeches. The second half undercut this mood. The actors quoted Chekhov's mordant play *The Seagull* and a young Australian/ Chinese artist read accounts of immigrant ordeals and authoritarian repression. *Pipe Dreaming* was fractured by more than gunfire: older actors and younger dancers moved separately around the stage; costumes and identities were chronologically mismatched. Cross-dressing between categories, generations, sexes and nationalities suggested identity in a state of flux. *Prediction Piece 10: As Time Goes By*, 1991, included images of the night sky, arguments about science and art, physicist Stephen Hawking's theory of time in reverse and, finally, an apple thrown in a wide arc across a darkened stage.

The issues that her theme of prediction addressed, from nuclear holocaust in the earlier performances to environmental catastrophe a decade later – were pretexts precisely because Jones' real attention was elsewhere. Feldenkreis therapy and postmodern dance oriented the way her performances unfolded: through vernacular movements and repetition. Characterised by a choreography of labour, they were like lectures that redirected the audience's attention. The Prediction Pieces dramatised the existing instability within our culture, and were thus explicitly pedagogical. Her early work was influenced by performance groups in London, like Welfare State. It was also a critique of that wave of 1970s feminist performances, rejecting the idea of exclusively female content and asserting the social construction of gender. Jones usually appeared as a commentator or story-teller, often in men's clothing. She observed that acts of prediction were "processes through which we arrange our future(s)". Although she was often described as questioning sexual identity, her Prediction Pieces became a meditation on nationality and historic global change. If the first works in her cycle were reductionist and formal, the later performances involved complicated choreography and large numbers of actors. Unorthodox eclecticism, and indifference to the idea that knowledge was gained through catharsis, showed in the artist's careful presentation of heterogeneous sources both in the performances themselves and in their representation, first in an archival exhibition of all the textual material and props at Sydney's Museum of Contemporary Art in 1992 and later by the incorporation of complex performance videos into installations. Jones was able to avoid the substitution of the Prediction Pieces by their video representation through enormously careful, patient "readings" of the elements in each performance. While Lyndal Jones' powerful performances explored the form of catalogues, they also denied the authority of classification.

John Gillies and The Sydney Front: Techno/Dumb/Show

Through documentation, the exemplary "truthfulness" of performance deteriorates. Video's and photography's capacity for near-infinite reproduction, the deterioration and increasing illegibility of images in replay, the inevitably severe editing of a time-based medium in text and images, and the falsification of artists' and critics' hindsight all invariably appear accidental. The Sydney Front's performances involved the use of documentation to create a video art work more expansive and amplified than any performance itself. *Techno/Dumb/Show*, 1991, was the result of collaborative work with

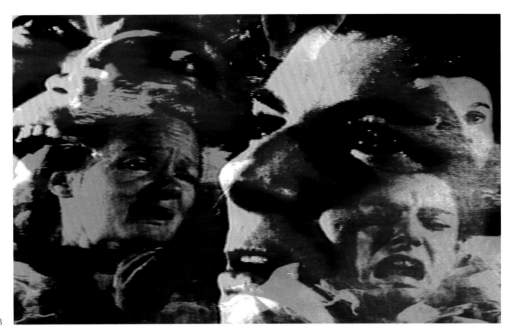

5:18

5:19

John Gillies. Deceptively simple, it blurred the borders between installation and film: one large screen, two speakers, a dark installation space, and an experimental film screening. Originally a performance, the video was filmed painstakingly as a separate work over three months, during which performer John Gillies worked less as director than as participant.

Techno/Dumb/Show was a catalogue of effects and endurance requiring similar work from the audience. For twenty minutes the viewer was engulfed in a landslide of sounds and theatrical images: bells; crowds clapping; hysterical laughing and crying; people whispering into phones; performers staring at the camera or acting out exaggerated mannerisms; actors running. *Techno/Dumb/Show* was also a catalogue of performance actions – an athletic, gymnastic, aesthetic workout. Gillies and The Sydney Front mimicked the tropes of performance documentation with hypnotic urgency. The video was divided into a succession of episodes, each lasting about five minutes. The performers' exaggerated facial expressions and endurance were metaphors for the experience of experimental film. Montaged images succeeded each other in staccato succession: phone conversations turned into actors running; acrobats balancing on wires were succeeded by applauding crowds; spinning trapeze artists mutated into a hyperactive man conducting a phantom orchestra. The arbitrary collage was overtly manipulative: through juxtaposition, reality was produced as an effect of the most transparent artifice.

Like Japanese installation artists Complesso Plastico, Gillies and The Sydney Front fabricated a sense of urgent, expectant presence; their gestures were separated from their bodily signifiers by over-saturated colour, montage, and a soundtrack like a mutant aerobics session. The constant replacement of one image with another displaced and reattached meanings, as if the images were caught in a continually revolving door. Sheer speed produced the expansion and then collapse of bodily and facial signifiers. At the intersection of performance and installation, *Techno/Dumb/Show* generated a set of untruthful allusions to narrative that varied from each other in such a way that a mesmerising copy was preferable to any original.

Parr's performance documentations, Grounds' installations, Jones' complex performances and John Gillies and The Sydney Front's videos were a considerable distance from unexceptional reification of the destabilised postmodern archive. Performance documentation gradually created hybrid works parallel to, but not coincident with, its original subjects.

INSTALLATION: THE ALIENATION OF ART

Domenico de Clario: The Post-industrial Dark Wood

During the early 1990s, contemporary artists habitually accepted an alienated relation to artistic language; this was seen at its most extreme in the fashionable intersection of grunge and installation, where a tacky garage-debris ethic bled into stylish reworkings of the forms of abstraction in, for example, the messy agglomerations of Sydney artists Hany Armanious and Mikala Dwyer.

5:20

Domenico de Clario's debris-strewn underworlds of the same period originated from the aesthetics of a much earlier period – from the early 1970s installations described in Chapter 1. Those anarchic works often involved random decisions and the transposition of grunge – the used paraphernalia of daily life and industry – into the domain of art. They had, then, many affinities with the work of the emerging Sydney artists. De Clario's objects were structured, unlike his earlier works or those of his young peers, by an alchemical conception of the human body. The urban architecture of his new installations was identified with separate elements of consciousness. Within each site, de Clario placed written fragments – often an extract from a book or a short story. His oblique clues were based on an awareness of the failure of previous artists to adequately deal with an ontology of minute experience. Anxiety, pathos and, paradoxically, plenitude

5:21

coexisted with an intensity achieved by few other artists of the time. What distinguished de Clario's work, though it found parallels in installations by younger artists such as Armanious or Adam Cullen, was the reversal of the normal economy of critique. De Clario's work aimed at the mystification of its audience rather than the avant-garde desire to mobilise social consciousness: he observed that "Answers are for others. I can be the catalyst or initiator of different processes."[3]

3 Domenico de Clario, interview with the author, Melbourne, 1993.

Between 1990 and 1993, Domenico de Clario repeatedly presented, in slightly different forms, several installations. Each installation reworked the themes that spanned the artist's career. His lone nocturnal vigils in deserted industrial spaces moved far outside the circuit of public and commercial exhibition spaces. *Memory Palace (Machine-for-contacting-the-dead)*, 1991, was de Clario's first major installation for fifteen years. One part of the Melbourne version resembled a complex simulation of a seance; the other appropriated factory walls and ceilings as a vast Southern sky at night. The assemblages of each component refused to settle into either single, discrete images or a unified masterwork; they skirted the walls or sat in the space's centre as fixtures or furniture. Their relations to each other, the environment and the viewer were architectural; de Clario's alterations were extraordinarily subtle and often imperceptible, blurring the division between art and life. Since literal meaning vanishes in darkness (many of his installations of this period were only open after dusk), he was able to focus attention into moments of hyperalertness, like the experience of a child's game of hide-and-seek. His

5:22 interventions were asymmetrical and unobtrusive: in *Memory Palace*, a scratched

diagram forced the awareness of another; the charcoal-black circle within a wall-drawing was in fact a cast shadow, the origin of which was suspended above one's head. Scale and a mark's position in space were thrown into doubt. *Memory Palace* and *Eleven Sons,* 1991, extracted sense from de Clario's emphasis on the elements of myth and history inherent in their constituent parts; connections occurred haphazardly. The sensations that arose for the viewer – of discovery – were immediately unstable. Domenico de Clario's focus on the threshold of experience was manifest in his fascination with sense and nonsense, invisibility and legibility. His interest in gateways and thresholds was seen in *Memory Palace* with the child-like notation "memory palace" posted at the factory entrance and at the installation's periphery. *Memory Palace* centred upon a sliver of intense brightness – an electric lamp hanging in blackness. Explosive points of light and eruptions of noise around it were quite logically organised: an electric blender bursting occasionally into action, a bubbling vat. Amidst a circle of chairs set as if for a séance, de Clario suspended a trembling chandelier, set in constant motion by ropes connected to an electric fan at the room's far end. Each of the four elements – earth, air, fire, and water – was represented by this garage-sale *bricolage*.

The outlandish constituents of de Clario's zone were not obviously at odds with

5:23

5:20 Hany Armanious, *Relativity of Perfection*, 1992, installation, 9th Biennale of Sydney. Photograph: Ashley Barber. Courtesy Sarah Cottier Gallery, Sydney.

5:21 Hany Armanious, *Teleplastic Emanations*, 1991, Sarah Cottier Gallery, Sydney. Photograph: Ashley Barber. Courtesy Sarah Cottier Gallery, Sydney.

5:22 Mikala Dwyer, *woops!*, installation, 1994, Sarah Cottier Gallery, Sydney. Photograph: Ashley Barber. Courtesy Sarah Cottier Gallery, Sydney.

5:23 Domenico de Clario, *Message from the Emperor*, 1992, installation, basement, ADA House, Melbourne. Courtesy Michael Wardell Gallery, Melbourne.

5:24 Domenico de Clario, *Memory Palace (Machine-for-contacting-the-dead)*, 1991, installation, Cable House, Melbourne. Courtesy Michael Wardell Gallery, Melbourne.

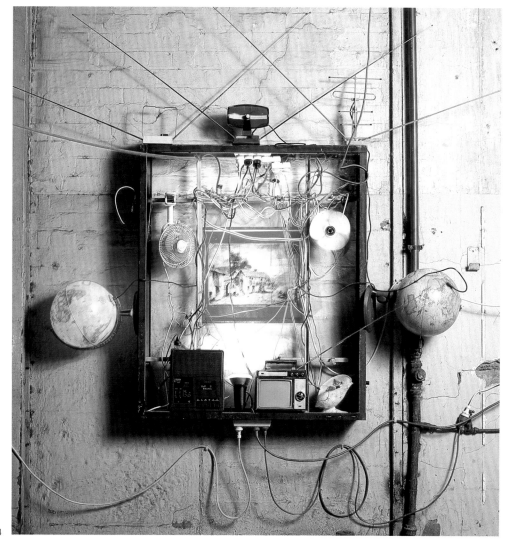

5:24

objective, scientific observation, since the works depended so heavily on natural forces like gravity, heat and hydraulics for their operation. They were, therefore, the physical incarnation of mental images that aimed to simulate reality. In *Memory Palace*, his inscription of words on doors and replacement of doorknobs with light globes suggested that de Clario's relationship to minimalist thought had become as perverse as his conception of sculpture as bizarre but verifiable *fantasia*. The ruined office-basement darkness of the Melbourne version of *Message from the Emperor*, 1992, cultivated confusion about where his work ended. After carefully inspecting the main room, one realised that through an almost invisible doorway there stretched another space. This contained nothing except, at its far end, a chair, a light bulb and a low table on which was pinned Kafka's short story of the same name. Close examination revealed subliminal, probably imagined, interventions almost everywhere. If the mind could have been described as the inhabitant of one room, the heart was located in another, in a pool of murky water, and the soul seen in a page from Kafka, hidden at the far end of that narrow passage.

During the first few months of 1993, de Clario presented a sequence of three installations. These were collectively titled *Components of an Expression Machine*. Firstly, de Clario converted the upstairs Fitzroy stockroom and gallery of Girgis & Klym, tracing the effects (on several lives) of Franz Kafka's phantom presence in Australia through recently discovered old correspondence, an antique embroidered dress, an electric fan and an old electric heater. A month later, he rented a vacant office (once his childhood home) in Collingwood and scattered photocopied memories of his first year in Australia across its walls, activating another circuit of an "Expression Machine". Finally, de Clario mapped the intersection of occult energy centres, the *chakras*, onto the architecture of an immense, ruined Pascoe Vale munitions factory, using a chandelier and a web of electric lights. At the end of one month, the artist retreated into an old caravan parked at the distant perimeter of the factory. At the postindustrial frontier of a black Melbourne night, each viewer discovered the luminous, spiritualised debris of suburban kitsch.

The system of de Clario's installations was a Medieval notion of inner faculties: through recombination and disjunction, new elements, creatures and senses could be created. De Clario appended a quotation by Max Jacob to the notes that he prepared for a 1991 exhibition *The Mendicant of Naples and Other Stories* at Mori Gallery, in Sydney: "When I lived in Naples there stood, at the door of my palace, a female mendicant to whom I used to pitch coins before mounting the coach. One day, suddenly perplexed by the fact that she never gave me any signal of thanks, I looked at her fixedly. It was then I saw that what I had taken for a mendicant was rather a wooden box, painted green, filled with red earth and some half-rotted banana peels."[4]

In their repeated incarnations, de Clario's installations were assembled from the found materials of suburbia, rust-belt industry and thrift shops. His systems were improvised rather than rigidly predetermined and were based on an accumulation of visual puns. This impression was reinforced by the interpolation of texts that accompanied each exhibition: short enigmatic narratives about the discovery of unexpected inner life. Often, the narratives blurred into parallel imaginary worlds. In the first of the three installations comprising *Components of an Expression Machine*, 1993, he tracked the miraculous coincidences between Franz Kafka, his fiancée Felice Bauer, a box of books, diaries and a beautifully embroidered dress (belonging to a "Franz Kafka", accidentally found in Australia and acquired by de Clario), and the intertwined lives of Kafka,

5:25

4 Max Jacob, quoted in artist's exhibition notes, *The Mendicant of Naples and Other Stories*, Mori Gallery, Sydney, July 1991, p.1.

5:25 Domenico de Clario, *Components of an Expression Machine*, 1993, installation, Bradken foundry (third component of a three-site installation), Melbourne. Courtesy Michael Wardell Gallery, Melbourne.

Bauer, de Clario's family and two Australian immigrants, Frantisek Kafka and Felix Bauer. Old television antennae graced the arrangement of chairs in *Memory Palace* and this, the room's central séance motif, was an admonishment to receive messages and second-guess fate. In *Eleven Sons* the chairs reappeared as symbols of absence and cryptic clues to an uncertain text.

Domenico de Clario's installation at the National Gallery of Victoria, *The Seventh Ārit (Elemental Landscapes: 1975-1993)*, 1993, was a reinstatement of the exhibition that had been removed in 1975 two days after its opening. For its expanded reincarnation, de Clario brought together an eccentric collection of objects from the museum's vast holdings: European landscape paintings, a J. M. W. Turner, an Egyptian mummy, crockery from the cafeteria, sentimental Victorian narrative paintings, ladders from the maintenance department, antique musical instruments and dozens of clocks, mirrors, vessels, and chairs. These were combined with thrift-store junk – old electric fans, blenders and school-room globes – and an astonishing variety of electric lights and coloured neon tubes. A suspended crystal chandelier dipped into a mound of dust at the installation's centre; the dust had been collected for de Clario by conservators as they vacuumed paintings in the permanent collection. This dust was ninety per cent composed of skin cells and hair fragments shed by visitors and, on some of the European paintings, was more than one hundred years old. For de Clario, this material marked the interweaving of audience and art in a synthesis of bodily decay with the slow disintegration of paintings.

The dimly lit installation was divided into seven groupings, corresponding to the seven halls of the Egyptian underworld – or Ārits – where the soul, covered in the dust of the decayed body, was gradually purified over successive after-death initiations. The trope of death was present in two forms: de Clario's recreation of the ill-fated earlier work; and his attempt to confound the museum's anodyne enervation of spiritual intentions whilst participating in its reification of artistic immortality. His theosophical subject matter deliberately invited misinterpretation and overdetermination (his own included) and his themes – death, spirituality and the detritus of culture – were treated, somewhat crazily, as morphological elements within the conflation of different orders of description. The necromantic, red neon-light bathed grouping – an old four-poster bed, a painting depicting sleep, chairs incorporating seated sculpted figures, bronze dancing cupids and three landscape paintings embodying the Sublime – typified the artist's attempt to elaborate a museological praxis essentially similar in appearance but different in intention to that of *Arte Povera*. The artist's cosmic symbolism was very different to the stripped-down, often literary, Classicism of his Italian peers such as Kounellis and Paolini. De Clario sublimated Conceptualism's formal lessons, as well as its ambivalence about insertion into the museum, into a series of funereal tableaux.

The Seventh Ārit drew on the iconography of de Clario's *Expression Machine*, which was structured by hermetic theories of the human body. The former represented a desire to deal with the particular disorientation caused by the experience of art as a form of cultural capital – fluid, abstract and invisible. Objects from the museum and everyday life were employed not as aesthetic forms but because of their existing meanings. The double coding afforded by their original functions allowed them to embody new figures within de Clario's hyperactive, hyperintangible occult formations.

De Clario was not alone in deploying alternative languages of clairvoyance: Californian artist Barbara Bloom presented a typically Cal Arts version of *Arte Povera* in her installa-

5 U. S. artist Barbara Bloom trained at Cal Arts in Los Angeles; her principal lecturer was John Baldessari, an important precursor of much recent photo- and media-based art. She produced installations that were allegorical arrangements of precious objects and furniture, and artist's books that drew together fragments of texts and images from many different sources. Her works dealt with sight, blindness, paranormal phenomena and narcissism.

6 See Stephen Greenblatt, *Marvellous Possessions*, University of Chicago Press, Chicago, 1991.

tions of the late 1980s, one of which was exhibited in the 1990 Sydney Biennale.[5] Bloom's play with the postponement of understanding illuminated de Clario's installations. David Salle once observed that Barbara Bloom was the perfect hostess; de Clario, then, was the sloppiest of hosts. What kind of messy house, after all, was comprised by these installations? De Clario posed a metaphysical proposition: consciousness was a palace of memories; inside its walls were many unopened rooms. He was acutely aware of the inevitable aestheticisation of consciousness in contemporary art, and deliberately exaggerated that process through calculated mystification.

Why did Domenico de Clario insist on mystification? Firstly, controlled blurring and obscuring of meaning was a way through which many contemporary artists avoided the seduction and commodification that had corrupted "radical" signification by the late 1980s. Although mystification was customarily taken for a simple paralysis of judgement, it was also a stage in the enlargement of understanding, as Stephen Greenblatt observed.[6] As artists from Duchamp onwards realised, the metaphysical could be anything whatsoever. Calculated mystification, in the grotesque, messy zone of Domenico de Clario's installations, stood in for the poetic during a period in which the ability of humanist metaphors to engage us in their older meanings was corroded by the consumerist spectacle of late-capitalist society. Even though the cynical *flâneur* – the street-wise voyeur – was glamorised in discourse during the 1980s, the *flâneur* was *persona non grata* on the boulevards of the hermetic city, as the European Fluxus artists had understood.

Domenico de Clario was always out of step with his environment. He was, however, tuned like a seismograph to shifts in art. He consistently registered the tremors of change too early for these movements to be recognised as anything other than autobiography: there was no critical context for his Night Paintings when they were first shown in the 1970s. These landscapes, painted outdoors at night, were incorporated in de Clario's installations as the deliberate demonstration of extreme subjectivity within larger texts. Just as the *Arte Povera* movement was engaged in a perpetual flirtation with the formally evocative nature of its materials, de Clario employed paintings as both found objects and untrustworthy indices of sensation. Domenico de Clario was deliberately moving outside determinism and intentionality, away from the phenomenological origin of his art. His installations insisted on the ability of the imagination to wander at will, recombining the elements of art and industry into precise diagrams of flux, motion and transformation: an unreliable but verifiable science of the inner senses.

Jennifer Turpin: Ecology and Artifice

Jennifer Turpin dramatised natural processes in a theatre of depth and surface, incorporating the element of water and the idea of darkness in vast, subtle installations. Her curtains of water were weightless structures comprising barely visible threads, along which water descended in a continuous stream of tiny droplets. Turpin's installations were the embodiment of multiple metaphors, as mutable as a bizarre pun. They oscillated in a kind of *temps perdu* between the demonstration of dangerous forces and a luminous suspension of normal bodily sensation: the five Water Works, 1990-93, resembled action-painting made concrete but subjected to the laws of hydraulics and gravity. The earlier unpredictable, moving assemblage of chair, ladders and flotation tanks, *Shifting Ground*, 1988, was subjected to tidal forces obsessively and energetically repeating themselves; their cycles had no end and no purpose. If reality were trapped in a continuous,

5:26 Jennifer Turpin, *Water Works III* (detail), 1991, installation of water, nylon threads, copper pipes and tank, 6 metres high x 1.7 metres base tank diameter, Australian Perspecta 1991, Art Gallery of New South Wales. Courtesy the artist.

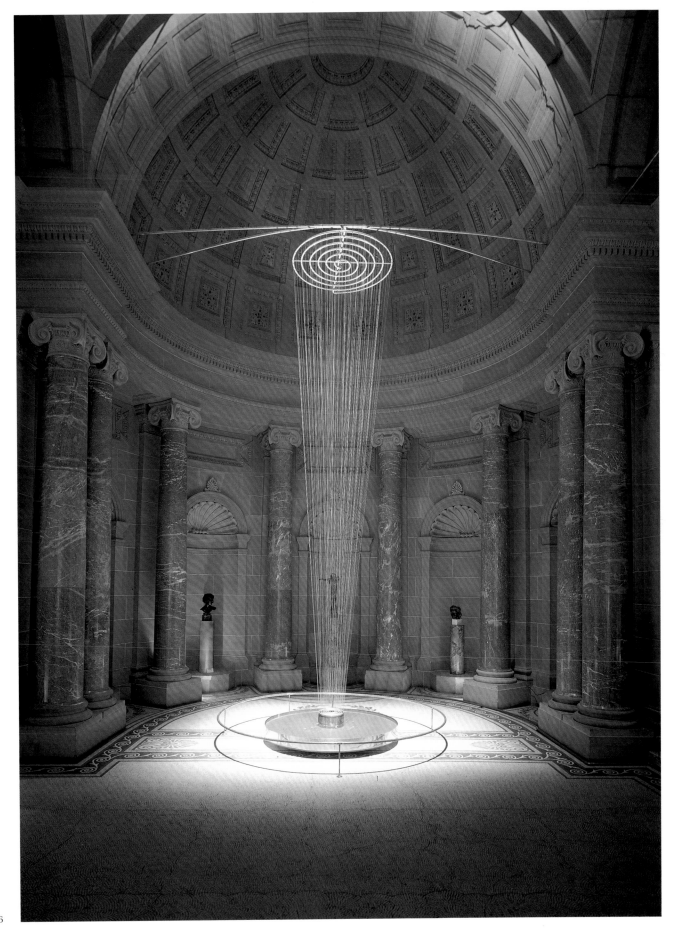

fluid zone between mythology and history, then the flow of time looked like Jennifer Turpin's installations.

At the entrance to the Art Gallery of New South Wales during the 1991 Australian Perspecta, Jennifer Turpin's two towering installations of water and wire, *Water Works III*, 1991, converted neo-Classic alcoves into aqueous shrines. As water ran down curtains of nylon filament to small artificial ponds, the light on moving droplets of water transformed the installations into two dematerialised webs of illumination – one in the shape of a hemispheric curtain, the other an inverted cone. This transfiguration of the gallery's antechamber was first of all a wonder. Unseen hydraulic forces produced a suspension of belief; water was directed through space along a fixed path. Transparent lines of watery movement were in turn a grille through which the gallery's marble columns and masonry domes were decontextualised into cavernous fantasy. Turpin's curtains of water disoriented and unnamed. Water was transparent and elusive; the agency of light created the primary impression of an intangible, disorienting, negative space in the shape of a temple. Like English sculptor Rachel Whiteread, whose plaster and rubber casts of ordinary objects and interiors came to prominence during the same period and were similarly substantial but ultimately intangible, Turpin's installations always referred to the spaces of somewhere else. Whiteread's and Turpin's works actively courted misinterpretation.

Turpin's machines also had an evident but inscrutable purpose of their own that saved them from the quiescent, well-meaning funk of ecological art – they were simultaneously anthropomorphic and efficient, a characteristic shared with German sculptor Rebecca Horn's constructions. Both artists presented the machine as feminised, and their works were able to embody the impersonality of natural processes but elicit uncomfortably sentimental emotions of wonder and amusement amongst viewers. Jennifer Turpin's *Shifting Ground* was a device that transmitted movement from Sydney Harbour, underneath Pier 2/3 at Walsh Bay, upwards through an elaborate apparatus of uprooted pine trees mounted on an old lift cage, from which an arc of four ladders, cables and pulleys spread into the warehouse interior. As water levels in Sydney Harbour fluctuated, a flotation tank underneath the gallery space transmitted haptic and often violent oscillations along the pulleys and spasmodically moving ladders hinged to an old chair at the termination of Turpin's assemblage; in Turpin's words, "It was nothing until the movement of the Harbour set the whole thing in motion. It was an amplification of what was going on beneath the building."[7] She avoided the consciousness of catharsis altogether: sensation, instead, occurred as a series of plateaux. The furniture's violent movement in *Shifting Ground* was both arbitrary and repetitively cyclic.

Avoiding crescendos, Turpin's webs of water neither began nor ended. Even though they were a colonisation of each building, her Water Works were far from architecturally imperial: on the one hand, they disoriented because the agency of light creates a more primary impression than that of water; on the other, their effect was substantial but ultimately intangible. The artist observed: "There is always a certain degree of trickery with water; the pieces play havoc with the notion of a large body of water. The water is broken up into such small components – a myriad of slow-flowing droplets that render insubstantial the whole physical element."[8]

As installations, the Water Works were landscapes within landscapes. They cooled their gallery spaces by several degrees, so audiences experienced a subtle but nonethe-

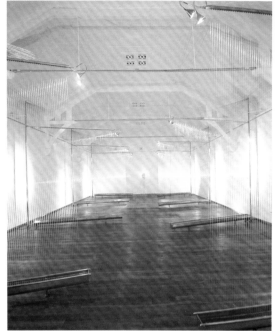

5:27

7 Jennifer Turpin, interview with the author, Sydney, November 1993.

8 Jennifer Turpin, interview with the author, Sydney, November 1993.

5:27 Jennifer Turpin, *Water Works IV*, 1992, installation of water, nylon threads, copper pipes and tank, in 10 x 19 m. room, Annandale Galleries, Sydney. Courtesy the artist.

less noticeable temperature drop upon entry. Even though the Water Works provided the impression of continuous harmonic motion, their expansive, spatial flow, like an enclosed waterfall, was disproportionately silent, as if the sense of hearing had been turned either off or up towards a white noise that resembled deafness. Turpin's watery curtains were screens through which the viewer could see the world as an extremely distanced glimpse: Turpin felt that the Water Works' closest affinities were with moments in art history and in particular, with the landscapes of Poussin and Claude. Space became a cultural projection screen: it was not for nothing that her works also recalled the aqueous medium of video and, specifically, the spellbinding video installations of American artist Bill Viola.

The poignancy of Turpin's Water Works lay in our awareness that, at the edges of metropolitan desire, on the brink of another millennium, traditional metaphors of the body and its transcendence became so unlikely that their reappearance was as exotic as it was unreliable. The unnerving mechanics of fluids in motion caused water to apparently defy gravity: if Turpin's liquid curtains offered this transcendent cultural memory, then *Shifting Ground* provided the reverse – it mimicked the vertiginous bodily sensation of a descent like that of fallen angels from heaven.

Turpin often placed her installations inside old industrial buildings near the waterfront of Sydney, the city in which she lived, and they seemed to promise access to a much vaster body of water – the Harbour – through hidden, subterranean passages. Turpin proposed a project to install another *Water Works* in one of Sydney's enormous, emptied underground water storage reservoirs, which were constructed towards the end of the last century. She said "the grand scheme was to have curtains of water parted, like the Art Gallery of New South Wales piece, *Water Works II,* 1991, but connecting every single one of the columns in the underground reservoir, suggesting a vast body of water through veils".

Dark netherworlds of storage and elimination underneath the modern metropolis featured in photography, film and art from Felix Nadar's 19th century photographs of Paris catacombs, onwards through Carol Reed's post-war film noir, *The Third Man,* to Peter Weir's eerie cult film, *The Last Wave.* In all these instances, the underground was a place beyond the reference points of normal life as well as a separate, autonomous world characterised by constant movement. Nadar's 1861 Paris sewers were images of the rapid circulation of waste and the reticulation of the dead to new resting places. Occupied Vienna's sewers, in Reed's 1949 film, were the scene of corrupt negotiations, escapes and mysteries. Turpin's installations were also characterised by their immediate replacement of normal experience with unfamiliar references and by their deployment of perpetual motion, the imagery of flight and the perception of dark depths. In 1993, Turpin worked on plans for the renovation of Sydney's Luna Park, and drew up designs for a "Dark Cave" ride.

The postmodern analysis of identity as a construction, traced in Chapter 3, cast new light on the way representation was now seen, but its perpetual rehearsal obscured the particularity of each experience of the stream of art itself. Turpin's works held more nuance. They staged ideas but, rather than transcribing thought, they presented the work of natural processes as a play of artifice directed by a scenographer. Art critic Edward Colless proposed the term "scenography" in opposition to the normal identification of installations with philosophy and conceptualism; Turpin's works, like Domenico de

Clario's architectural interventions, were essentially scenic. Meaning was manufactured through suggestion because Turpin's motifs were submerged. The sculptural arcs of the Water Works were camouflaged by shimmering water droplets that hid precise dimensions and surfaces. Because of the attenuated motion of the drops, water appeared to flow upward; the ability of the viewer to discriminate between physical cause and false physics was blurred. Turpin displaced the properties of one element onto another and was attracted to the ambiguity of certain physical phenomena – wave motion, surface tension and gravity.

Jennifer Turpin's installations were literal embodiments of many metaphors found in discussions about art. They were motivated by a variety of representational problems. The multiplicity of their parts – seen, most obviously, in the webs of thread of the Water Works – was peculiar because of the parity of each constituent part and the absence of climactic drama. The Water Works were composed of opaque signs entangled in a forest of transparent moving artifice. Turpin's installations did not exist to convey pragmatic information as does a map or a manifesto, even though they looked like engineering diagrams come to life. Space traced by water, and the connection of architectural levels in *Shifting Ground*, represented the inscription of a set of aesthetic desires. The references were not to things represented (to the phenomenology of colonised spaces or to metaphorical bodies). Instead, they referred to negotiations and protocols: water apparently floated upwards; sculptural space became a theatre in which perspective was displaced by transparency. Turpin's installations embodied a visual refutation of the proposition that modern and postmodern art should acknowledge the opacity of representational acts. Her works were both transparent and referential; they were Heraclitan counter-memories.

How could we explain the wilful mystification offered by Jennifer Turpin and Domenico de Clario? According to Gary Wills, wonder and disbelief were fundamental terms in the West's colonial discourse during the Age of Exploration.[9] Stephen Greenblatt explained that "wonder" was a double-edged phenomenon: it prompted curiosity but made one recoil in horror from the *monstrum*.[10] Thirteenth-century Dominican monk St Albert the Great discussed the heart-stopping *prodigium* of a natural anomaly, which led to a suspension of the desire for knowledge. The interregnum of wonder, Wills and Greenblatt argued, became a kind of paralysis of the will. On the other hand, this suspension was also, according to St Albert, "the movement of the man who does not know on his way to finding out". According to Greenblatt, the sense of wonder and mystification had a history that changes over time.[11] This experience was the inverse of the quality of resonance – the appreciation of the complex, dynamic forces and causes from which an object emerges – that often became a totalising determinism within postmodern art of the 1980s. Both Turpin and de Clario insisted on the metaphoric and literal suspension of time, belief, process, and materials.

9 Gary Wills, "Man of the Year", *New York Review of Books* v.38 n.19, 21 November 1991, pp. 12-18.

10 Stephen Greenblatt, *Marvellous Possessions*.

11 Stephen Greenblatt, "Resonance and Wonder", in I. Karp and S. Lavine (eds.), *Exhibiting Cultures*, Smithsonian Institution Publications, Washington, 1990, pp. 42-56.

Postcolonial Art and Peripheral Vision

POSTCOLONIAL ART AND PERIPHERAL VISION

The End of the World: A Postcolonial Perspective

Australia is a postcolonial nation and is, therefore, neither an enclave of the great metropolitan centres of world culture in North America and Europe nor even a remote branch office. Australia is not, contrary to the conservative fantasies of royalists, an island floating off the coast of Europe. Although its population is relatively small (a number comparable to Holland), it is an industrialised, highly urbanised, and comparatively wealthy nation. Sydney and Melbourne, for example, are both more and less metropolitan than European cities such as Brussels or Manchester: they are larger, with the vibrancy and extensive cultural infrastructure accompanying dense concentrations of three or four million people from wildly diverse ethnic origins.

Australian artists are, for better or worse, postcolonial artists whether they belong to indigenous peoples or are immigrants and their descendants: the majority of Australians, like Canadians and Chileans, belong to the second category. The political and historical fact of colonisation, most obviously by Britain, makes Australians postcolonial: Australians have inherited political and social systems designed somewhere else; they inhabit an economic system designed to benefit someone else.

Postcolonialism itself is a disputed term and, as is often the case with theory in art, can be mobilised to support severely different opinions. The term can signify either the consequences and aftermath of colonisation, or can simply refer to the period in which colonisation has been left behind upon the attainment of political independence. The latter usage is a far less confrontational definition, leading a number of Aboriginal artists and writers to take issue with the "post-colonial" model.

The previous chapters described how, due to the impact of postmodern thought over the last two decades, identity came to be regarded, by many artists and thinkers, as a social and political construct. Despite the obliteration of old subjectivities, the idea of possessing an "identity" survived in unexpected forms. There were two ways in which identity was now conceived: firstly, the earlier conception of an individual's "essential" character still lingered; secondly, the idea of a socially constructed self formed as much by stereotypes (of class, nationality, gender, age, education, health status and race) as by individual character and personal experience became orthodox. To an earlier generation of feminist artists, for example, identity was principally a function of gender. Assertions of national identity were found in the conservative and usually hagiographic writing surrounding older artists including Arthur Boyd and Russell Drysdale; these descriptions of "Australian" identity usually involved the desert, the outback and the artist-hero. Such definitions were far from accurate, and many of the images with which Australians framed themselves – as a nation of big, bronzed, sun-worshipping, sports-loving men – were biased towards the perpetuation of unequal relationships of sex, class and race; those surf life-savers weren't born bronzed. These definitions, in turn, mirrored international inequalities such as that between the periphery and the centre.

To many postmodern artists, however, identity occurred in cultural and social transactions and was signalled in the activity of consumption – in buying brand-name goods and Madonna books. From the late 1980s on, the processes through which cultural identity was formed became an important issue to many artists, and the facts of location – geographic, historical and national – became the means through which apparently

Previous page: detail from **6:6**

6:1 Gordon Bennett, *Aborigine Painting (The Inland Sea)*, 1994, acrylic on canvas, 216 x 197 cm. Photograph: Kenneth Pleban. Courtesy Bellas Gallery, Brisbane and Sutton Gallery, Melbourne.

6:1

self-evident ideas about culture were examined. Hybridisation and mimicry appeared consistently in the culture of many postcolonial societies.

The erosion of the triple dogmas of modernism, modernity and avant-gardism in the 1980s coincided not only with the emergence of postmodernism but with the realisation that there were increasing complexities of "Otherness" and therefore different types of subjectivity – those of gender and sexuality, race and class, geographic location and dislocations – which were overdue for re-examination. Art communities, especially those of the great metropolitan centres, were increasingly aware that non-European cultures could no longer be understood through conquest, appropriation or blunt domination.

The artists whose work is mentioned in this chapter, including Narelle Jubelin, Tim Johnson, Juan Davila and Tracey Moffatt, reflected upon their location and mimicked, or even perverted, the international postmodern culture of the world's main centres. For most, but not all, of these artists, difference was a source of interaction and not of friction.[1] Postcolonial status was both a perspective and a position, imposed by geography and history, with different effects on non-Aboriginal and Aboriginal artists.

Postcolonial perspectives, which became crucially important during the early 1990s,

1 Trinh T. Minh-ha, Biennale symposium, "A Matter of Timing", Art Gallery of New South Wales, Sydney, March 13, 1993, author's notes.

suggested that modernism was a culturally conditioned construction. Translated to an Australian (or a similar but Third World) environment, modernism and postmodernism *per se* carried no necessary element of the avant-garde crisis which drove modern art in Europe and America from the middle decades of this century onwards.

THE ARBITRARY CENTRE: PROVINCIALISM, REGIONALISM, "WORLD ART"

Provincialism: The Conditions and Status of Australian Art

The dominant and arbitrary power of Western culture makes us blind; it assumes the image and function of an absolutely convincing organised global market. This network of ideas and information is transmitted and organised by the world's technologically dominant economies and constitutes the real contemporary world metropolis.[2]

There are several persistent reasons for the blindness caused by modernity, which invariably refuse to take into account the hybrid condition and status of Australian art. According to Raymond Williams, the first reason for the continuing power and prestige of the avant-garde paradigm and the central metropolis was the ongoing privilege accorded to older cultural forms like those of modernism: cultural authority allowed the centre to arbitrate meaning and value. The phantom metropolis was constituted by prestigious magazines, publishing houses and intellectual institutions, which still exercised vast authority. Legitimacy was determined by the institutional and academic networks located in North America and Europe.

Awareness that the authority of these arbiters was merely relative could illuminate the messages received by those beyond. For example, subscribers to international art magazines usually subscribed in order to find out what was happening in the world of contemporary art. Magazine editors simultaneously constructed a careful impression, through subtle juxtaposition, editorial commentary and layout, that the art they featured was the most newsworthy. The metropolitan cultural centres of the West largely preserved their cultural power and remained immune from the so-called challenges and subversions of art from the periphery. It was unlikely that metaphors outside those of the metropolis could suffice to image power and authority. The metaphors of the world's large art centres were of shallowness and artificiality, epitomised in the supremely self-conscious sexual consumerism of Jeff Koons and the worldly hauteur of Australian photographer Bill Henson, whose work was described in the last chapter. It was equally unlikely that art outside postmodernity and its metropolitan centres of origin could effectively intervene, either literally or metaphorically, in the international discourse of magazines, museums, art fairs and curated shows.

Whatever the desirable attributes of provinces, wilderness or the utterly Other, they were invariably imaged as powerless, even if mysterious and life-affirming.[3] The metropolis was culturally dominant in both metaphors and museums. The relationship between the main centres of Western culture and Australia was limited and fairly straightforward: the colony occasionally provided "raw materials" (including works by regional artists) for theorisation. This image correctly suggests the appropriation of terms from the domain of politics, highlighting the fact that analogous forms of domination are practised within cultural, political and economic spheres. During the 1980s metropolitan postmodernism exercised a benevolent and usually uncontested cultural hegemony in ex-colonial societies like Australia.

2 Raymond Williams, "Metropolitan Perceptions" [1985], reprinted in his *The Politics of Modernism*, p. 38.

3 See the essays, choice of artists, and artists' statements in Jean-Hubert Martin (curator), *Magiciens de la Terre*, exhibition catalogue, Centre Georges Pompidou, Paris, 1989.

The modernist dogmas governing early-20th century culture continued to seem absolutely permanent. Amongst these dogmas, as Williams noted, were the often encountered definitions of the subject as a self-conscious, self-reflexive inmate of the prison-house of language. Metropolitan centres and their avant-gardes saw their own processes as universal. Within the complexity and openness of the modernist metropolis, there was no formed, settled society to mediate or assimilate new art. The metropolis, even now, exists in different stages in different cities.

As commodities of monetary and cultural value, art works established their importance through evaluation, which usually took place with reference to the values and hierarchies of the main metropolitan centres of art: at the large museums and contemporary galleries, in magazines, at artists' studios, and through the reflections of these institutions at the periphery. From all these diverse places, Western culture magnanimously recycled the previously subversive marginality of peripheral cultures in order to preserve its own sovereign position.

This was understood through an international debate to which Australians contributed, both through the adoption (and co-option) of Aboriginal art, and in the participation of Australian artists and theorists. The artists, writers and galleries who form the subject of this chapter were active contributors to these debates, while also being objects of study. Many postcolonial theorists, including Gayatri Chakravorti Spivak and Trinh T. Minh-ha, lectured in Australia, just as Australian writers and artists such as Meaghan Morris and Tracey Moffat contributed to important publications and appeared at major international events.

The metropolitan centres of America and Europe even made a fetish of national difference in order to erase its presence.[4] In a 1989 symposium on "The Global Issue" for the American art magazine *Art in America*, U.S. critic Craig Owens noted a need to distinguish between the benevolent Third Worldism of contemporary metropolitan culture – the sudden, predictable interest of curators, critics and artists in cultural products such as Aboriginal painting – and the more indigestible, rigorous inquiries into national representation by postcolonial intellectuals such as Edward Said, Spivak and Homi Bhabha.[5] A confusion between the two approaches – Third Worldism and postcolonialism – produced art and theory that once again privileged the point of view of colonising Europeans. White artists' sentimental empathy for Aboriginal culture, for example, allowed them to once again appropriate their cultural terrain.[6]

Postcolonial thinkers also criticised postmodernism because, by the early 1990s, postmodernism had become, in Australia and overseas, another powerful, conservative institution. The attractiveness of postcolonial thought in art circles was in no small part due to the openings created by other marginal subcultures, such as those of feminism and gay culture during the 1980s, which were both critical in the formation of postmodern theory. Similarly, the description of the present as hyper-real by postmodernists such as Jean Baudrillard was only partially correct because that experience occurred differently from one part of the globe to another, and differently in Australia to the United States. Gayatri Chakravorty Spivak argued that postmodernism presented itself as neutral, perspectiveless and universally valid, whereas it was in fact unable to accommodate autonomous terms outside its own frame of reference.[7] This argument, in turn, became something of a postmodern and postcolonial orthodoxy in the early 1990s, and was demonstrated in the ambivalent reception of Imants Tillers' Aboriginal appropriations,

4 When, as Simon During noted, an exhibition of Maori art from New Zealand, "Te Maori", toured the United States in the mid-1980s, Mobil Oil was its main sponsor. Mobil hoped to sign several large contracts with the New Zealand Government. A question arose: should Maori spiritual leaders allow particularly sacred but artistically significant treasures to tour? Allowing them to leave the country was to assent to their decontextualisation. Whereas some postmodern theorists, for example American anthropologist James Clifford, argue in such cases that this is inevitable, others felt here that pre-colonial culture could not be torn free of its context without further disruption, loss of tradition and destruction of still intact spiritual traditions. Eventually, the Maori community allowed the art works to travel and they were submerged as the background of the postmodern museum experience. Carol O'Biso, the show's U. S. curator, described one occasion where the museum lights mysteriously went out – the "King Tut" phenomenon – when sacred objects were photographed. She immediately incorporated the incident into the show's pre-publicity, demonstrating a contemporary museum curator's indomitable ability to absorb and profit from the supernatural. See Simon During, "Waiting for the Post: Some Relations between Modernity, Colonisation and Writing", in Ian Adam and Helen Tiffin (eds.), *Past the Last Post: Theorising post-colonialism and post-modernism*, Hemel Hampstead, Harvester Wheatsheaf, 1991, p. 36-37.

5 Craig Owens, interview in "The Global Issue: A Symposium", *Art in America* v.77 n.7, July 1989, p. 7.

6 Homi Bhabha suggested that the deconstructive analysis of postmodernism served to reinscribe the conceptual boundaries of the West on the colonial periphery. See Homi Bhabha, "The Other Question: Discrimination and the discourse of Colonialism" [1983], in Marcia Tucker (ed.), *Out There: Marginalisation and Contemporary Cultures*, MIT Press, Cambridge, Mass., 1990, p. 71.

7 See Gayatri Chakravorty Spivak, *The Post-Colonial Critic*, Routledge, New York, 1990.

The Nine Shots, 1991, which were themselves unforgettably appropriated by Queensland artist Gordon Bennett.

"World Art": The 1992 Biennale of Sydney

The themes of postcolonialism and Australia's geographical location within the Asian region recurred throughout the 1990s as Australian artists developed new cultural links in response to the hybrid present. Whilst Australians' backgrounds were diverse, their sympathies lay with the West; along with most people in developed nations, they were informed and entertained by a media whose orientation was that of the major Western metropolitan centres. In the face of prosperity as fulsome as it was fragile, Australians were nonetheless members of a postcolonial society in transition. The 1992 Sydney Biennale appropriately took as its theme "The Boundary Rider": Australia sat on the fence, straddling the boundary between the major metropolitan societies of the north and the rest of the world, marginal to the concerns of each. The following year's 1993 Asia-Pacific Triennial, at Brisbane's Queensland Art Gallery, attracted enormous interest and enthusiasm from the Australian arts community, testifying to Australian artists' and art bureaucrats' awareness of changing times.

For the American and European art worlds, however, Australia remained part of an intriguing, postcolonial, postmodern scenography which included world music, Japanese television advertising and Pacific Rim cuisine. Australian artists seemed to create exotic signs that testified to the mixing of cultures, proving that the mainstream accommodated diversity according to a benign multicultural cliché. Accordingly, Hispanic-American performance artist Guillermo Gómez-Peña, who toured Australia during the 1992 Sydney Biennale, referred constantly to "cultimulturalism". Well-meaning official clichés of pluralism always worked to diminish cultural conflict resulting from changes, just as the cultural Other was invariably stereotyped and recolonised. The world beyond the big cities of Europe and America was seen as undeveloped, primitive and a source of raw materials; the West was fascinated by both "the Orient" and "the primitive", which it found highly erotic and a source of aesthetic ideas.

Western intellectuals traditionally assumed that they spoke from the cutting edge of an ostensibly global culture – and thus on behalf of all the less developed peoples of nations at the periphery, since these margins existed as impure copies of the centre. International art journal commentaries on Australia often featured a lurid nostalgia for ghostly fantasies of wildness and spirituality; the centre fetishised difference in order to efficiently and unobtrusively manage its erasure. Of course, Australian culture did the same to Aboriginal societies, duplicating, at the periphery, all the centre's duplicity and self-absorption. This misdemeanour, however, did not mean that white Australian artists were able to qualify for full membership of the centre. It meant, as Vietnamese/American theorist Trinh T. Minh-ha observed, that there was a First World in every Third World, and a Third World in every First World.[8]

Such was the background behind the Biennales of Sydney. The 1992 Biennale was held at the cavernous old Bond Stores 3 and 4, and at the Art Gallery of New South Wales. Its Director, Tony Bond, wrote:

In recent thinking the idea of a cultural avant-garde as an arrow pointing down a single "progressive" path towards the future has been replaced by theories of borders where conceptual

8 Trinh T. Minh-ha, "A Matter of Timing", author's notes.

6:2 Coco Fusco & Guillermo Gómez-Peña, *Two Undiscovered Amerindians Visit Sydney*, 1992, performance, Australian Museum, Sydney. Photograph: Carl Bento. Courtesy Australian Museum.

9 Anthony Bond, "Notes on the Catalogue and Exhibition", in Anthony Bond (curator), *The Boundary Rider: 9th Biennale of Sydney*, Art Gallery of New South Wales, Sydney, 1992, p. 15.

territories must constantly be negotiated as they shift and expand, intersecting with diverse other territories. The questioning of limits and our ability to change them becomes a more complex and infinitely more flexible process. In recognition of this change and its obvious implications for a multicultural project, I rejected the quest for universalising tendencies.[9]

The Biennales were, from their inception in the 1970s, Australia's major exhibitions of international contemporary art. They were perhaps the only event in contemporary Australian art attracting considerable overseas media attention, because scores of international artists were brought to Australia to exhibit next to local artists. Over 112 artists were selected for the 1992 exhibition, of whom 84 travelled to Sydney from overseas.

Colonised space had always informed the centre: thus, both modernism and postmodernism could be rewritten with colonial and postcolonial genealogies. In fact, cultural borders between periphery and centre were always porous and their negotiation more complicated than imagined by museums of modern art. An examination of borders – of conditions at the edges of culture, politics and science – was clearly timely, given the dubious credibility of cultural convergence.

The 1992 Biennale of Sydney, the ninth such event, indexed the strategies of postcolonial art: *bricolage*, mimicry and hybridisation. Biennale Director Tony Bond focused on art about boundaries and transgression, locating recombinative *bricolage* as crucial to Border art. Latin American artist Romero de Andrede Lima constructed androgynous cult figures from composite parts. From New York, Orshi Drozdik's installation, *Cynical Reason I*, 1992, combined medical props and theories of cultural control in a literalisation of the gendered subject's borders. Italian artist Guilio Paolini's installation of chairs and canvas, *L'Ospite*, 1992, elegantly constructed the illusion of reflected space seen in negative, highlighting *Arte Povera*'s affinity with the art of the margins; British artist Melanie Counsell's glassed-off warehouse space defined borders as the almost imperceptible framing edges of art. For such metropolitan artists, as for Paolini, the border represented an aspect of Duchampian tradition.

10 Anthony Bond, "Notes", in Anthony Bond (curator), *The Boundary Rider: 9th Biennale of Sydney*, p. 15.

The concept underlying most of the work in the 1992 Biennale was the *bricoleur*, a concept borrowed from the structuralism of French anthropologist Claude Lévi-Strauss. A *bricoleur* is an odd-job man who makes do with whatever materials come to hand, and repairs or devises new tools from junk and scraps. Bond decided that "*bricolage* has proved the most successful strategy for disrupting the linearity of cultural hegemony".[10] Whether or not it actually did so was open to discussion; the Biennale met with very mixed reviews. It had inadvertently marked the probable demise of installation as the means for artists to dismantle or rewrite fixed ideas of identity, because sanctimonious conformity and political correctness often smothered the Bond Store's vast space, just as they asphyxiated the 1993 New York Whitney Biennale. The illustration of social activist sentiment invariably produced sentimentality.

Fiction and deliberate misinterpretation emerged instead as the most challenging aspect of contemporary border art: Narelle Jubelin's *Dead Slow*, 1991, and Coco Fusco & Guillermo Gómez-Peña's *Two Undiscovered Amerindians Visit Sydney*, 1992, reworked the idea of borders through metaphors of intercultural mobility. Jubelin recorded the links between Bombay, Scotland and Australia, tracing the intertextuality of sewing manuals and translating these sources into painstaking *petit-point* tapestry. At the Australian Museum, Fusco & Gómez-Peña exhibited themselves as ostensibly caged Amerindian

6:2

savages from a recently discovered island in the Gulf of Mexico. As a re-enactment of the scandal that greeted the discovery of New World cultures in 1492, *Two Undiscovered Amerindians Visit Sydney*, resonated with a different set of associations in Australia: awareness of comparatively recent trade in deceased Aboriginal bones intersected with an affront to, using Gómez-Peña's term, contemporary "cultimulturalism".

Installation, *bricolage* and the readymade have a long tradition as "survival practices" in peripheral societies. Ashley Bickerton's *Seascape: Floating costume to drift for eternity*, 1991, alluded to these functions; it was a simulation of a lifeboat assembled from fibre-glass, webbing, glass and an embalmed Christian Dior suit. In an interview during the Biennale, Bickerton commented:

> It is a Dior suit. It is the suit of light that one puts on to interact with business, power and politics … To represent a certain Western idea. It is an international symbol that floats around the world endlessly, like the Flying Dutchman.[11]

11 Ashley Bickerton, in unpublished interview with Peter Hill, Sydney, December 1992.

12 Wim Delvoye, in unpublished interview with Peter Hill, Sydney, December 1992.

Wim Delvoye's *Labour of Love*, 1992, continued the artist's displacement of Flemish decorative tradition. In an allusion to Dutch East Indian colonial furniture, Delvoye hired traditional Indonesian craftsmen to carve road-works equipment – a heavily ornamented wooden cement-mixer, shovels and road barriers. The artist commented that:

> The connection is quite strange. The Indonesians imported a certain kind of 17th century Baroque wood carving from the Dutch. I have now employed them to carve a life-size concrete mixer from teak, so in a way I am taking back to the West what was already given to them three centuries ago. Prior to the Dutch influence, Indonesian wood carving had been quite superficial in terms of surface treatment … In my piece here, although it is still wood carving, it becomes a concrete mixer and traffic barrier.[12]

6:3

6:4

6:3-4 Wim Delvoye, *Labour of Love*, 1992, installation comprising carved and ornamented simulations in wood of road works equipment including cement-mixer, shovels and road barriers (all items carved by Indonesian craftsmen), 9th Biennale of Sydney. Courtesy the artist.

Like Narelle Jubelin, Delvoye examined the complex networks of global trade. Lush embellishment re-enacted postcolonial economic relations, through deliberately emphasised exploitation of the European colonial past; art represented the fantastic over-expenditure of an Other's labour.

In an impressively manipulative, expressively eclectic critique of museum spectacle, Fusco & Gómez-Peña addressed the instability of the identities conferred upon them as Hispanic Americans. Like Delvoye's *Labour of Love*, the deliberate outcome of *Two Undiscovered Amerindians Visit Sydney* was cultural-border kitsch in which straightforward complicity was avoided. In other performances during the Biennale, Gómez-Peña simultaneously legitimised and overturned the exhibition's thematic authenticity through urgent, apocalyptic monologues – forecasts of end-of-century global nomadism. Similarly, *Two Undiscovered Amerindians Visit Sydney*'s savages, imprisoned in their large golden cage, owned hi-tech joggers, supermarket kitchenware, lap-top computers and exotic native headgear. The native Americans' availability for photography and media representation coincided with their exploitation of the audience.

Delvoye and Fusco & Gómez-Peña rewrote traditional ideas of artistic authenticity through a deliberate Border art, arguing, in effect, for the colonisation and perversion of the mainstream through the appropriation of both modernity and postmodernity by artists at the periphery. This was the direction taken from the late 1980s onwards by many of the Australian artists who exhibited at the Bond Stores.

POSTCOLONIAL REGIONALISM: CONTEMPORARY ABORIGINAL ART

Celebrity and Commodity

Celebrity transfigures its object. The overwhelming spectacle and commodification of art returned the aura that theorist Walter Benjamin so unkindly removed. It gave Australian Aboriginal painting, from the mid-1980s onwards, a special radiance. Since commodification was a particularly contemporary way of Dreaming, and the contemporary imagination was acquisitive, art audiences were able to witness a cultural convergence of sorts. At the utopian end of the Cold War, when free markets were installed across the globe, the majority of black Australians still lived in conditions as desperate as any urban ghetto.

One sceptical opinion held that Western Desert artists forfeited their identity by participation in white culture. These commentators doubted that the art boom led to much-needed social improvements; attention was assumed to represent a marketing strategy stage-managed by non-Aboriginal connoisseurs and bureaucrats.[13]

However, Aboriginal artists remained particularly resistant to contemporary theory's counsel on correct decorum. They were not nearly as passive as the above account suggested, and Western Desert painters used a market for their work as a way of retrieving cultural power, through influencing an audience that became both international and local. In areas like Australia's Red Centre, ceremonial activity and artistic production flourished against enormous odds. There was some evidence of artistic and financial exploitation, but it was neither significant nor widespread. There were by 1990 about six thousand Aboriginal painters of whom a quarter earned more than $1000 in a year.[14] The prices paid for Aboriginal artists' work remained significantly lower, however, than those received by their non-Aboriginal peers.

Painter Michael Nelson Tjakamarra once said: "It's time for us to teach white people about our culture through our paintings. They probably will learn somehow. It's going to take a long time." Success in American and European galleries carried enormous weight in Australia, and Aboriginal people were intensely aware of the prestige their art generated through exhibitions like "Dreamings", in New York's prestigious Asia Society Galleries during 1988.

When German car manufacturer BMW commissioned Tjakamarra to paint one of its Art Cars (participating artists had included Robert Rauschenberg, Andy Warhol and Roy Lichtenstein) the contract specified that a design be executed in "an identifiably Aboriginal style".[15] The same deeply-held Western sentiments about good value in cars also conditioned responses to art – a preference for reliability, design complexity and, above all, exclusivity. The impact of Australian Aboriginal painting in the arena of contemporary art had, therefore, little connection with intellectual discourse. It was more a case of Western metropolitan culture – the culture of New York and Europe – redefining itself against its own centrality, turning relations to the world's periphery inside-out with the most fastidious propriety.

Leah King-Smith, Tracey Moffatt, Gordon Bennett: "Who do you take me for?"

Many Aboriginal artists, especially those working in urban centres such as Melbourne, Sydney and Brisbane, did not work in variations of traditional artistic idioms at all: Leah King-Smith's photographs were montages of Aboriginal faces drawn from old photo-

13 This view is forcefully if inaccurately put in Tony Fry and Anne-Marie Willis, "Aboriginal Art: Symptom or Success?", *Art in America* v.77 n.7, July 1989, pp. 159-161. A more lucid and convincing account is found in Roger Benjamin's "Aboriginal Art: Exploitation or Empowerment?", *Art in America* v.78 n.7, July 1990, pp. 73-81.

14 Alan Attwood, "Black Art Breaks into a White World", *Time Australia*, July 16, 1990, p. 61.

15 See Vivien Johnson, "Running Trees", *Tension* n.17, August 1989, pp. 52-55. Johnson is one of the most articulate writers on Aboriginal art.

6:5

6:6

16 Gordon Bennett, quoted in Joyce Morgan, "Visions of a Black Heart", *The Australian*, July 6, 1994, p. 16.

17 Tracey Moffatt, quoted from an exchange of letters between Moffatt and curator Clare Williamson, in Tracey Moffatt and Clare Williamson, "Exchange of letters: 'Who do you take me for?'", *Eyeline* n. 18, Autumn 1992, p. 5. Also printed in Clare Williamson, "Who do you take me for?", in *Who do you take me for?*, Institute of Modern Art, Brisbane, March 1992, pp. 3-4.

6:5 Leah King-Smith, *Untitled (#5)* from the Patterns of Connection series, 1991, cibachrome photograph, 102 x 102 cm. Courtesy Gallery Gabrielle Pizzi, Melbourne.

6:6 Leah King-Smith, *Untitled (#11)* from the Patterns of Connection series, 1991, cibachrome photograph, 102 x 102 cm. Courtesy Gallery Gabrielle Pizzi, Melbourne.

6:7 Clifford Possum Japaljarri, *Women's Ceremonies at the Site of Illera*, 1993, acrylic on canvas, 94 x 127 cm. Courtesy Gallery Gabrielle Pizzi, Melbourne and Aboriginal Artists Agency, Sydney.

graphic archives dissolving into Edenic landscapes of trees and water in large ciba-chrome double exposures. King-Smith's images refracted two iconographies – those of anger (the photographs were patched together from a particular moment of colonial history marked by white malevolence) and the uncanny (they were percolated through the psychedelic undercurrent of much contemporary urban Aboriginal art). Their curving, spiritualised space was capacious, spooky and permeable: the fish-eye viewpoints enclosed an enormous field of vision and blurred the boundaries between objects and people. Gordon Bennett painted hybrid, angry appropriations of contemporary postmodernism and rejected easy labels, including that of "urban Aboriginal artist". According to Bennett, "The problem with that terminology is that you become a professional Aborigine instead of a professional artist who is an Aborigine".[16] Other black Australian artists, for example photographer and film-maker Tracey Moffatt, were highly ambivalent about being bracketed as "artists of colour". The photographs in Moffatt's series, *Something More*, 1989, were moments in a carefully staged enactment of a multi-ethnic, ambiguous sexual narrative involving symbolically loaded images of motorcycles, boots, whips and at least two interwoven love stories. Moffatt carefully rejected all simplicistic categorisations:

> I have never been a mere social issues type artist, in fact my work has never been BLACK. (If there is such a definition). I have made a point of staying out of all black or "other" shows (except once, years ago, my work wasn't even well-known but even then I felt it was a step backwards in my career). I want to be exhibited in Contemporary Art Spaces and not necessarily always bunched together with other artists who make careers out of "finding themselves – looking for their identities"!
>
> The reason why I have been successful is that I have avoided allowing myself to be ghettoised as a BLACK ARTIST.[17]

Western Desert Painting: The Business of Art

Western audiences were typically romantic in their assumptions that grand themes and distinctively "authentic" messages lay behind every Aboriginal subject. Over the 25 years since a white school teacher, Geoffrey Bardon, provided a group of old men in Australia's desert centre with acrylic paint, Western Desert artists have sought exactly the opposite, trying to conceal great dramas and avoid their disclosure. The moment that produced the earliest acrylic paintings is unrecoverable but its importance could be sensed from the urgency with which linoleum, old fruit tins and fragments of masonry – any material at hand – were covered. From that time on, the art produced in these communities changed at a rate faster than simple Western models of ethnocidal domination allowed. Aboriginal painters actively sought to enter the institutions of art. The first Aboriginal paintings constituted a crisis: portable representations of sacred images circulating outside the control of responsible initiates. A process of editing out these secrets obviously commenced, and thus what was seen was regarded as not worth hiding. Imants Tillers, amongst white Australian artists, understood and wrote about these issues from the early 1980s, in part because his own painting had been a portrait of a Western culture in which there were no longer any secrets worth keeping.[18] It was necessary to understand the hermetic nature of Aboriginal society. As one anthropologist, Richard Kimber, observed, there was a "fantastic amount of secrecy" involved in the continuous initiatory religious activity of Western Desert communities.[19] Apart from de-tribalised Aboriginal groups, according to other observers, "Aboriginal people have no atheists, no agnostics. Each Aboriginal person is a true believer in their own religious culture."[20]

An irresistibly postmodern script: Fourth World artists raced against their own success to edit out the last traces of mystic meaning, whilst embracing with media-smart subtlety the business of art. The same men – and women – created in the process science fiction spaces so vacant yet loaded that the slightest inflections suggested meaningful infinitude. The more that Western Desert artists worked to eliminate the traces of tribal secrets that earlier slipped past their self-censorship, the more recognisable that transcendent absence became. Foreign audiences expected Aboriginal artists to create paintings as close as possible to traditional culture, but the desire of Aboriginal culture was, apparently, for the artists to avoid those truths. One result was the proliferation of infill dots and repetitive marks that dominated many paintings and separated precise motifs. Anthropologist Eric Michaels suggested that "current Aboriginal paintings be confronted directly as products of explicitly contemporary manufacture".[21] This was exactly how they were intended: Western Desert acrylic painting did not exist before 1971. Traditional relationships, between *kirda* and *kurdungurlu*, or Dreaming-owner and Dreaming-guardian, were indispensable to the correct censorship and transmission of secret motifs; these were now complicated by the production and proliferation of art. The earliest examples of Desert painting were far less carefully interrogated for traces of sacred-secret knowledge than more recent examples. Whilst relatively few women in the Papunya community painted initially, at Yuendumu a large proportion of artists were women and they utilised the phenomenon of art to improve their status and community facilities. Some artists exhibited a greater facility and continuing commitment to painting. The initial waves of enthusiasm in Aboriginal communities were tempered by changes that the production of art for commercial circulation induced.

How, then, were these paintings to be regarded, and how much would outsiders be

18 Imants Tillers, "Locality Fails", *Art & Text* n.6, Winter 1982, pp. 51-60.

19 Richard Kimber, quoted in Max Charlesworth (ed.), *Ancestor Spirits*, Deakin University Press, Geelong, 1990, p. 40.

20 Noel Wallace, in Max Charlesworth (ed.), *Ancestor Spirits*, p. 62.

21 Eric Michaels, "Postmodernism, Appropriation and Western Desert Acrylics", in *Postmodernism: A Consideration of the Appropriation of Aboriginal Imagery*, Institute of Modern Art, Brisbane, 1989, p. 32.

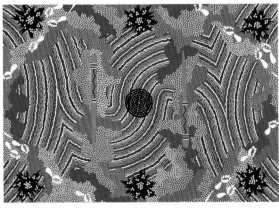

6:7

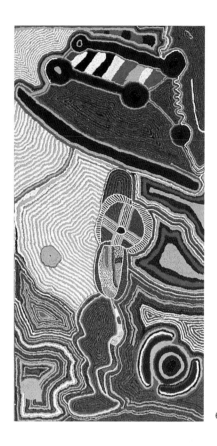

6:8

22 Mudrooroo Narogin, quoted in Robert Rooney, "Dreaming by Design", *The Australian*, July 22, 1989, "Weekend" section p. 16.

23 Alan Attwood, "Black Art", *Time Australia*, July 16, 1990, p. 57.

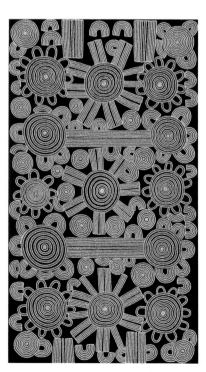

6:9

allowed to know about ritual functions? How was curiosity to be balanced with respect? The painters should have been taken at their word, and acknowledged to be as much in control of the circulation and meaning of their paintings as any other artist. Aboriginal commentator Mudrooroo Narogin suggested that while "stress is laid on the fact that one needs to know the story behind the painting to be able to appreciate it … I deny that this is necessary."[22] Since one could make little real sense of the landscape's topography from a literal attempt to identify geography with painted marks, there was still a tendency to gauge these works by romantic allegorical yardsticks. As the art dealer in Bruce Chatwin's *The Songlines*, a novel about Western Desert Aboriginal communities and anthropologists, declared: "I can't sell a picture without a story".

Donkeyman Lee Tjupurrula's painting, *Yata Yata/Tjarinpa, West of Lake Mackay*, 1990, satisfied this curiosity through an excess of information since a place – in desert terms – was where a lot of things pass through. Every element the artist included was there for a purpose – to confer upon a particular composition a narrative authority and to hide its presence. Complaints about the trivialisation of traditional culture may have therefore missed the point. On the one hand, this painting purported to be a panoramic view, like a map, of the region west of Lake Mackay. In this picture there was in fact a fairly coherent illusion of the representation of a place: meandering lines suggested a creek; dazzling line patterns implied salt-lakes. Tjupurrula's formal brilliance – seen in the interlocking patterns and asymmetrical dynamic – concealed the rupturing of one representational code by another. The black diagonal made by the Marpurri snake, and two arcs, symbolising mythical men, beside the roundel at the corner of the painting, comprised descriptions of altogether different types. On the other hand, in paintings, such as Dave Perle Ross's *Arunbunga's Star Flight*, 1991, all ability to decode the images as maps was defeated by emblematic, almost self-parodic, frontality and the juxtaposition of contrary perspectives. Firstly, the now familiar signs of an aerial view were observed; secondly, the artist interpolated a diagrammatic depiction of body paint and head-dresses for ritual performers. The *knowing* character of these pictures was seen even more clearly in Fred Ward Tjungurrayi's *Three Snake Dreaming towards Karrilwarra*, 1989. It was manifest in the superimposition of schematic snakes – as if drawn from a comic – across a more recognisably "Aboriginal" geometric diagram. Such intrusions appeared in many Aboriginal Desert paintings, for example as the magisterial skeleton in Tim Leura Japaljarri's famous *Possum Spirit Dreaming*, 1980.

Western cultural discernment remains one of its crucial myths. For better or worse, the West's activities as the Other's gatekeeper could be traced via the mediating influence of postmodern theory and through the furore surrounding exhibitions such as "Magiciens de la Terre", at the Centre Georges Pompidou in Paris.

The first standard response to art like Western Desert painting was anecdotal, journalistic and biographical. Based around reporters' accounts of insiders and field workers, it read like a set of character references.[23]

The second reaction to Aboriginal art was to reconstruct the artists in a Western image, emphasising the "pure" qualities of the art and talking about it as if it represented a new phase of international abstraction. The crudity of this view prevented integration of Aboriginal art into discussion and exhibition, in the long run producing a discourse about art at the level of restaurant criticism – an appreciation of subtle audacities. Formalist interpretation of these paintings was as absurd as representing works like the

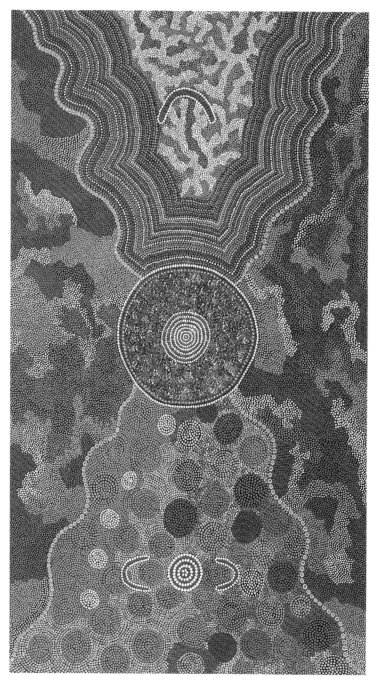

6:10

6:8 Donkeyman Lee Tjupurrula, *Yata Yata/Tjarinpa, West of Lake Mackay*, 1990, acrylic on canvas, 150 x 175 cm. Courtesy Gallery Gabrielle Pizzi, Melbourne and Coo-ee Art, Sydney.

6:9 Dave Perle Ross, *Arunbunga's Star Flight*, 1991, acrylic on canvas, 215 x 124 cm. Courtesy Gallery Gabrielle Pizzi, Melbourne and Delmore Gallery, Alice Springs.

6:10 Pansy Napangati, *Untitled*, 1988, acrylic on canvas, 162 x 90 cm. Courtesy Gallery Gabrielle Pizzi, Melbourne and Aboriginal Artists Agency, Sydney.

Russian art that emerged to international attention at exactly the same time, for example, Svetlana Kopystiansky's towers and walls of books, as purely abstract constructions, as if printed pages and words were simply neutral raw materials.

The third standard reflex was an ethnographic representation of works that were, however, produced for circulation as art. This procedure usually matched Aboriginal paintings with crushingly banal symbolic explanations. Mick Namarari Tjapaltjarri's *Site of Putjana in the Artist's Country*, 1991, was, contrary to wall-text explanations, "about" its mythic description in a paradoxical and ironic way; the painting was deliberately *about*, but did not *represent*, its Dreaming source.

The last, and most complex, response of Western critics was a hypermannerist denial of authenticity. The new art was accused of participation in the accelerated erasure of

cultural difference, through assimilation and absorption into Western art systems. The effect of this purism – certainly not intended – was to quarantine these artists from the rest of the world and to image them as its passive victims. By the mid-1990s many Australian artists, both black and white, including Gordon Bennett and Tim Johnson, were crossing these demarcation lines from opposite directions.

All of these ways of making sense out of Aboriginal art – journalism, formalism, "mix'n'match" museology and hypermannerism – perpetuated long discredited divisions between form and content. Western demystifications in the long term were a source of disinformation. The desire to fix Aboriginal Australian art within the particular structures of First World myth reflected a world view that could not accommodate other logics, and a politics that would not come to terms with unequal divisions between rich and poor. Two very different examples will illustrate these distinctions.

The works of the most apparently traditional Western Desert painters showed rapid, unpredictable transition and evolution, refusing the categories of eternal and unchanging art. Utopia artist Emily Kame Kngwarreye and Papunya artist Pansy Napangati, for example, schematised the desert landscape in signs and designs that became fields of uncertain provenance and type. According to Pansy Napangati, a field of dots flanking the central line of encampments, digging sticks and seated women in *Untitled, Number 3*, 1988, represented waves of desert flowers. Her testimony clarified the picture's codes but, as well, revealed the extent to which contrary significations took place. The use of personal symbolism, such as the field of flowers, indicated the increasing importance of individual invention in Napangati's work, as well as an awareness of the role that she, like other artists, was now playing as a public figure. This self-consciousness was at odds with many commentators' ideas of timeless Aboriginal art. Napangati was not just showing off what she knew: her multiple figurations were strategies, a game of hide-and-seek and a far-from-disinterested statement of ownership. Her work issued from a metaphoric sensibility, and the description of experience unfolded temporally and horizontally. Although her painting offered the same pleasure of imperial possession offered by any easel painting of landscape, the viewer's sense of "possession" of a view was blocked by the production of a surfeit of competing meanings.

Australia's $10 banknote was the subject of litigation by an Arnhem Land artist from Australia's "Top End" in the late 1980s. The banknote included an unauthorised copy of Terry Yumbulul's ceremonial morning-star pole. The case was eventually settled out of court, but controversy and legal action respectively surrounded the use of Aboriginal motifs by contemporary Australian artists and T-shirt designers.

Non-Aboriginal Australians continued to miss the very point of Aboriginal ownership of places, images, and rights to their reproduction. These maps and charts were strategic, acting like deeds and titles as well as art made by *auteurs*. The word "business" was used in some tribal communities to refer to secret ceremonies. To understand this diverse art required that other Australians look beyond its candid inaccessibility to take seriously the business of Aboriginal artists with their audience. Having in a sense done away with imagery, these artists dissipated an awareness of the remaining void by proliferating a multitude of descriptions. Their paintings enacted a refusal to represent that collided with non-Aboriginal expectations, but coincided at times with the ironic minimalism examined in an earlier chapter. As in all good travel stories, Western audiences found themselves and their postmodern ideologies in the most surprising places.

6:11 Emily Kame Kngwarreye, *Desert Life Cycle*, 1991, acrylic on canvas, 231 x 130 cm. Courtesy Gallery Gabrielle Pizzi, Melbourne and Utopia Art, Sydney.

CULTURAL MEDIATION AND MIMICRY

Tim Johnson: Navigating Constraint and Silence

The intercultural role of the go-between – the intermediary between cultures – is both complicated and dangerous. Several white Australian artists have attempted to work in co-operation with Aboriginal people and to learn from their cultures. Although Tim Johnson was probably the best known of these artists, there were many others, including Alice Springs-based painter Rod Moss, installation artist Anne Mosey and several community-based muralists including Carol Ruff.

Tim Johnson's first visit to Alice Springs in 1980 was prompted by marvellously oracular dreams about the Yardbirds' lead singer, and since then he evolved a complex cross-cultural *mélange* of visual languages, incorporating elements from Papunya painting, Mahayana Buddhist art and, more recently, Native American imagery; he also worked with Aboriginal artists and their communities during the explosion of Western Desert painting during the 1980s. His meticulously respectful appropriations of Aboriginal art represented the intersection of his wry 1970s performances with indomitable psychedelia. He recirculated two attributes of Aboriginal painting: forms (he was deeply respectful of traditional owners' copyright); and space (objects were distinguished by both formlessness and exact location within mystical cartographies). In part because of his deliberately constrained invention, his paintings appeared, *en masse*, to be repetitive and undifferentiated as, initially, did many Western Desert paintings. This impression was unfair: uniformity resolved into its opposite on closer inspection. Seemingly lollipop lyricism was, in reality, a mordant Clear Light with dark edges.

Johnson consistently refused to act the authoritative original artist, preferring the role of go-between, collaborating with many artists – Aboriginal, Tibetan and Native American. His paintings were the heterogenous ground across which other artists left signs; his contribution to many paintings was either a neutral infill of dots or a brushy, fragmented field of hypersuggestive distances. Early Papunya works reflected Johnson's initial impulse, on arrival, to document the Aboriginal community. By the mid-1980s, his pictures shifted into another gear: adapting the ambiguous, pixilated Papunya dot-screens, Johnson incorporated their images into his own by asking the artists to complete his paintings. In more recent work, the previously ubiquitous dots became intermittent and passages of gestural, metallic paint formed gaps like the reflective, luminous voids of Buddhism. His analysis of the space of Western Desert paintings insisted on its extendable, infinite depth. *Yam Dreaming*, 1989-92, virtually eliminated the artist's trademark dot-screen. Around Michael Nelson Tjakamarra's design, Johnson painted a darkly romantic moonscape; the spiral pattern and underlying recessions together suggested the drama of Mannerist distortion. In a Tim Johnson/Michael Oglesa Red Shirt/Karma Phuntsock collaboration, *Judgement*, 1993, vaporous space became violent; angelic figures dissolved in the carnivorous multicultural radiance surrounding a serenely floating Buddha.

The separate authorial voices in Johnson's collaborations always remained identifiable. As part of the flood of textual representation delivering Aboriginal culture to the West, Johnson's humble stance constituted him as a particularly reliable witness. Over more than a decade, his painting accumulated a particular discursive authority as a postcolonial form of conceptual art. As landscapes, his works did not attempt to possess the

6:12

6:12 Tim Johnson/Michael Oglesa Red Shirt/Karma Phuntsock collaboration, *Judgement*, 1993, mixed media, 180 x 180 cm. Courtesy Tolarno Galleries, Melbourne and Mori Gallery, Sydney.

6:13 Tim Johnson, *Eden Burns*, 1991, acrylic on linen, 150 x 210 cm. Private collection. Photograph: Greg Weight. Courtesy Tolarno Galleries, Melbourne and Mori Gallery, Sydney

6:13

soul of a place; they articulated an altogether more unfamiliar, incomplete subjectivity, imagining spaces of idealised reconciliation. The dots and purple hazes of his collaborations were not the transcendental spaces of early Modernism because they were not emptied of signification. Instead, they represented the naming and navigation of discourses of constraint and silence. Tim Johnson came to occupy a spaced-out niche – absolutely crucial and ambiguous – at the mutable edges of contemporary art.

Juan Davila: Art History at the Periphery

During the early 1980s as described in Chapter 3, Juan Davila painted images from the margins of gender and sexuality; he "perverted" the straightforward icons of Western art. By the late 1980s Juan Davila's use of appropriation began to change. His paintings increasingly quoted and copied from art history at the periphery, rather than the European mainstream. Copies, in Juan Davila's work and in those of the other artists in this chapter, had special meanings at the Australian periphery. Mimicry was a strategy of reinventing meaning through the recombination of cultural forms, rather than the familiar "emptying out" of content attempted by Australian, American and European postmodern artists during the 1980s.

Pictures such as *Retablo*, 1989, for example, included a hybrid mix of Latin American art and Australian painting. A *retablo* is a small votive painting belonging to a Mexican tradition of folk art; made by humble artisans, they usually feature narratives with inscriptions, a tale of suffering and a *coda* of divine intervention. Mexican artist Frida Kahlo, who became a cult figure amongst neo-expressionist artists and feminist critics during the 1980s, was considerably influenced by the *retablo* tradition.

Many of Davila's 1989 paintings, such as *Retablo*, were undeniably powerful – rather like being caught in a tropical storm. Because of their overwhelming presence, one wished that it was possible to feel some interest or empathy in Davila's cast of characters. He did not, however, communicate anything about his largely Latin American subjects – Frida Kahlo, Diego Rivera and others – except their identities. They were, as in *Stupid as a Painter*, ciphers constituting an argument. Davila said that "painting has no inner life" and he juxtaposed *retablo* narratives with homosexual pornography, modernist painting and science fiction. *Monogram*, in common with much of Davila's work, was a gallery of identities in the Australian avant-garde and a museum of works of art: Rauschenberg's combine painting of the same name was parodied in the title, although Davila included a kangaroo instead of a goat. The game of find-the-art-work was his way of telegraphing to the metropolitan centre – New York – that its gaze comprehended only what was generated by its own tradition.

The specific identity of people seen in these outsized paintings was clearly of the greatest importance, since Davila chose to render museum labels for some figures, like Frida Kahlo, or to brand others with the marks of their signature style. Mike Parr, for example, appeared in *Monogram* with his head anamorphically distorted. In *Retablo*, Manet's *Bar at the Folies-Bergères* was populated by Fred Williams (with a swastika around his neck), John Nixon (his face reduced to a Suprematist cross), Mike Parr, Albert Tucker and John Brack. These were portraits of the professional and public aspects of people – of an appearance within art's economy rather than revelations of personality. Public identities posed in tableaux that were messy and anarchic but highly self-conscious: the characters were known to Davila and "occupied" their roles. The meanings of

his large allegories were far more explicit and less bound by theory than the artist and his critics assumed. The Australian animals and kitsch of *Monogram* were borrowed from children's stories and games. Their presence was obviously metaphorical and suggested the play, reward, punishment and judgement that, like the *retablo*, was the painter's chief narrative. Images of people engaged in sexual play shadowed by animal accomplices (for example voyeuristic lap-dogs in Rococo artist Fragonard's paintings) usually heighten the symbolism of erotic longing or desire. Thus, the stuffed kangaroo whose head burst through the canvas in *Monogram* was a reluctant symbol of traditional desires.

It seemed, then, that there was a productive inconsistency in Davila's paintings through the 1980s. His notoriety could be explained by suggesting that he heightened and refined the fantasies of his art-world contemporaries. This was the background for the various scandals that surrounded his work, like the seizure of *Stupid as a Painter* or the events of August 1994: Davila was at the centre of a minor diplomatic firestorm when the putative exhibition in London of his portrait of a transvestite Símon Bolívar (the Latin American hero of the wars of independence) prompted protests to the Chilean government from its Venezuelan, Colombian and Ecuadorian counterparts. On the one hand, these scandals were probably an integral aspect of Davila's activity as an artist. On the other, Davila imaged an unrelenting paradise of parody, contained in the museums that he affected to despise and scandalise. Although ironic meanings were made abundantly clear, *Monogram* was a hybrid testimony to the intoxication of dreaming.

Juan Davila's large installation, *Interior with Landscape,* 1992-3, appeared at Sydney's Museum of Contemporary Art in 1993 as part of a survey of contemporary South American art, "La Cita Transcultural". Its seven assemblages combined different images of possession, oppression and conquest: a panoramic view of a volcano from a mountaintop; silhouettes of couples copulating in several different positions spied upon by an excited voyeur; a representative of 1960s Op Art (by Argentinian artist Luis Tomasello, collected at the time by Sydney University's Power Institute) embedded within a chaotic bas-relief *merzbau* of decorative hybrid Mexican-Australian cubism. As in his earlier works, Davila's installation was a compendium of sources: in this case of imported forms that artists of colonised countries, from the late 18th century onwards, combined with the art of indigenous peoples to create a defiantly hybrid culture. *Interior with Landscape* perverted postmodernism and modernism through mimicry and copying.

What, then, was Davila suggesting in this heterogenous installation? From a cosmopolitan modernist viewpoint, the great European and American art centres were places of light and the periphery was a site of darkness. Davila's metaphors of copulation, possession, domination and exploration were juxtaposed with images of stylistic mutability, as science fiction interpolated itself into cubist still life. Davila's friend and essayist, Latin American art critic Nelly Richard, suggested in a particularly acidic essay that the dual metaphor of an original and its copy was an apt description of the centre's colonisation of cultures at the periphery such as Australia or Chile.[24] Richard observed elsewhere that: "Our problem then consists in demanding a gaze accustomed to disqualify all secondary or minor forms of art under the "déjà vu" label".[25] Accordingly, the gaze of the Western centre comprehended only what was generated by its own tradition, ignoring the specific social and political contexts that emerged in other cultures. The cosmopolitan centre was invariably conceived as the inevitable model for all innovation – the original. The periphery was the copy and its artists were involved in the mimetic reproduction of lan-

24 Nelly Richard, "Postmodern Disalignments and Realignments of the Centre/Periphery", *Art Journal* v. 51 n. 4, Winter 1992, pp. 57-59.

25 Nelly Richard, in Juan Davila (interviewer), "Interview with Nelly Richard", *Art & Text* n.8, Summer 1982/3, p. 57.

guage that was subordinate in power and originality to that of the original. This arrangement was especially convenient (if complex) for it included its inverse: the exotic nature of the periphery enabled the centre, which saw itself as cosmopolitan and imagined that its synthetic internationalism was fake, to retrieve authenticity through sanctioned theft. Since art at the periphery (aside from pale copies of Western models) was viewed as exclusively and purely ethnic, it was also allowed to be uniquely authentic. It was then pillaged as a mine of inspiration.

By the early 1990s, however, it was no longer possible to reduce the relationship between societies at the periphery and those at the Western centre to that of copies and originals. Therefore, Davila's *Interior with Landscape* collaged and parodied reproduced styles as they existed at the periphery in a particularly disturbing way: he emphasised through their transvestism, remorseless mutability and brutal sexuality that they existed, both at the centre and at the periphery, without systematic organic and structural basis.

Juan Davila's postmodernism had commenced as a dialogue with the metropolitan centres of world art; from the later 1980s into the 1990s, his ongoing subjects were domination and authority, but also increasingly the continuous alternative presence of marginal societies. There were, for Davila, many margins and they were not solely geographical.

As long ago as 1978, in his widely influential book *Orientalism*, Palestinian/American critic Edward Said had traced Western writers' fantasies about the margins, and particularly the Middle East, analysing the tension inherent in colonial discourse: a conflict between an imperial vision of domination that fixed others' identities, which he called "orientalism", and the need to acknowledge each cultural moment's specificity in place and time, allowing for difference and change.[26] In Said's schema, the reforming, civilising mission of the West was constantly threatened by the displacing gaze of its colonised double.[27] The imperfect imitations and mimicry by the postcolonial subject disrupted the dominating discourse and displaced fixed identities. This insight became rapidly familiar in postcolonial theory: at the margins of metropolitan desire, in the ambivalent world of ex-colonial culture, the canonical objects of the West became accidental, incidental, and erratic. In the work of Juan Davila and many other Australian artists, including Matthÿs Gerber, Susan Norrie, John Young and, most pertinently, Narelle Jubelin, these objects lost their representational authority.

Postcolonial theory took cultural hybridity as its subject. It suggested that modernism and postmodernism were culturally conditioned and, translated to an Australian or ex-colonial environment, would probably not embody an inherently avant-garde critique. The link between cutting-edge art and real radicalism – political, ecological, ideological or social – no longer existed. This, in turn, implied that postcolonial artists would be interested in kitsch and bad taste, which were cited in the work of most of the artists in this chapter – both of which were an anathema to the avant-garde.

6:15 ### Narelle Jubelin: Colonial Culture and Canonical Texts

As one of the most important methods of cultural control, colonising cultures always circulated their own libraries of canonical texts. Postcolonial writers and artists, therefore, now frequently rewrote the great European masterpieces.[28] The creative possibilities of revision allowed both black and white postcolonial artists to evolve new perspectives. Narelle Jubelin's *Boer War Comrades Relaxing*, 1988, displaced and translated imperial

26 Edward Said, *Orientalism* [1978], Penguin Books, London, 1985.

27 See also Homi Bhabha, "Of Mimicry and Man: The Ambivalence of Colonial Discourse", in Annette Michelson (ed.), *October: the first decade, 1976-1986*, MIT Press, Cambridge, Mass., 1987, p. 318.

28 See, for example, a postcolonial rewriting of Shakespeare's *The Tempest* in Marina Warner, *INDIGO or Mapping The Waters*, Chatto & Windus, London, 1992.

6:14

history to the edge of another, juxtaposed, Australian narrative. Jubelin's use of translation – transforming Boer War photographs into delicate *petit point*, and craft techniques into contemporary art – was a type of open-ended appropriation that set itself at a vast distance from straightforward postmodernism. Her parodic response to modern history, and the astonishing kitsch Australiana picture-frame, indicated more than an anxiety of influence.

Jubelin's installations were not allegorical arrangements. They were indexes of precious objects in frames and furniture, drawing together fragments of texts and images by other, often unknown, artists, craftspeople and authors. Her pieces were small-scale and labour-intensive, featuring exquisitely made panels in the needlecraft technique of *petit point*, antique frames and objects from colonial and imperial histories (including, on different occasions, old coins, milk-jug covers and tribal masks). She presented these combinations as site-specific installations, researching the history of each gallery's specific location in advance of her exhibitions. Jubelin's works were shown widely in Australia and internationally: *Trade Delivers People* was shown in the Aperto section of the Venice Biennale in 1990; *Foreign Affairs* was created for "Places With A Past: New Site Specific Art in Charleston", at the Spoleto Festival, Charleston, U.S.A. in 1991; *Dead Slow* was shown in Glasgow during 1991 and in Sydney at the 1992 Biennale.

Trade Delivers People, 1989-93, comprised images of cultural exchange along imperial trade routes, including a mask from the Pacific Islands, another African coin-covered mask from the Ivory Coast, a needle-point picture of a steam-driven warship, elaborately carved wooden frames and a New Guinea brideprice armlet made of porcelain buttons. The installation's parts were clearly carefully chosen, both for their ability to suggest the networks of trade and cultural transactions amongst cultures but also for their often spellbinding curiosity and beauty. Thus, *Trade Delivers People* deliberately combined the two qualities of resonance and wonder described in the previous chapter: it emphasised astonishing attention to detail and preciousness, but framed these sensations for the viewer through the apparatus of didactic museological arrangements and carefully chosen references to local traditions that valued these elements of beauty, intricacy and preciousness.

Jubelin recycled items – all of which exaggerated the expenditure of labour – from museum collections, antique shops and forgotten craftspeople, combining them with her *petit point* interpolations, which were either citations or copies of other artists' works. She fetishised this unusual technique, aware that the fetish had become, in many artists' works, a postmodern paradigm for the art object. The constituents of *Trade Delivers People* that did not illustrate exchange mechanisms – of ships, trading tokens, money and gunboat diplomacy – instead catalogued a range of displacements of identity. *Trade Delivers People* was therefore a catalogue of artistic methods of representation, mediated by the embroidered depiction of different types of "self". A silhouette in black and cream needlework of the artist was a depiction of likeness through a pre-modern mimetic formula; the quotation in yellow and green of a similar form – Sidney Nolan's *Moon Boy* – juxtaposed a representation of another type – of mid-20th century surrealism's sense of a disruptive self. A more minimal panel, of a vertical zip made from loose horizontal threads on a blank orange field, imitated the reductive, sublime sense of self in American Post-Painterly Abstraction such as that of Barnett Newman. Another tapestry copied the contents page from the National Gallery of Victoria's *Art Bulletin* of 1967-

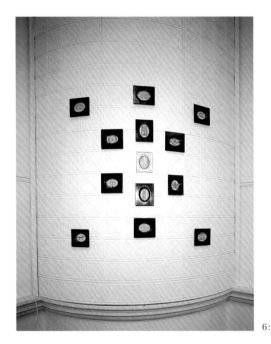

6:16

6:14 Narelle Jubelin, *Boer War Comrades Relaxing*, 1988, *petit point* and frame. Courtesy Mori Gallery, Sydney.

6:15 Narelle Jubelin, *Trade Delivers People*, 1989-93, installation including Pacific Islands mask, Ivory Coast coin-covered mask, *petit point* pictures, carved wooden frames and a New Guinea bride-price armlet covered in porcelain buttons. Collection: National Gallery of Victoria. Courtesy Mori Gallery, Sydney.

6:16 Narelle Jubelin, *Foreign Affairs* (detail), 1990-91, mixed media and *petit point* installation, one of four groupings of miniatures placed in the corners of the Customs House mezzanine around an ironwork centrepiece set at the building's ground level. Photograph: John McWilliams. Courtesy Mori Gallery, Sydney.

6:17

68, and thus referred to the constitution of an identity (in this case corporate) from the written, listed total of many assembled parts.

Jubelin's installation in the Charleston Customs House, *Foreign Affairs*, 1990-91, comprised four groupings of miniatures placed in the corners of the Customs House mezzanine and an iron-work centrepiece set at the building's ground level, each of which represented an aspect of local Charleston history and the city's relationship to the world through trade. In one corner, elegantly framed slave tags were arranged around the central icon of two United States coins framed in ivory. Another corner contained miniatures based on local ironwork arranged around an ivory-framed centrepiece made from brass detonation springs which had been produced in Sydney for export to the United States. *Foreign Affairs* made relationships visible by juxtaposition: Diane Losche observed that in this case the linkage between international order, the artistic avant-garde and local communities was made manifest as the labour of ordinary people.[29]

The important Guggenheim collection of modernist paintings, as Jubelin knew, had its first major showing in Charleston in 1936. In the *Solomon R. Guggenheim Collection of Non-Objective Paintings*, 1990-91, she translated the pure language of international modernism into a hybrid postcolonial form, converting modernist abstraction in the Guggenheim collection into *petit point* vignettes and a litany of modernist artists' names in fragile handmade lace. These were not faithful copies of specific paintings, but distillations of familiar styles in modernist geometric abstraction. Jubelin's work was inextricably embedded in the network of art history; scaled down to intimate size, her logos, names and diagrams on cloth were both deconstruction and homage. The preciousness of the frames and fantastic, exaggerated expenditure of labour, like a parody of the economy of capital, did not trivialise or programmatically "subvert"; they memorialised a utopian sector of modernist mythology. Jubelin embroidered the signatures and names of great modernist artists in pairs (Ben Nicholson with Picasso, for example) placing them around a Foreign Order medal in an ivory frame. In *Foreign Affairs*' rendering of the Solomon R. Guggenheim collection in needle-point names, Jubelin contextualised international modernism as a fetish of a particular place and time, mimicking modernism's forms rather than appropriating or approximating its appearance.

Generic versions of similar modernist abstraction were then created and memorialised in the needlecraft manuals incorporated in *Dead Slow*, 1991-2, which enacted through the shadow play of adapted designs and patterns the uneasy decay or mutation of styles as they moved from centre to periphery. If *Dead Slow* appeared, on the surface, to delineate the export of items from Scotland or designs from Berlin to the far reaches of empire, then it clearly drew a parallel between this dissemination and Dada artist Marcel Duchamp's appropriation of mass-produced objects as readymades. Duchamp commenced his appropriation of everyday objects at the dawn of modern consumerism and mass production; at that time it was still possible to imagine that the possession of one mass-produced bottle rack would imply the possession of a generic, homogenous range of bottle racks.

Jubelin converted Duchamp's methods to the more heterogenous intellectual and feminist climate of the 1990s. Her carefully rendered "readymades" were, like American artist Sherrie Levine's watercolours of the early 1980s, new works of modernist art, craft and design; they were copied and presented, with deadpan elegance, as didactic, educational museum installations. The viewer's attention was directed to framing and context,

29 Diane Losche, "Subtle Tension in the Work of Narelle Jubelin", *Art and Australia* v.29 n.4, Winter 1992, p. 466.

6:18

6:17 Narelle Jubelin, *Solomon R. Guggenheim Collection of Non-Objective Paintings*, (section of *Foreign Affairs* installation, Customs House, Charleston), 1990-91, *petit point*. Photograph: John McWilliams. Courtesy Mori Gallery, Sydney.

6:18 Narelle Jubelin, *Dead Slow*, 1991-2, mixed media and *petit point* installation, Glasgow. Courtesy Mori Gallery, Sydney.

while the various sources and authors of her quoted "texts" – the fish-scale patterns for pressed steel sheets or real 19th century Gujarati wooden printing blocks – were either left intact or partially but accurately copied. If Jubelin's installations constituted a denial of authorship typical of 1980s postmodernism, her needle-points and carefully curated displays were deliberately passive, accentuating both preciousness and fidelity.

Occidentalism: Reversing Messages from the Emperor

The precedent of the feminist art of the 1970s enabled artists such as Jubelin and Susan Norrie, whose work was described in Chapter 4, to adapt representations through simulating their processes. Although a new abstraction had emerged during the late 1980s as both homage to and rejection of modernist abstraction's claims, Jubelin's *petit points* were at least as aware of the readymade and simulation. Her eclectic works, however, deliberately and precisely demonstrated that modernist styles were inherently neither critically reflective nor historically necessary. Jubelin's abstractions, in both the *Solomon R. Guggenheim Collection of Non-Objective Paintings* and *Dead Slow*, were self-conscious, consummate deceptions: they apparently sought to disrupt the paternalistic canon of modernist abstraction through spelling out its fate as decoration. Her small pieces of cloth were thus shrouds at modern art's funeral. Jubelin's *petit points* sidestepped recapitulation of the modernist crisis by virtue of their exquisite craft quality and fabrication in a medium other than that of oil paint. She demonstrated a contrary, feminist command of technique that was hard to test since its criteria were so obscure. Her simulation of painting by needlework reduced the history of modernism to conventions, impersonating the medium's history and suggesting its parallel narrative, that of commerce.

Impersonation, translation and mimicry were particularly important tools for artists working in peripheral art centres. The seduction of a literal identification with the history of Western art, especially through translation into a perversely inappropriate medium, allowed a postcolonial projection of fantasy that defined Australian culture against a Western Other. Reversing the more familiar Orientalist schema with its unorthodox and unfamiliar inversion, Jubelin, like many other Australian artists during the 1990s, projected an unorthodox, distorted image of the West back towards its centres.

Conclusion: Treachery and Fiction

CONCLUSION: TREACHERY AND FICTION

The Thief in the Attic: Renegotiating Contemporary Art

The 1990s represent a moment between shifting artistic paradigms – a window through which the recent past's postmodern insistence on artificiality and fragmentation intersects with the detachment of memory from objects and thus, inevitably, the intervention of treachery and fiction. If artistic identity was revealed, in the postmodern art examined in this book, as a construction in the library of late-20th century intertextuality, then fiction is the terminus through which the resulting images depart towards the end of the millennium. Images circulate in an underground network of meaning and its necessary opposite, betrayal; certain older artists – Imants Tillers, Robert Owen and Robert Rooney – have been prescient in their understanding of this mutability just as Aleks Danko's or Domenico de Clario's installations remain exemplary illustrations of its preference for darkness.[1]

1 The male gender of these artists is no accident; just as it would have been easy to assemble another list composed of women artists of the following generation whose works illustrate this theme, so the absence of women here makes a point about familiar inequalities in artistic practice and opportunity during the late 1960s and 1970s. Lyndal Jones' or Vivienne Binns' works, for example, did not specifically explore the issues of failure and treachery.

Three predicaments draw the works described in this book together: the metropolitan centre's failure to take care of its children (settler societies such as Australia or Canada); the failure of nationality as a viable construction (a cultural cure-all for our politically and economically dependent condition); the decadence and bad faith of the avant-garde as it survives in Australia (or, for that matter, in the metropolitan centres of Europe and North America, and in its obliviousness to anything other than the forms of a crisis of representation at the large centres of culture in Europe and the United States).

A gradual but complete renegotiation is, therefore, under way. For example, many of the artists in the later chapters of this book represent a generation of artists who question art's capacity to operate as a vanguard movement. They have come to doubt the idea that art has the capacity to "subvert" society. Some, such as Susan Norrie, reveal the complicity of art in the politics of commodification and spectacle. Paradoxically, others – the new abstractionists described in Chapter 2 – seek to reclaim the rhetoric of "resistant art", as if non-objective abstract shapes on canvas or wood could challenge the overwhelming power of material culture. Finally, just as certain theorists argue for the appropriation of both modernity and postmodernity by the periphery, artists such as Juan Davila are involved in a perverse colonisation of the mainstream.

The Library: 1990s Perspectives on Artistic Identity

The deepening shadows of postmodernity have forever blurred our picture of the artist. Because its revelations of fragmentation and intertextuality are by now a reflex, a work of art is often visualised as a library and the artist as a community of authors. If artistic meaning is seen as a construction, then it is also able to be a fiction; invented worlds in art are a way of deciphering hybridisation. Libraries and catalogues abound as images in contemporary art and are often the result of collaborations between artists – from the West Australian-based Glick Foundation's mysterious exhibition programs to Pat Brassington's 1993 collaboration, *incorporeal 2: "book of jonah, 1932, sinking into a world whose bars would hold me fast forever"*, 1993. The *incorporeals* were a series of installations and Happenings, in which Tasmanian critic Edward Colless and photographer David McDowell co-operated with other artists to create works that would have been unrealisable by the collaborating artist alone.

Postmodernity has irrevocably altered the shape of our awareness of international

Previous page: detail of **7:2**.

7:1 Kevin Henderson, with Edward Colless & David McDowell, *incorporeal 3: "The Insect Cage. Correct Sadist. Between the wish and the thing lies the world"*, 1993, performance/scenography, Hobart. Photograph: David McDowell.

7:2 Pat Brassington, with Edward Colless & David McDowell, *incorporeal 2: "book of jonah, 1932, sinking into a world whose bars would hold me fast forever"*, 1993, installation/scenography, Hobart. Photograph: David McDowell.

7:1 7:2

culture; Australian artists appear within the world of international contemporary art as postcolonial participants, and absorb the implications and bankruptcies of imperial representation. Neo-modernist abstractionists (including the Melbourne Store 5 group and Sydney artists who originally showed at First Draft West) mixed and cited styles; they have created hybrid postcolonial forms almost in spite of themselves and thus their work resembled that of historically alert postmodern artists like Susan Norrie and A. D. S. Donaldson, whose dry, ironic installations were a *bricolage*-like instant recreation of mainstream, modernist art.

Imants Tillers' 1980s paintings prefigured such artists' concerns. Taking the history of art as both subject and language; his pictures described the gap between the periphery and the centre. He emerges, therefore, as an extraordinarily prophetic artist. Tillers' paintings became a widely accepted Australian referent for postmodern art, but also demonstrated that it is no longer possible to reduce relations of dependency between centre and periphery to a linear equation. The original/copy relationships of modernism, where the metropolitan centre of world culture (New York or Paris) was the source of new ideas that were gradually disseminated to the periphery, is no longer meaningful.

Tillers' paintings await thorough reassessment; so do the early 1970s works of Dale Hickey, Robert Hunter and Robert Rooney. Such reassessment is crucial because the revival of abstraction, that began in the later 1980s as an attempt to redefine discursive relevance and conventionalised styles, fragmented under the weight of its own contradictions. The new abstract painters treated abstract painting as a period style available for revival and therefore demonstrated clear affinities with the work of these earlier artists. The parodic abstraction of Hunter's, Hickey's and Rooney's pictures already existed in an ambivalent relationship to late-modernist painting, representing a conscious betrayal of international formalist abstraction. Hunter's 1990s paintings, such as *Untitled #4*, 1990, were major achievements in their luminous antipathy towards conventionally understood minimalism.

The links of Australian artists to modernism are complicated: neo-modernist artists (such as Constanze Zikos) and late-modernist artists (for example Robert Rooney) both produced work that explored signifying practices at the borderline between figuration and non-figuration, or design and fine art. Profound, unacknowledged connections exist in terms of the betrayal by painters of their models. Copying is often held to have

7:3 Robert Hunter, *Untitled #4*, 1990,
acrylic on plywood, 122 x 244 cm.
Photograph: John Riddy. Courtesy
Pinacotheca, Melbourne.

7:4-6 Robert Owen, *Phase Zone Three
(Into the Light)*, 1987, installation,
Victorian College of the Arts Gallery,
Melbourne. Courtesy Anna Schwartz
Gallery, Melbourne.

been reinvented through postmodern appropriation as a new, culturally critical practice, resulting in the rethinking of representation. Modernist art was supposed to be a window opening inward to imaginary worlds; recent art instead, according to many critics, opens away from truth onto a series of even more abstracted models.

Much of the contemporary art in this book looks genuine but refuses to function as painting or sculpture, eschewing self-expression or even artistic status. Many artists are now suspicious of art that poses as critique. Their work, distinguished from the earlier avant-garde by its lack of overt *cultural* criticism, operates instead through infiltration. These artists – "grunge" artists, installation artists, photographers and Aboriginal painters (urban and tribal) – implement the strategy articulated by critic Thomas Lawson nearly a decade ago; they deliberately combine representation with misrepresentation.[2]

The Terminus: Messages for the Centre

As it departs from the periphery, art presents itself as a mirror. The mirror needs to appear as clear as possible if the important global metropolitan centres such as New York are to contemplate themselves. Mimicry is the means by which, according to writers as diverse as Homi Bhabha and Trinh T. Minh-ha, the periphery's awareness of formlessness is communicated to the centre. From this perspective, Australian contemporary art emerges like an image in a painting by Chilean artist Arturo Duclos that was shown at Sydney's Museum of Contemporary Art in 1993: a coffin in a museum, containing a picture by Mondrian inside its wooden walls.

Domenico de Clario's underworlds describe the end of a paradigm that can be traced back to Marcel Duchamp; they forego the supposedly exemplary but now enervated museum experience of aesthetic nomination. Grunge artists (for example, Hany Armanious) illustrate the same elision. Edward Colless described one type of installation as scenography, differentiating its filmic dimension, in which the setting itself is foregrounded, from conventional post-object art's invocation of the aesthetic frame and demarcation of art's edges, even within an expanded field. Colless and McDowell's *incorporeal* collaborations share many similarities with de Clario's three-part Melbourne installation, *Components of an Expression Machine*, emphasising their audiences' participation within Antonin Artaud's concept of an "activated metaphysics".

For artists at the periphery – in Australia as well as Chile – this adaptation or mimicry often results in a twisted version of minimalism – a minimalism with content. On the one hand, Trinh T. Minh-ha argues for a breakdown of cultural separatism, ironically warning white artists of the probability of failure and misunderstanding: "It is better to mind your own business".[3] On the other, the presentation of two themes – silence and treachery – is an accurate description of an immensely complicated dematerialisation of meaning and the politics of representation. From the 1970s onwards, Robert Owen's installations crossed disciplinary and cultural borders; their primary metaphor was silence, and they were constructed within a consciously disingenuous employment of minimalism's international syntax to create visual paradoxes. In Owen's 1987 *Phase Zone Three (into the light)*, abstract painting was returned to its synaesthesic and scientific sources. Deciphering *Phase Zone Three*'s components was of considerable consequence because the experience of the work was far from classic minimalism, which emphasised a phenomenological resensitisation of perceptions. Instead, Owen assembled a library of information, incorporating an absent collaborative community of twelve powerful

2 Essays by many writers, including Eric Michaels, Imants Tillers and John Welchman have explored the deferral and editing of meaning and the reception of contemporary Aboriginal art. See Thomas Lawson, "Last Exit: Painting", in Brian Wallis (ed.), *Art after Modernism* pp. 153-165. Both Thomas Lawson, the Scottish-born but American-based artist, art magazine editor and critic, and American curator William Olander have written about the role of the spy, the infiltrator, the collaborator and the fake in contemporary art – in short, about treachery.

3 Trinh T. Minh-ha, "A Musical Accuracy: The Politics of Identity and Difference", public lecture, Melbourne, August 18, 1993, author's notes.

7:4

7:5

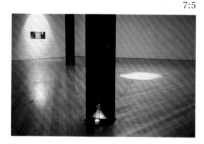

7:6

7:7

7:7 Lindy Lee, *The Ulterior Function*, 1993, photocopy and acrylic on Stonehenge paper, 16 panels, 175 x 125 cm. Courtesy Roslyn Oxley9 Gallery, Sydney and Michael Wardell Gallery, Melbourne.

7:8 Lindy Lee, *Erase*, 1993, photocopy and acrylic on Stonehenge paper, 30 panels, 182.5 x 168 cm. Courtesy Roslyn Oxley9 Gallery, Sydney and Michael Wardell Gallery, Melbourne.

4 According to Chatwin, the Lizard Man travels across Central Australia, singing the world into existence; the stanzas of his story are preserved as inscriptions upon the landscape, recognised by us as rivers, rocks and mountains. Kiefer compared this with other epic journeys, like that of Ulysses, as a voyage of self-discovery. Incipient truth is recognized through revelation: this, rather than dialectical learning and discussion, is the effective arena of art. Paralleling Scottish artist Ian Hamilton Finlay's distance from the modernist aesthetic, Kiefer disregarded the importance of present-day culture; in his view, art has been in a state of decline since the Fall of Byzantium. He identified European mysticism with the Dreaming, and epigraphy with Aboriginal representation of songlines through visual and spoken codes. The Lizard Man's journey implies travel, a destination and a split between the cultural, spiritual and social bodies that is not perhaps present as a teleological movement in Aboriginal paintings' narrative structures. In Adelaide, Kiefer emphasised the mobility of meaning and the relativity of artistic intentions: "For the way between the intention and the artwork which appears when the process comes to its

female authors and artists who were, as willing collaborators, denying the potential for betrayal in works of uncertain gender.

German neo-expressionist painter Anselm Kiefer's status as the contemporary celebrant of loss within the European cultural tradition is well known. Kiefer is contemporary art's unreconstructed image of the charismatic male "genius"; his enormous paintings are hung as centrepieces in Australia's major collections. He is also the most obvious type of "thief in the attic" – the mainstream artist appropriating peripheral culture. Reactions to his sophisticated thefts, however, underestimate the artist's interest in heterogeneity and expose the unreflective demands for homogenous "enlightenment" at the periphery. Inevitably, an aura of scandal surrounded the artist's visit to Australia to deliver an address at the 1992 Adelaide Festival. Adelaide, for Kiefer, represented the border between metropolitan culture and the still authentic, mystical culture of Aboriginal Australia. Greeted with media attention usually accorded important film stars, he was described in newspaper reports as the world's most renowned living artist. His speech, on March 11, 1992, was awaited with the expectancy due an art-world Delphic oracle, but also as the expression of Eurocentric self-absorption. To the surprise and evident disappointment of his Australian audience, instead of speaking about his paintings Kiefer chose to recite a long poem that he had written as a meditation on a narrative from Aboriginal mythology, gleaned from a reading of Bruce Chatwin's eclectic novel *Songlines*.[4]

What Kiefer saw, of course, in Australia was his own subjectivity. Similarly, the New York feminist collective, Guerrilla Girls, also in Adelaide for the Festival, found the sexism and domination of a Manhattan or Cologne art machine duplicated at the Antipodes. During question time, the Guerrilla Girls demanded that Kiefer donate a percentage of his income to "women and artists of colour", unhesitatingly importing an American discourse and terminology that translated imperfectly to an Australian cultural context except as the reflection of their own imperial subjectivities, educating the unsophisticated locals whose culture had absorbed many more lessons about marginality than the Guerilla Girls realised. Much of Kiefer's hostile white-Australian audience constructed an equally problematic, protective relationship – in their case to Aboriginal mythology, even though their Australia exists as the destroyer of much of that culture. The confused, censorious and hostile reaction to both Kiefer and the bizarre mythic imagery customarily found in mysticism and mythology (where sexual metaphors are used to describe esoteric propositions) was eerily reminiscent of the medieval Iconoclastic controversies that Kiefer drew on for his paintings of the early 1980s.

South African journalist Rian Malan's controversial book, *My Traitor's Heart*, describes the scarifying effects of colonisation and the tragedy of apartheid through the white South African population's refusal to act with any kind of good faith.[5] Adrift from empire and living in another land corralled from its indigenous inhabitants, Malan's "Just White Men" are just as easily seen as the cultivated, sophisticated Australian audience of artists, intellectuals and thinking people from all immigrant backgrounds – since, as Anne-Marie Willis has pointed out, a common materialist ethos applies to all non-Aboriginal Australians.[6] These Just Whites, unable to come to terms with their historical situation, were Kiefer's Australian audience.

The intolerant materialism of late-capitalist society appears to be simply inadequate to deal with dispossession, which requires an apparent act of altruism that would in

7:8

temporary end. The result is always different from the intention - the boomerang comes back, but in a different mode. And, secondly, the movement of the boomerang is a metaphor for the changes a work of art undergoes on its way to the spectator." [Anselm Kiefer, quoted by Michael Shmith, "Different Strokes", *The Age*, March 12, 1992, p. 11.] Kiefer is easily criticised as the paradigmatic male artist. His work is conservative because of its point-of-view: hermetic European phallocentrism is judged to be outmoded and reprehensible. Kiefer obviously is a privileged male European; his art has been based on participation and debate within that tradition. However, the Adelaide criticisms of Kiefer, though well-intentioned, reflected a woolly misunderstanding of critical terms such as phallocentrism and deconstruction, confusing methods of reading texts with political strategies. Postcolonial feminist Gayatri Chakravorty Spivak clarified the inescapability of such identifications: "The subject is – the subject must – identify itself with its self-perceived intention. The fact that it must do so is not a description of what it is. That is the difference between decentered and centered. There is no way that a subject can be anything but centered … There is no such thing as the decentered subject". (Gayatri Chakravorty Spivak, *The Post-Colonial Critic*, p.146.)

5 Rian Malan, *My Traitor's Heart (Blood and Bad Dreams: A South African Explores the Madness in His Country, His Tribe and Himself)*, Vintage, London, 1990.

6 See the concluding chapter of Anne-Marie Willis's incisive book about cultural identity, *Illusions of Identity*, Hale & Iremonger, Sydney, 1993.

7 Trinh T. Minh-ha, "A Matter of Timing", author's notes.

8 Narelle Jubelin, quoted in Jennifer Stevenson, "Art Trade", *Vogue Australia*, May 1990, p. 146.

Facing page: Joan Grounds, *Bridge* (detail), 1990, installation, 200 Gertrude Street Artists Space, mixed media. Photograph: Terence Bogue. Courtesy Annandale Galleries, Sydney.

reality permit the colonisers' cultural survival. Two centuries of oppression and conquest have produced European settler populations, in Malan's words, "spiritually deformed" and unable through greed and pride to do anything constructive to repair the damage. Peripheral cultures such as Australia and Canada recycle the terminal forms of avant-garde subversion received from New York and Cologne as a means of simultaneously overcompensating for a peripheral status and knowingly reinscribing their marginality – a desire to both reproduce the centre and flaunt difference.

Melancholic longing to be up there with the big players of the international art world is a pathological condition, enabling a denial of the ambivalences in Australian cultural relationships with European and American centres. Amongst contemporary artists and critics, a surplus of rectitude (of what has come to be known as political correctness) customarily overpowers acknowledgment of the illegitimacy on which local histories are founded. The productivity of working rigorously through this inauthenticity is illustrated in the works of Rooney and Owen.

At the 1993 Sydney Biennale symposium, Trinh T. Minh-ha asserted that difference is a source of interaction, not friction.[7] Very few white Australians are able to deal constructively with their "hyphenated" identities – as cultural inhabitants of several worlds. Some artists have already acknowledged their hyphenated identity, either working, like Tim Johnson, on approximately the terms of the original inhabitants, or resurrecting meaning, like Sydney painter Lindy Lee – in the Asian/Australian artist's outrageously poignant, multi-panelled, manipulated photocopies of ghostly Old Master paintings. She consciously delineates experiences that foreshadow an elaborate world in which it is necessary to say or be two or three things at once, even dispensing with the ubiquitous postmodern cloak of irony, as in *Erase*, 1993. These artists move outside the boundaries of nationality, fixed authorship and a mainstream; they work with the hybridisation of an Antipodean creole culture.

Of the major questions to be asked during the 1990s, the most critical concern the manner in which postcolonial and diasporic cultures such as Australia can interact with other world centres of culture and information. What can the centre trade with them; what can they offer the centre? The attraction between centre and periphery has always been mutual, and the centre's hegemony has often been benevolent. Cultures at the periphery have frequently been willing subjects. Almost all the Australian art examined in this book requires an acknowledgment of hybridisation – the mixing of terms and meanings – to a greater or lesser extent. The treacherous relation to an apparently essential self is probably inevitable and is seen, finally, in the experience of many Australian artists. As Narelle Jubelin observed, "Of course it is a dicey trade swapping, mixing, integrating cultures, which is why I've included myself in the self-portraits. I'm involved in the whole deal".[8] The two metaphors of a library and the terminus refer to Australian artists' inevitable boundary-crossings. These boundaries are more than inflexible formations of class, gender, nationality and race. The evidence of contemporary Australian art has been that the idea of the body as the edge of the personal self is being refigured at the end of the world.

Index

Opposite: Bonita Ely, *Histories* (detail)
1992, mixed media, 55 x 215 cm.
Courtesy Sutton Gallery, Melbourne
and Annandale Galleries, Sydney.